nstances, it was about resurrecting an art form that had fallen into obscurity. In ten incisive chapters, from comic books to earthworks to street art, from the sixties through present day, Polsky explores the relationship between marketing and making, between connoisseurship an hard work, and, finally, between disc and promotion. For anyone intereste the modern art world, The Art Proph presents an enlightening and enter portrait of groundbreaking artists and the visionaries who helped pave their way.

# The Art Prophets

Also by Richard Polsky

*Boneheads: My Search for T. Rex*
*I Sold Andy Warhol (Too Soon)*
*I Bought Andy Warhol*
*The Art Market Guide (1995–1998)*

# THE ART PROPHETS

## The Artists, Dealers, and Tastemakers Who Shook the Art World

Richard Polsky

Other Press
New York

Production Editor: *Yvonne E. Cárdenas*
Book design: *Simon M. Sullivan*

This book was set in 11.25 pt Electra by Alpha Design & Composition of Pittsfield, NH.

10 9 8 7 6 5 4 3 2 1

LIBRARY OF CONGRESS CATALOGING-IN-PUBLICATION DATA
Polsky, Richard.
The art prophets : the artists, dealers, and tastemakers who shook the art world / Richard Polsky.
p. cm.
Includes bibliographical references.
ISBN 978-1-59051-406-1 (hardcover : alk. paper) — ISBN 978-1-59051-407-8 (e-book : alk. paper)  1. Art—Collectors and collecting—United States—History—20th century.  2. Art dealers—United States—History—20th century.  3. Art—United States—Marketing.  4. Art—Forecasting.
I. Title.  II. Title: Artists, dealers, and tastemakers who shook the art world.
 N5201.P65 2011
  709.2'2—dc22     2011013296

*For my mother, the writer Marlit Polsky*

# Contents

viii  Contents

Introduction
## What Is an Art Prophet?

I F YOU CONDUCTED a survey in the art world and asked, What's
the first name that comes to mind when you think of a vi-
sionary art dealer?, chances are the answer would be Joseph
Duveen. As anyone who has read S. N. Behrman's wonderful
biography *Duveen* knows, he was the man who introduced
America's early-twentieth-century industrialists to Europe's old
masters. Duveen perfected the art of the deal, way before Don-
ald Trump. There was almost nothing Duveen wouldn't do for
his most important collectors—procuring architects to design
their homes, wrangling reservations in fully booked hotels and
tickets on sold-out cruises, even finding spouses for a select few.
His clientele included the Rockefellers, Henry Clay Frick, and
Andrew Mellon. He helped them develop collections that often
wound up being donated to such institutions as the National
Gallery of Art, where, in this case, they formed the core of the
National's Italian Renaissance holdings—further burnishing his
legendary status.

Despite Duveen's lofty reputation, he needs to be seen as a
business visionary first—and an art-world visionary second. His
empire was built on the simple observation that Europe had
plenty of art and America had plenty of money. His plan for
marrying art and commerce was based on understanding the

psychology of his clients and the current zeitgeist. Duveen figured out that the nouveau riche tycoons he dealt with needed daily reminders of their accomplishments, and what better way to celebrate one's greatness than to live with iconic works of art?

The eleven men and women you are about to read about were all pretty fair business-minded people in their own right (for the most part). But what they ultimately achieved, in many ways, was greater than Duveen's success. It went beyond the art of the deal and returned to the appreciation of art itself. The art prophets in this book *altered lives*. In some cases, the artists themselves were the beneficiaries, in others the collectors. Each of these seers snatched something out of the wind and conjured up a hurricane that redirected the art scene. As for the ten selected categories of art, from Pop Art to Native American art to photography, this book offers a glimpse into some lesser-known art movements and a fresh take on some already well-known ones. Sometimes it was a matter of identifying a group of like-minded artists and packaging them as a movement. In another scenario, it was about resurrecting an art form that had fallen into obscurity. It's also important to bear in mind that the key figures in each chapter weren't just dealers or promoters; they were also the artists' friends, supporters, patrons, and biggest fans.

This book concentrates primarily on American art created from the sixties—when our country's boundaries for the arts were exploding—to the present day, when the arts have become a growth industry. The art market also experienced a dramatic upheaval during this time span. Back in 1958, when Jasper Johns painted his famous *Three Flags*, it would have been inconceivable that the triptych of superimposed canvases, which originally sold for approximately $950, would sell only twenty-two years later to the Whitney Museum of American Art for $1 million. Now, we shrug when we hear about a Picasso or

a Giacometti bringing $100 million at auction. While the art world has come to be dominated by an investment mentality, at the end of the day it still comes back to the art itself. As Jasper Johns said when asked to comment after the sale of *Three Flags*, "A million dollars is a lot of money, especially to someone born during the Depression. But it has nothing to do with art."

The lives of the art prophets in this book have everything to do with art. Their love of art is both personal and professional. Their lives revolve around it. They read it, eat it, and sleep it. But at the end of the day, they would all agree that what matters is whether the art they've chosen will survive the test of time. Joseph Duveen dealt in classics whose greatness had been acknowledged for centuries. The visionaries in this book have had a much tougher task. They've put their reputations on the line for artists whose work has been in existence (in most cases) for roughly fifty years—but what a fifty-year period.

Another thing to keep in mind is that no one sets out to become an art-world visionary. Instead, what connects these movers and shakers is an insatiable curiosity that propels them forward in their search for visual revelations. You also work hard. During the early 1960s, Ivan Karp, one of the book's subjects, was known for visiting up to five artists' studios per day. He certainly wasn't doing it for his health; he did it because he was on an artistic mission. The rewards were there for those who found themselves in the right place at the right time and possessed the ability to detect authentic art. You might even find yourself waking up one morning and reading about one of your discoveries in the *New York Times*—such as the arrival of Andy Warhol—which began to happen to Karp with increasing frequency. Whether or not celebrity was awaiting them at the end of their roads was inconsequential. What mattered was the artistic process and its outcome.

Part of the job description for a visionary in this field is simply showing up at art-world events, staying in circulation, and letting the art and artists come to you. It's a lot like the music producer Ahmet Ertegun's philosophy of success. During an interview he was asked how he managed to meet everyone from John Coltrane to the Rolling Stones, sign them, and shape their careers. He responded with typical humility: "If you keep walking around, you just might bump into a genius."

Needless to say, the individuals in this book did a lot of walking around.

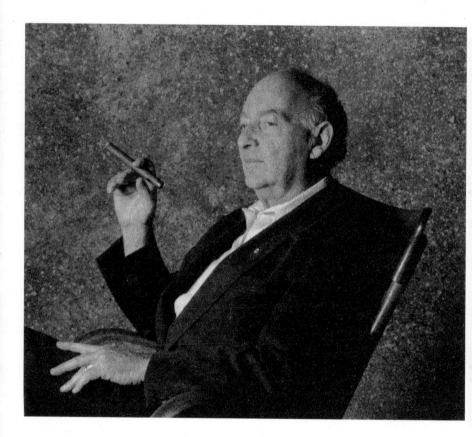

Ivan Karp.

Chapter One
## Ivan Karp and Pop Art

THE EVENING WAS BILLED as "Ivan Karp Live in Los Angeles." Not since Irving Blum's Ferus Gallery first exhibited Andy Warhol's original *Soup Can* paintings, in 1962, had the spirit of Warhol returned to L.A. Twenty-five years later, here was the man who *discovered* Warhol—a dealer who rarely traveled above Fourteenth Street in Manhattan, let alone cross-country—about to descend on the art scene New York viewed with contempt as its lightweight counterpart.

Great things were expected: revelations about the art world, never-before-heard anecdotes about Pop Art, secret histories of the period's key figures. The lecture was being hosted by Jack Glenn, a character in his own right. Glenn was once known as the only serious Pop collector in Kansas. For that matter, he might have been the only serious collector of *anything* in Kansas. Now he ran a gallery on the West Coast, which specialized in emerging local talent. By going to great expense to fly in Karp, he saw the occasion as a chance to grab some much-needed attention for his program.

Glenn had labored overtime to promote Karp's visit, taking out ads in art magazines and working the phones to drum up a crowd. Now Glenn stood there, beaming at a space packed with artists, dealers, and collectors hoping to see the celebrated figure

who had altered the course of art history by sensing the Pop Art zeitgeist. Though Karp was only in his late fifties at the time, he had already been credited with helping to identify a second important art movement—Photorealism. Would tonight be the night that he revealed a third?

After an over-the-top introduction from Jack Glenn, Karp cleared his throat and smiled benevolently. The audience looked on, filled with anticipation. Then Karp launched into a forty-five-minute discourse on the history of *blackened redfish*. Since he was a dedicated "foodie," and these were the days of the Paul Prudhomme–inspired Cajun food craze, the talk was perverse but oddly relevant. Personally, I loved it and applauded wildly at the end, as if I had experienced something profound. So did Jack Glenn. In his mind, the $5,000 that it cost him to host Karp had been worth every penny.

As for the rest of the audience, they filed out to the parking lot in a state of confusion. But in weeks to come, Glenn heard from a number of them who confessed that Karp's outrageous performance had provoked them into thinking about art in a new way. By sharing his fascination with blackened redfish—which also encompassed tales of New Orleans and the town's myriad art forms—Karp was trying to goad the crowd into viewing art as something you had to discover for yourself.

One of the stories the audience at Jack Glenn's assumed it would hear was about the birth of Pop. Despite taking its place in the pantheon of art-world folklore, it's a tale that's never been told the same way twice. The version I am familiar with began one day in 1961, when Roy Lichtenstein schlepped five of his paintings on the roof of his station wagon to the Leo Castelli Gallery, arriving without an appointment, seeking representation. At the time Lichtenstein made his living as an art teacher.

He was greeted by Ivan C. Karp, the gallery's director. Karp had been hired in 1959, based on his burgeoning reputation as someone who could bewitch people with his passion for the newest art. After Karp looked over Lichtenstein's comic book–derived imagery, complete with Benday dots, he was both thrilled and flabbergasted. The paintings were cold, dumb, and bright, all at the same time. There was definitely something there, but what? About the only thing Karp was certain of was that it wasn't going to be a slam-dunk to convince his boss, Leo Castelli, to show them.

Castelli was already well on his way to becoming an art-world legend, having paved the way for Pop by courageously exhibiting Jasper Johns and Robert Rauschenberg in 1958. With his sophistication, knowledge of art history, and strong eye, Castelli was primed for what might come next. As Karp put it, "Leo saw himself as a spokesperson for American culture." But Lichtenstein's pictures may have gone too far even for him. Karp told Lichtenstein that rather than unnerve Castelli by immediately calling him over to have a look, he would show them to Leo at the right moment. When that moment arrived, Karp set them in front of Castelli and only half-jokingly said, "I'm not sure he's allowed to do that." Castelli nervously concurred.

The two dealers decided to hold onto the work and see what developed before they made a commitment. But fate had another idea. A collector soon arrived at the gallery and asked Karp, "What's new and exciting?" Without hesitation, Karp went to the racks and extracted a small Lichtenstein that depicted a foot stepping on the pedal of a kitchen garbage pail. Apparently the collector shared Karp's enthusiasm because he promptly snapped it up. When Karp called Lichtenstein with the wondrous news, exclaiming, "You're not going to believe this but someone just bought one of these paintings!," the deal to represent Lichtenstein was cinched.

Part of the reason Karp was open to Lichtenstein's potential was probably that he wanted to own one of the paintings himself. Many art-world tastemakers are passionate collectors at heart. Karp's collecting roots can be traced to the 1950s, when he was young and broke. While most hobbyists were content to search for stamps and coins, Karp began accumulating carved stone ornaments from buildings in Manhattan that were being torn down. Eventually, he had so many chiseled gargoyles, cherubs, and classical faces that he formed his own small museum, the Anonymous Arts Museum, in upstate New York.

Karp's love of collecting cannot be overestimated in his emergence as a seer. Along with his wife Marilyn, an artist and former art history professor at New York University, he has spent a lifetime tracking down whatever he thinks is wonderful. As he once said, "I have a flirtatious eye for objects, and these objects seduce me. They put me in a state of unreasonableness. When I see one, I need it. How can I leave it in melancholy isolation in someone's shop?"

Not long after Lichtenstein arrived at the Castelli Gallery, Karp found himself face to face with a thin man with a pale complexion named Andy Warhol. As one of the top commercial illustrators in Manhattan, Warhol was wealthy enough to collect art. He had found his way to the gallery with the intention of buying a Jasper Johns. After he had selected a drawing of a lightbulb priced at $375, Karp asked him, "Would you like to see something curious?" He then pointed to a picture on the wall. It was the famous Lichtenstein painting of a girl holding a beach ball over her head (now in the collection of the Museum of Modern Art in New York). Warhol was dumbstruck, declaring in a shrill voice, "I make paintings like that." Karp quickly agreed to visit Warhol's studio. It was a space cluttered with paint cans, screens, and canvases. After seeing a number of

*Campbell's Soup Cans* and other early gems, Karp's antennae began to twitch for a second time.

Later that month, Karp came upon the work of James Rosenquist, who made a dangerous living working on a scaffolding dozens of feet above the ground as a billboard painter. Karp was astonished by what he saw at Rosenquist's atelier as he gazed at pastiches of imagery derived from billboard advertising, including Chef Boyardee spaghetti, Coca-Cola bottles, and the front grill of a Ford. Rosenquist's style was economical. He strove for a basic accuracy, staying true to his vocational roots of trying to get the job done between nine o'clock and five o'clock. Here was yet a third painter making art lifted from popular culture. And here again Karp was able to spot the significance of Rosenquist's work because he genuinely responded to random imagery drawn from everyday life.

The fact that Warhol's work overlapped Lichtenstein's could have been written off as a coincidence. But when Karp came upon Rosenquist and saw how his paintings related to the other two artists, he realized there was a similar spirit behind their connection. Karp recalled, "I was so excited at the prospect of a new movement that I went breathless when I spoke about it. I remained awake at night trying to fathom the implications."

Understanding what makes a work of art great and developing an eye for quality are one thing. Being able to spot trends before others, as Karp had, was another. The term "visionary" is most often associated with the business world. There are businessmen like Warren Buffett who have a sixth sense as to where the economy is headed. The Buffetts of the world make their bets largely on existent data. They work with the profit-and-loss statements of a corporation, analyze its management, factor in world economic conditions, and come to a conclusion whether to buy or sell a company.

Being an art-world visionary is a whole different animal. The best description I ever heard came from André Emmerich, who once owned a gallery in New York that represented Sam Francis, David Hockney, and the estate of Hans Hofmann. Emmerich postulated, "Art dealers are like surfboard riders. A good surfboard rider can sense which waves will be the good ones, the ones that will last. Successful dealers have a feeling for hitting the right wave." The only hole in Emmerich's observation is that it leaves out a crucial piece of the equation—a certain intangible, something akin to magic.

When I once asked Karp to enlighten me about his visual prowess and how he was able to see things before others, his explanation was as enigmatic as his talent: "I was born with a chemical compound in my head that made for a heightened sense of visual acuity. Being a visionary is something you can't learn—it's not a scholarly process." Though his comments were unexpected, they rang true. With hard work you can become a scholar. With even harder work you can become a connoisseur. But according to Karp, unless you're born with a gift—an internal aesthetic radar—you can never do what he did when he put Pop Art on the road.

One of the great debates of the Pop years was over who should receive recognition for discovering all of the great artists that came out of the Castelli Gallery. Art history texts generally give Leo Castelli almost full credit. Anyone who ever met him would certainly not deny his intelligence, diplomatic skills, and ability to connect people with art. By all accounts, Castelli's love of art and his desire to put it before profit was sincere. There's also no doubt that his wife, Ileana Sonnabend, possessed a great eye and had some influence on who joined the gallery's roster of artists. But Ivan Karp's ability to see beyond the traditional definition of art was the master link in the chain of events that led to the

Pop Art movement. Pace Gallery's Arne Glimcher observed, "There was magic in Leo, but alone he could not have made it, absolutely not. Do you realize how Ivan Karp changed things for Leo? If Leo became so important it was because Ivan went to work for him."

With Karp's enthusiasm for the visual world equally split between the highbrow and lowbrow of popular culture, he was the perfect avatar to conjure up a blend of both. Pop blew everyone's minds because there was no precedent for it; no one saw it coming. Art history usually develops gradually. But Karp was able to speed up its slow march and sync it to the times because he sensed the art world was ready to embrace a fresh approach. Or at least he was.

To understand what Karp was up against, you have to travel back to the mid-1950s and the heyday of the Abstract Expressionists. Theirs was an exclusive boys' club whose members' macho personas translated into oversize paintings with highly charged brushstrokes and lots of drips. Anyone who has seen the movie *Pollock* can attest to the personal and financial insecurities of that period's artists, which led to prodigious amounts of drinking, ultimately costing Jackson Pollock his life. Willem de Kooning, the greatest pure painter of the fifties, credited Pollock for "breaking the ice," when he got his portrait plastered on the cover of *Life* magazine. But it made little difference. The burst of publicity came and went, leaving the future heroes of art history, like Pollock, de Kooning, Franz Kline, Mark Rothko, and Clyfford Still, facing a bleak future. No one was buying art.

Collecting art has always been an elitist pursuit, and that remained true during the conservative fifties. Most serious collectors bought Impressionism. Progressive collectors bought Matisse and Picasso. They were classics; you couldn't go wrong. The main problem with Abstract Expressionism was there was

no easy way to "enter" its pictures. A Jackson Pollock painting, with its tossed skeins of paint, had no focal point. Ditto for Mark Rothko's floating clouds of color. Potential collectors longed for art that they could grasp more easily. Pop Art had an attractive market appeal that started off slowly and then picked up speed, finding its way onto collectors' walls.

In 1958, when Jasper Johns had his first show at Leo Castelli, Johns focused on popular imagery that "the mind already knew," such as American flags, targets, and numerals. Though his show was a revelation—one of his paintings landed on the cover of the influential magazine *ARTnews*—there were still many doubters. And one of the biggest was not surprisingly an Abstract Expressionist. After seeing Johns's targets and flags, Mark Rothko angrily weighed in, "We've worked for years to get rid of all that." Rothko was referring to representational imagery.

But Johns also had his supporters, including perhaps the one who mattered the most, Alfred Barr Jr., the first director of the Museum of Modern Art (MoMA). Barr acquired three Johns paintings from the Castelli show, but coveted a fourth. The only problem was that it was a yellow-and-blue target on a red ground, with nine wooden compartments above the main image, each with a lid that opened to reveal a painted plaster cast of a body part—including a green penis. Barr nervously told Castelli: "The trustees will never go for this. But I might be able to buy it if we can keep that one compartment closed." Castelli said that he'd have to ask the artist how he felt about it. Johns's response was that the compartment could be kept shut only part of the time. Barr reluctantly decided to pass.

By 1962, the year of *The New Realists* exhibition at Sidney Janis, the first gallery group show of Pop Art, the dominance of the Abstract Expressionists had started to wane. Though Rothko, de Kooning, and Still were still painting, their best years were

behind them. With the coming of Pop, many of these living colossi felt threatened. To the Abstract Expressionists, art was about looking inward for inspiration, rather than the corner supermarket. Barnett Newman raised the level of brinksmanship when he told his dealer Allan Stone that he would leave the gallery if Stone followed through on his promise to show Wayne Thiebaud, the realist painter of confections, whom Newman referred to as the "pie guy." Stone decided to show his work anyway.

This tug-of-war was the prevailing mood as Karp spent his personal capital recommending radical new art to Castelli. And no recommendation was more radical than Andy Warhol. As many know, Castelli thought Warhol's early work bore too close a resemblance to Lichtenstein's. But Karp claimed that Castelli also dismissed Warhol because "he was uncomfortable with him as a person." Apparently, Castelli was put off during his initial studio visit when the artist handed him a theatrical mask and begged him to wear it, to say nothing of the loud rock music blasting from the stereo.

Still, Karp knew what he had in Warhol, and did everything he could to champion his work and keep things moving forward until the artist found representation, whether with Castelli or another gallery. Karp did it by dragging collectors to his studio, buoying Warhol's spirits with the occasional sale. When a collector failed to buy, Karp would comfort him by saying, "They fail to perceive the singular consequence of your work." Karp also brought over a handful of serious dealers and came close to striking a deal with Allan Stone. But the normally perceptive Stone turned Warhol down for a one-person show, and offered a three-artist show in its place, with Rosenquist and Robert Indiana. Warhol shrugged and turned *him* down—he was holding out for Castelli. He was keenly aware that an artist had to be

seen with his peers, which meant showing at the right gallery. He understood that exhibiting at Castelli gave collectors confidence in acquiring your work. As Warhol astutely observed, you didn't buy a Dior dress from a discount store.

Eventually, Warhol found a home at Eleanor Ward's Stable Gallery, which led to his breakthrough show of *Marilyn* paintings in 1962—both a critical and financial success. By the time of his second Stable Gallery show in 1964, which featured rows of red, white, and blue *Brillo Boxes* displayed on the gallery's floor as if they were in a warehouse, Castelli had seen enough to realize his mistake and finally offered to exhibit Warhol's work. At long last, Warhol had achieved his goal of showing with the "big boys." It was a remarkable accomplishment. He had gone from an advertising background, to making fine art using the commercial technique of silkscreening, to the pinnacle of the contemporary art universe, taking his place at the banquet table with his idols, Johns and Robert Rauschenberg.

What's more, with Castelli's agreement to handle Warhol, Ivan Karp had been vindicated. Without Karp's persistence, Warhol may have grown frustrated by his inability to penetrate New York's serious art world and given up his dream to become a fine artist. It is no stretch to say that Andy Warhol, undoubtedly the most influential artist of the second half of the twentieth century, might never have emerged without the tenacity of Ivan Karp.

Once Warhol had arrived, he threw the art world a curve ball when he declared that he wanted to be thought of as a "business artist." During the 1960s Warhol's revelation was diametrically opposed to the era's consciousness, which put personal job satisfaction before money. Warhol was interested in art and profit! In the art world, which was supposed to be about the purity of

the creative gesture, Warhol's stance that "good business is the best art" stood out like a sore thumb.

Art and business have always had a thorny relationship. The reality of being an artist is that at some point you have to show your work to gain exposure and ideally sell your work so you can afford to make art full-time. Since the origin of the gallery system, artists have continually griped about dealers who make money off *their* talent. As Marcel Duchamp once said, "Dealers are lice on the back of an artist. But they're necessary lice." Conversely, gallery owners argue that they give artists credibility by representing them. Regardless of its flaws, the artist-dealer relationship has endured.

But Warhol turned that traditional alliance on its head when he decided to open a studio that he referred to as the Factory (a name meant to be taken literally). Despite being represented by Castelli, he encouraged collectors to "buy direct" from the Factory—the better to keep a larger percentage of the profits. Castelli wasn't thrilled by the arrangement, but ever the diplomat, decided to look the other way. Taking his philosophy a step further, Warhol used his silkscreen technique to mass-produce paintings and sculpture, which ran counter to the gallery pitch of "rarity" to its collectors. Andy was proud of his approach. After learning that Picasso had painted approximately twenty thousand paintings in his lifetime, he supposedly boasted that he could accomplish that in two weeks.

Warhol's philosophy on making and selling art slowly began to influence other artists as he became more successful at it. The first hint that artists were becoming aware of their rising power in the art-market food chain came with the auction of Robert and Ethel Scull's contemporary art collection in 1973. They were major clients of the Leo Castelli Gallery and had frequent dealings with Ivan Karp, who recalled Robert Scull's

aggressive ways. "He would run right over Leo when it came to negotiating a discount. But I have to say that he was fully involved with the pictures." Despite his genuine feeling for art, Scull never lost track of the bottom line. The taxicab tycoon was the first contemporary collector to perfect the art of the deal.

Much has been written about the night of the infamous Scull sale at Sotheby's. It was a defining moment not only for the art market, but for the greater art world and how it would conduct itself in the future. The sale totaled a then inconceivable $2.2 million—Jasper Johns's *Double White Map* brought $240,000, more than twenty times what the Sculls paid for it. That one evening signaled the end of the traditional art-making process as we had known it. The Pop artists would never be the same, now that the potential of earning serious money had entered their lives. When a "tanked-up" Rauschenberg shoved Scull after the sale and yelled, "I've been working my ass off for you to make that profit," it indicated that from that day forth, an artist could never work in his studio without giving some thought to the marketplace.

The Scull sale signaled a shift in the commingling of art and business, which had until that point been left in the dealer's hands. Now collectors often bypass dealers, receiving more money for their pictures by working directly with the auction houses. Some artists increasingly began to think more of their place in the market and how to use it to their advantage, strategizing what to paint, where to show, and which critics and collectors to befriend.

All they really had to do was look to Andy Warhol. Though his approach to creating and marketing his art has been written about ad nauseam, books continue to appear about him because his genius seems only to deepen with time. What's relevant here is that he inspired a generation of "business artists," starting with

Jeff Koons, who took Warhol's paradigm to a new level. His is a story that Warhol predicted. Had he lived past 1987, he probably would have collaborated with Koons.

During the mid-1980s a new burgeoning gallery scene was growing outside SoHo in what was known as the East Village. Young dealers, finding themselves priced out of the artsy West Side neighborhood, found inexpensive rents in Alphabet City on the edgy Lower East Side. The minimal overhead allowed them to take risks on new talent that never would have gotten a chance if storefronts weren't renting for hundreds of dollars instead of thousands.

At first blush it appeared that the East Village would provide an alternative to Warhol-inspired careerism. Artists made art with little regard to salability. There was also an initial burst of cooperation between artists and dealers; a pervasive team spirit presided in the nature of artistic purpose. Galleries were almost antibusiness, preferring not to open until noon. But after a few short years, the cream rose among artists, adventurous collectors swooped in to buy their work, and SoHo's leading dealers soon lured them away.

Jeff Koons was one of those artists. With his current mega-success, few observers remember his humble origins. I recall seeing his first show in the East Village at International with Monument, where he displayed his iconic basketballs floating half-submerged in forty-gallon aquariums. Thinking like a business artist, Koons took a financial gamble on the exhibition. He wound up offering his basketball tanks, along with a host of cast bronze sculptures (including an inflatable life raft), as loss leaders. Koons was quoted as saying that the show cost him more to produce than the aggregate retail price of the work. But by doing whatever it took to get serious collectors into the

gallery, he found acceptance and a market. The money would be earned back later.

As Koons's reputation in the art world grew, he began to think big. Deciding to create a group of complex stainless steel sculptures that would prove to be extremely expensive to fabricate, Koons once again thought like a businessperson. He spread his risk by using other people's money. Enlisting dealers like Jeffrey Deitch to run interference, Koons found working capital through the collectors Dakis Joannou, Eli Broad, and Peter Brant that allowed him to complete such ambitious projects as his flower-studded giant *Puppy* and colored stainless steel balloon dogs.

Koons's business acumen should have come as no surprise. During the early eighties when he was struggling to stay afloat, he found work as a commodities trader at a New York "bucket shop," where he specialized in buying and selling cotton futures. Koons developed into an ace salesman, pitching potential clients on the phone with smooth lines like "Cotton is soft and fluffy, it can't hurt you." From there he progressed to selling memberships at MoMA. He turned out to be extremely good at this too, setting a record for most memberships sold in a month.

His sales training came in handy once Koons became a successful artist. He went on to organize his studio along the lines of Warhol's Factory—only he took it a step further. Koons functioned as an art director, completely detaching himself from the process of making art, while hiring others to execute it for him. Warhol at least *participated* in creating his work, often manning a silkscreen squeegee. The Jeff Koons "method" launched 101 philosophical discussions about what constitutes an original work of art.

One thing that wasn't debatable was Koons's ambition. He was a perfectionist who went to ruinous expense to hire skilled Italian

artisans, while supplying them with the finest materials. Koons's monetary trials almost led to personal bankruptcy, but the results always seemed to justify the financial stress. Koons's kitsch ceramic sculpture of Michael Jackson with his pet chimpanzee Bubbles, along with his iconic stainless steel inflatable bunny, are now featured in every survey book on contemporary art, and his work has become synonymous with the art of the eighties.

While art history liked Jeff Koons, the art market liked him even more. He was acquired by high-profile collectors, who often bought his work in depth—to this day. The allure of his sculpture was so powerful that one prominent collector, desperate to make a deal, went to outrageous lengths to secure a major work from the Gagosian Gallery. The story has it roots in 2006 when a high-ranking female member of Gagosian's staff got romantically involved with one of the gallery's better clients. The relationship blossomed and the employee became engaged to the collector. Forsaking a traditional diamond ring, she requested an important Jeff Koons instead. Her fiancé honored her with *Hanging Heart*, a nine-foot-tall stainless steel magenta heart adorned with a matching gold ribbon. Though it weighed as much as a Mercedes, it was designed to be installed suspended from the ceiling. The talk of the trade was Gagosian gave the collector a "deal," charging him a rumored $3.5 million. The collector rewarded Gagosian by immediately putting the piece up to auction at Sotheby's in November 2007, where it soared to $23.6 million—an auction record for a living artist. Further compounding the lunacy, Gagosian wound up buying it back at the sale. Regardless of the morality behind the deal, one thing was for certain: the art market "heartily" approved of Jeff Koons's business artist status.

Koons's auction triumphs over the years were also a victory for Pop Art. While Ivan Karp got the ball rolling and Andy

Warhol propelled it down the hill, Jeff Koons opened the door
for the likes of Japan's Takashi Murakami and England's Da-
mien Hirst. Pop had achieved an international momentum
that showed little sign of slowing down. Robert Rauschenberg
once claimed, "Painting relates to both art and life. Neither can
be made. I try to act in the gap between the two." Koons, Mu-
rakami, Hirst, and to a lesser degree Richard Prince erased that
fissure by becoming "brands."

Moving into the turn of the twenty-first century, some art had
gone so far as to become indistinguishable from consumer goods.
Exhibit A is undoubtedly the work of Takashi Murakami. Like
Koons, Murakami took mass-market iconography—in his case
Japanese Manga comic books—and used them as a springboard
to create fine art. Murakami proved equally adept at sculpture
as painting. Using the requisite team of assistants, he designed
a collection of women's handbags for the French luxury goods
company Louis Vuitton. These were accompanied by a group
of paintings—both unique and multiples—highlighting the LV
logo. Murakami's marketing strategy reached its apotheosis at
the artist's 2008 retrospective at MOCA Los Angeles. Incred-
ibly, the museum allowed Louis Vuitton to install a retail shop
in its parking lot, which offered Murakami bags and related
products—with MOCA surprisingly agreeing not to get a cut.
A press release for the show reassured visitors: "Louis Vuitton
has guaranteed that enough merchandise will be produced to
last the duration of the exhibition." This was art as commercial
goods.

   But the most daredevil inheritor of Warhol's mantle is Da-
mien Hirst, who took marketing and self-promotion to yet a new
acme. Warhol was the first artist to have a business manager, the
stylish and savvy Fred Hughes, who was an aesthete, a collector,

and an art maven. Hirst followed in his footsteps and bypassed art knowledge considerations by hiring Frank Dunphy, a business manager whose expertise was solely finance. It was no surprise, then, that Hirst's most famous work, the large shark immersed in a tank of formaldehyde, was sold in 2007 to the hedge fund director Steven Cohen, who promptly agreed to lend it to the Metropolitan Museum of Art, theoretically enhancing its value. The arrangement drew so much attention that for the first time ever, the *New York Times* ran an editorial about the art market. The *Times* went on to refer to Hirst and Cohen as "the coming together of two masters in the art of the yield."

Later that year, Hirst commissioned a London jeweler to set 8,601 investment-grade diamonds in a platinum-covered human skull, called *For the Love of God*, which was then offered for $100 million. It goes without saying that its debut at the White Cube Gallery in London was accompanied by an adjoining gift shop which sold skull-related merchandise, including fifty-dollar T-shirts and limited-edition *For the Love of God* prints, each silkscreened with a layer of diamond dust—a concept nicked from Warhol. When Hirst found no takers for his nine-figures masterpiece, he and a consortium of speculators bought it themselves. Some jokingly wondered if the next step was "going public" by selling shares in himself that could be traded on the Nasdaq.

A year later, in 2008, while the world economy appeared to be on the verge of cratering, Hirst collaborated with Sotheby's to offer an entire sale of his own work. The sale was unprecedented because Hirst did something even Warhol never would have dared do—bypass his dealer to work exclusively with the auction house. His gamble paid off when the sale grossed a mind-boggling $200 million. The publicity was relentless. The art world couldn't stop talking about it, especially in light of the

collapse of Lehman Brothers. The wealthy were scared to the point of paralysis as they worried about losing their fortunes, yet "art collectors" were spending hundreds of millions of dollars on Hirst. The sale made him one of the most famous artists in the world.

The circumstances surrounding the success of the Hirst auction, however, were questionable. Doubts were raised about whether the work was actually sold to bona fide collectors or even to Hirst himself. This was no longer business art, it was now investment banking. By 2009, perhaps feeling pressure to restore his artistic credibility after his $200 million money grab, Hirst actually returned to the studio and *painted his own paintings*—which were a blatant knockoff of Francis Bacon— right down to their wide gold-leaf frames. Even business artists need to get back to the basics every now and then.

As the art world morphed into the art market, Ivan Karp continued to launch new talent and herald the showman. In 2009 he celebrated the fortieth anniversary of his gallery O.K. Harris Works of Art. Back in 1969, with Pop Art firmly established, Karp made a decision to leave Leo Castelli and open his own space. Along with the dealers Max Hutchinson and Paula Cooper, Karp was the first to colonize SoHo, a former light-manufacturing-based neighborhood south of Houston Street in downtown Manhattan. Where most people avoided this decrepit section, Karp was thrilled by the majesty of its neglected cast iron architecture and the raw beauty of its streets. No doubt it brought back sweet memories of scavenging building ornaments in his youth.

Other dealers gradually followed Karp to SoHo, including his mentor Leo Castelli and his former wife Ileana Sonnabend, as well as Mary Boone. By the end of the 1980s SoHo had reached

its zenith as a gallery haven and was on the cusp of being trans-
formed, yet again, this time by hip furniture stores, designer
clothing boutiques, and upscale restaurants. Ironically, the ex-
cess of consumerism recalled the root influences of Pop Art.

I caught up with Ivan Karp at O.K. Harris at the time of
his anniversary. He was seated behind his desk, a smoldering
Romeo y Julieta cigar clenched between his fingers. He was
in a characteristic humorous mood. The first thing he did was
hand me a curious-looking booklet, which turned out to be a
hilarious collection of letters from artists seeking representation.
Inquires included one from a painter who claimed to be from
another planet, *demanding* a show as soon as possible, and an-
other from a Nigerian artist arguing he deserved a show because
his hand-carved figurines offered both a visual and religious
experience—each contained a hidden compartment stuffed
with marijuana. Judging by the bizarre nature of each query,
it was as if Karp had written them himself, given that he was
an accomplished fiction writer. In 1965 his novel *Doobie Doo*
was published, with a dust jacket designed by Roy Lichtenstein
(depicting a Benday-dot blond beauty).

Ever the jokester, Karp had also once put together an "Of-
ficial List of Artist Rejections." As one of the very few dealers
in SoHo willing to look at the work of new talent, Karp would
devote a good part of his day to gently turning down artists who
had spent years of their lives assembling a body of work. To sim-
plify the process and gratify an innate desire for self-amusement,
Karp devised a list of rejections that ranged from "You appear
to be the disciple of a certain cubist—unfortunately we're not
concerned with work of a historical nature" to "You're much
too beautiful to be making work like this." The latter quip was
once uttered to a young artist named Marilyn Gelfman—who
became his wife.

At the age of eighty-three, Karp was enjoying a revival. Here we were four decades removed from the Pop decade, and a Niagara of books and articles featuring Karp had cascaded onto the shelves of bookstores. These volumes included *Pop: the Genius of Andy Warhol*, which attempted to recount every minute detail that Karp could still recall about how he helped ignite Pop. There was Arthur Danto's book, simply called *Andy Warhol*, which repeatedly cited Karp's contributions. There was also James Rosenquist's memoir, *Painting Below Zero: Notes on a Life in Art*. Even my own book, *I Sold Andy Warhol (Too Soon)*, paid homage to Karp, discussing the lighter side of his career. Remarkably, all of these books appeared within a thirty-day period, roughly mimicking the amount of time it took Karp to discover Lichtenstein, Warhol, and Rosenquist.

As we reminisced about the good old gallery days and the insanity of the present art auction sales, I asked Karp what he thought of Warhol's legacy and how it led to the birth of the business artists like Koons, Murakami, and Hirst.

After a moment, Karp responded, "Warhol certainly enjoyed being prosperous but it didn't dominate the creation of his art. The pursuit of money and grandeur is really a character trait . . . part of an artist's personality. Some artists feel their careers need to be bolstered with material evidence of their success." For Karp, in the end it all came down to the art. His involvement as a dealer grew from his love of the visual world — whether the blunt beauty of an antique wooden washboard or the sublime beauty of an anonymous nineteenth-century folk art portrait — and was guided by a sense of discovery and a desire to share his revelations.

Just then, Karp fielded a phone call, asking for the umpteenth time his opinion on some art-related matter. Always believing that he was never given enough credit for all he had

accomplished, I was pleased that the sun was finally shining on him. Thinking of all the attention that had recently washed over his life, I asked Karp, "How does it feel to receive all of these accolades?"

There was a pause. Then, in typical Ivan-speak, he answered, chuckling, "Accolades? Accolades never come in here because they can't be sold!"

Stan Lee.

## Chapter Two
## Stan Lee and Comic Book Art

L IKE MANY BOYS during the mid-1960s, I read comic books, primarily *Superman, Batman,* and the *Justice League of America.* Kids used to refer to these titles as DC comics— which stood for Detective Comics, created in 1934. Along with collecting baseball cards, buying comic books was a rite of passage in a boy's life. When allowance time rolled around, you would bicycle down to the corner drugstore to purchase the latest copies of your favorites, often followed by a lively round of trading earlier issues with your buddies.

When you plunked down your twelve cents, you knew you were buying a book in which good triumphed over evil, the guy always got the girl, and all was "made right" with the world within a scant twenty pages. You never questioned the quality of the stories you read or the artwork, which was penciled by "artists" who clearly would have benefited from a life drawing class or two—anatomy, foreshortening, and perspective were afterthoughts.

One summer I attended a day camp in Detroit and met a group of kids who shared my love of comic books. But I soon found they were reading something different. They were engrossed in Marvel comics—whose modern incarnation began in 1961. I borrowed a copy of *The Avengers* and discovered that

in the Marvel universe, superheroes led believable lives. They had ordinary problems: girl troubles, disputes with their boss at work, money issues, and so on. In other words, their lives were messy just like ours.

I had never heard of Stan Lee, but under his editorial direction the Marvel comic narratives were more human and complex; writers rarely tied up loose ends by the conclusion of each book. While this may have been an intentional ploy to get you to buy the next issue, it still made for exciting reading. For instance, *Incredible Hulk* comics never resolved themselves because the scientist Bruce Banner (the Hulk's alter ego) was constantly trying to find a cure for his condition—namely being transformed into the Hulk whenever he became stressed out. Peter Parker, also known as Spider-Man, had never-ending tsuris (troubles) with his sickly Aunt May, who was always on the verge of being hospitalized. And then there were the Fantastic Four with their diverse personalities and character flaws: Reed Richards, known as Mr. Fantastic, had a monster-size ego and couldn't commit in a relationship; Sue Storm, the Invisible Girl, was extremely vain and obsessed with getting Reed to notice her; Johnny Storm, the Human Torch, was a rebellious teenager and a know-it-all; and Ben Grimm, the Thing, had a chip on his shoulder the size of Texas. Marvel comics were character- and story-driven.

Not only were these comics a joy to read, they were also a visual treat thanks to their lead illustrator Jack Kirby, who introduced a new concept—superior draftsmanship. He utilized a dynamic line, beautiful shading, and a sure sense of placement on the page. Each panel was a work of art. With the success of Marvel's new vision and approach, DC comics instantly became passé. It was the art-world equivalent of pitting Andy

Warhol against Leroy Neiman, or even Thomas Kinkaid. Kirby's spectacular artwork brought Stan Lee's compelling characters to life. But ultimately it was Lee's progressive storytelling that turned the comic book world on its head.

While famous writers such as Stephen King, John Grisham, and Danielle Steele have sold an awful lot of books, their combined sales total is a spit in the ocean compared to Stan Lee's sales figures while at the helm of Marvel. Granted it may be an unfair comparison to pit a 250-page novel against a skimpy comic book, but in reaching the widest possible audience, Lee towers above them all. Much as Ivan Karp paved the way for Andy Warhol and eventually Murakami, Koons, and Hirst, Stan Lee's creations set the table for Jack Kirby, who in turn created a beachhead for R. Crumb, followed by the development of Art Spiegelman's *Maus* and eventually the success of graphic novels.

Lee's prescience, like that of other art-world visionaries, was not something he planned or set out to accomplish. He began his career with the simple goal of earning a living—what he did mattered less than how much it paid. Lee grew up under modest circumstances in the Bronx in the 1920s, completed a stint in the military, was an avid reader, and displayed an early interest in writing. Appropriately, his first job was working for a publishing house. Only it wasn't a literary firm—it was a small business that produced comic books.

In 1939, when Lee was only seventeen and still went by the name Stanley Lieber, an uncle introduced him to his cousin's husband, Martin Goodman, owner of Timely Comics (which would later become Marvel). Goodman's company was better known for publishing pulp magazines, which were far more popular at the time than comic books. As a family favor,

Goodman hired Lee to fill an entry-level position. Starting at the bottom, Lee was essentially a gofer, assisting the artists and writers with the most mundane of tasks—bringing them coffee and sandwiches, refilling inkwells, erasing errant pencil marks on their pages. It was a start. A teenager in the adult world, Lee ignored basic office protocol and often reverted to juvenile behavior. He habitually played his recorder, annoying Jack Kirby, while setting a pattern of conflict between the two men that would play itself out over the next forty years. Despite Lee's immature ways he was the proverbial quick study, absorbing the comic book publishing business through osmosis and hands-on experience.

At the time of Lee's hiring, Jack Kirby, formerly Jacob Kurtzberg, was Timely's chief illustrator. His responsibilities at the company included *Captain America, Sub-Mariner,* and *The Human Torch,* Timely's three biggest-selling titles. Though it was obvious that Kirby was extremely talented, he was still two decades away from developing into an artistic force. It would be under Lee's helm that he would finally break out. In 1941 Kirby, along with the editor Joe Simon, got into a dispute with Timely, and Simon left. Goodman, who was only thirty himself, installed the nineteen-year-old Lee as the interim editor. With only two years of experience it was a sink-or-swim opportunity.

Lee was asked to pinch-hit and script a few pages of *Captain America,* getting his first shot at writing actual text for a comic book. Lee gave it his all, calling on his knowledge of both the classics and popular literature. He had a sensitivity for realistic plots founded on the great works and a keen eye for detail. He was careful to credit his work for the first time to Stan Lee, thinking ahead to the day he might want to write fiction and then use his real name. Though his initial foray into writing wasn't what he dreamed of, he was understandably thrilled to

see his work in print. Whether he knew it or not, Stan Lee had found his life's direction.

Superman, the first popular superhero, was introduced by DC comics in 1938. It's important to remember that comic books were lowbrow entertainment, designed to appeal to the masses. They were certainly not considered an art form, nor were their storytellers viewed as writers or their illustrators classified as artists. While I'm sure *Superman's* creators, Jerry Siegel and Joe Shuster, thought of themselves as professionals, the comic book industry thought otherwise. Illustrators and storytellers were treated as blue-collar workers and paid by the page rather than given a salary. It was all about productivity, not the quality of your effort. In fact, publishers thought so little of the finished artwork that once it had served its purpose it sometimes wound up in the waste bin.

Despite the lack of respect bestowed upon comic books and their creators, they were incredibly popular. DC's top book, *Superman*, and Timely's top seller, *Captain America*, each sold more than a million copies per month. During the 1940s, known as the Golden Age of comic books, the key characters included Captain America, Captain Marvel, the Human Torch, the Whizzer, Batman, Superman, and the Sub-Mariner. Given the times, the villains they faced often had Nazi connections. The plots were basic and predictable: an Axis mad scientist was developing a rocket that would win the war for Germany—but not if Captain America got there first! As you might expect, Captain America always did just in the nick of time, rescuing the free world from certain destruction. War-themed stories meant good business not only at home but abroad. Tens of thousands of comic books were shipped overseas to entertain our troops.

With few other entertainment options available, publishers felt little need to improve their product. The main competition for comics was radio and film. And even radio—which was free—featured the adventures of comic book star Captain Marvel. As for the movies, they offered better instant value than comics. Twenty-five cents bought you up to five hours of Saturday afternoon cartoons and adventure features, versus maybe thirty minutes of escapism afforded by a ten-cent comic book. And yet comic books remained popular; they could be read over and over again.

As America moved into the postwar era, interest in comic books began to fade. The unsophisticated comics were something you outgrew rather than something you grew with. It was as if they had a built-in obsolescence. The new generation of kids had television at their fingertips. This medium was a threat to comics, and an even bigger problem for the industry was looming in the form of a U.S. Congressional committee that targeted comic books as one of the leading causes of juvenile delinquency. Comics, especially those illustrated with plenty of blood and gore, were viewed as bad influences on America's youth. Stories with sexual references or those where the bad guy "got away with it" were also seen as corrupting. The writer David Hajdu sarcastically referred to comics during that period as "the ten-cent plague." Unbelievably, comic books were subject to a witch hunt complete with actual book burnings.

In response to public outrage, the Comics Code Authority was established. If you were a publisher who wanted to stay in business, you had to produce books that toned down the violence. Though *Superman* comics were given a boost from the television show starring George Reeves, the days of superheroes were numbered. The code decreed that family values be maintained no matter what. Comics soon mimicked television's

wholesome *Father Knows Best* and *The Adventures of Ozzie and Harriet*. Even *The Many Loves of Dobie Gillis*, with its perpetually out-of-work antihero, Maynard G. Krebbs, would have been too subversive for the hyper-conservative code.

Interestingly, the only facets of the business that were doing well by the end of the 1950s were Westerns, like *Kid Colt Outlaw*, and romance comics, especially *Patsy Walker*. Western comics were in vogue partially because of the popularity of John Wayne movies, along with the influence of television shows like *Bonanza* and *Rawhide*, featuring a youthful Clint Eastwood. As to why the romance genre flourished, the answer may lie in the then newly popular *Gidget* beach movies, along with the Frankie Avalon and Annette Funicello vehicle *Beach Blanket Bingo*. Though it must have been humiliating, Jack Kirby was forced to draw men with "spurs that jingle jangle jingle" and young women in "itsy bitsy teeny weenie yellow polka dot bikinis" if he wanted to eat. It's hard to believe now, but Kirby even drew a few issues of *Archie*—the equivalent of Picasso being forced to churn out a couple of paint-by-number paintings.

By 1961, ironically the same year as the birth of Pop Art, the comic book industry was irrelevant. Superheroes had largely vanished from the spin racks of the neighborhood drugstore. All this time, Lee had been keeping Marvel going with cheap entertainment that lacked any thrill for him or his team of artists. They had kept themselves afloat and managed to pay the bills, but Lee was looking for inspiration. It was at this point that Stan Lee had his great epiphany. With nothing to lose, he went for broke and decided to invent a whole new cast of superheroes. Lee was able to tap into the sixties zeitgeist, channeling the political tensions and spiritual openness of the times into his characters' personalities. He was also determined to tell stories that were more genuine, with an eye toward appealing to an older,

more educated readership—*maybe even college students*. Thus was born the Silver Age of comics.

Lee's great technical innovation was to reconfigure the relationship between the artist and the writer. To a more enlightened reader it must have been painfully obvious that in comic narratives the artist and the writer were out of sync. It was as if the right hand didn't know what the left hand was doing. Writers wrote dialogue, illustrators drew the characters, but they never communicated on how to plot or pace the story. This led to action scenes that didn't always move the drama along as convincingly as they might have. The traditional working method had been for the writer to come up with an entire script. He would then block out each individual panel—complete with dialogue—detailing how the story would unfold. It then became the artist's responsibility to render each panel as faithfully to the script as possible. The upside was there was "quality control," with little improvisation or diversion from the writer's instructions. The downside was the books developed a monotonous look.

Lee was so busy keeping up with all of his superheroes he couldn't physically write copy for all of the comics. In order to keep things moving he had to rethink how Marvel conducted business. Lee's bold approach was to give the artist a synopsis of the story and then allow *him* to plot it panel by panel over twenty pages. He would then go back in after all of the illustrations were complete to insert dialogue and text. This reverse process made artists like Jack Kirby and Steve Ditko responsible for the pace of the story, effectively linking their illustrations to Lee's synopsis, while allowing them the freedom to improvise. Stan Lee began referring to this concept as the Marvel Method.

But with the Marvel Method came a conundrum. While it allowed Lee to work with more artists and create more books (and

profit), the credits on the first page of each comic book still read "Written by Stan Lee," giving it the appearance of a one-man show. Steve Ditko took exception. So did Jack Kirby. As Ronin Ro explains in his book *Tales to Astonish*, "Ditko was drawing his own plots and sending them in. Stan added dialogue and captions, and someone lettered the pages, and then Ditko inked his drawings." This strategy was efficient, but he felt cheated for not being designated the cowriter.

In the beginning, Ditko tried to steer the direction of *Spider-Man* toward Ayn Rand's Objectivism philosophy, which held that everything in the world was either black or white, good or evil. For Ditko, that translated into clear divisions between morality and immorality in the telling of each *Spider-Man* story. But Stan Lee had his own ideas about the direction of the comic book and gradually asserted himself, earning the enmity of Ditko. After drawing the first thirty-three issues of *Spider-Man* and inventing the complex personal life of Peter Parker, Steve Ditko resigned from the book. To this day, Ditko, who is revered by comic book aficionados almost as much as Kirby, refuses to grant interviews or answer questions about the demise of *Spider-Man*.

The never-ending battle over authorship and credit grew heated. Given the Marvel process and the collaborative environment, Kirby and Ditko, along with Lee, were cocreators of Marvel's characters. Lee may have had the vision, expressed how he wanted his characters to look, and defined their individual superpowers, but it was the artists who gave them visual form. This led to acrimonious legal disputes for years to come over who created such valuable commodities as the Fantastic Four, the Hulk, and Spider-Man. Despite promises from Martin Goodman that he would share the considerable profits with his top two artists, Kirby and Ditko, the money was not forthcoming.

This later became a serious financial matter when Ron Perelman acquired Marvel in 1989 and it began to trade publicly (Disney has owned the company since 2009). Marvel's financial potential increased exponentially with the development of its lucrative film division and the release of the *Spider-Man* and *Iron Man* movies.

Once Kirby's and Ditko's relationships with Goodman became poisoned, they also began to resent Lee for being the public face of Marvel. They realized that Lee made a hell of a lot more money than they did, and as a cousin of the owner, his position was secure. Lee then began touring college campuses, giving paid lectures, which further alienated Kirby and Ditko. Eventually they resigned themselves to the fact they would never be treated fairly and all but quit talking to Lee.

Books have been written about Stan Lee, Jack Kirby, Steve Ditko, and the history of Marvel, and all of them have been sympathetic toward the artists. Lee, on the other hand, has been portrayed as having an elephantine ego, while also claiming innocence over being at fault for the lack of recognition (and income) that should have gone to the artists. Eventually Lee did come around to agreeing that Kirby and Ditko should have received a "cowriter credit" on each comic book.

Although credit is due to the artists behind Marvel comics, the big picture shows it was Lee's visionary prowess that created a fertile environment that allowed Jack Kirby and Steve Ditko to flourish. It was akin to how Ivan Karp championed Pop Art, and in turn Andy Warhol, by helping to create a strong gallery context to showcase him. Under the Marvel umbrella, Kirby and Ditko became the 1960s comic book world equivalent of Jasper Johns and Robert Rauschenberg.

Lee did it by creating a system that went beyond the Marvel Method. He became the equivalent of a great coach. Lee

realized that for Marvel to succeed he had to get everyone involved, not just the superstars like Kirby and Ditko. There's a good analogy in professional basketball. The unworldly Lebron James could easily score fifty points each game if he wanted to. Early in his career, when he began playing for the Cleveland Cavaliers, his teammates would stand around watching him rather than contribute. James was savvy enough to share the ball (and the glory), dishing off rather than taking most of the shots. Because of his unselfishness, when push came to shove his supporting team raised their level of play because they felt more connected to the group effort. That's how you win a championship.

During its glory years of 1962–1965, Marvel operated as a team. With a large number of titles to turn out each month, Lee and his superstar artists would have been overwhelmed if he wasn't able to bring a substitute off the bench. When Lee decided Kirby was overworked, he would have Don Heck spell him on an issue of *Iron Man*. Like an outstanding coach, Lee was able to recognize ability and assemble a team that was deep in talent. So when he moved around an artist to plug a gap in that month's production schedule, the books never suffered a drop-off in quality. That's how you win a readership.

Another aspect of Lee's brilliance was his ability to understand his times. Never one to miss a trend, Lee saw a correlation between his superheroes and the leading Pop figures. In 1965 the left-hand corner masthead of every Marvel comic book read, "A Marvel Pop Art Production." Each letter was puffed up like a pillow, giving the typeface a Pop sensibility. The connection between the two worlds was not far-fetched. Pop artist Mel Ramos had already painted a series of superheroes, including one of Batman and Robin flanked by the Batmobile. Even the television version of *Batman*, starring Adam West, portrayed a

Pop style with lots of "Pow!" and "Wham!" comic book balloons detonating during action scenes, echoing Roy Lichtenstein's cartoon paintings. Marvel even released an issue of *Dr. Strange*, drawn by Steve Ditko, with a full-page outer space panorama covered with large Benday dots, in further homage to Lichtenstein. Here once again the influence of Ivan Karp had trickled down into another art form.

The similarities between Lee and Karp and how they were able to influence their respective fields are remarkable. Both developed a personal charm that allowed them to ingratiate themselves with certain serious players—in Karp's case wealthy art collectors, in Lee's publishing executives. Yet both men also possessed a "down home" touch that helped to forge a bond with their audience. In sharing an appreciation for the commonplace, Karp championed Pop Art because he reveled in what others mistook for ordinary objects, and Lee could do the same with the humble comic book, imbuing his superheroes with the personality foibles of ordinary people because he could relate to them. Visionaries could not afford to be elitist.

Stan Lee was able to realize the potential of comics as works of art because of his ability to combine humanity with fantasy, which fired the imagination of his artists and gave them the support they needed to raise their game to the next level. Most important, his vision helped pave the way for the emergence of Jack Kirby, the first comic book artist to be acknowledged as simply an *artist*, period. As Neil Gaiman wrote in the introduction to *Kirby*, by Mark Evanier, "He took vaudeville and made it opera."

So what made Kirby special?

Kirby's drawing chops were polished by years of freelance cartooning. He eventually landed at Timely in 1940, approximately

a year before Lee's arrival. This was followed by years of shouldering an almost inhuman workload, churning out probably more pages than anyone in the history of comic book art, in order to provide for his family. Kirby was dedicated to the welfare of his wife and kids, eventually working at home so he could spend more time with them. In turn, Kirby's wife Roz was not only a devoted partner, but his unofficial business manager, catering to her husband's every need to free up as many hours as possible at his drawing board.

By the start of the 1960s, Jack Kirby had been through the wringer. Since the previous decade had been a fallow period for the comic book industry, he was now not only working on books that held little personal interest, but was barely scraping by financially. Things looked bleak until Stan Lee's breakthrough with *The Fantastic Four* in 1961. Lee then installed Kirby as Marvel's art director, leading to the birth of a number of new books that came out kicking and screaming: *X-Men*, *Giant Man*, *Daredevil*, *Thor*, *Iron Man*, and the miraculous return of *Captain America*. Kirby not only was able to parlay the success of these new and old superheroes into finally earning a respectable living, but also achieved a creative peak.

How an artist reaches his apotheosis is one of the great mysteries of art. But there are always theories, and in Kirby's case it may well have come down to the confidence he gained through receiving unprecedented recognition from his audience. With the resurrection of Marvel, Lee's mailbox was crammed with as many as a hundred fan letters per week. For the first time in history, a comic book company had emotionally bonded with its readership. Each Marvel issue soon contained a Letters to the Editor page, enabling its readers to feel connected not only with the books, but with one another. Though these letters often questioned why there weren't more sinister villains like Dr. Doom, or

why only the "bad guys" ever seemed to die in action and the superheroes never lost their lives, the majority of reader comments were directed at Jack Kirby.

Fans wanted to know all about Kirby. What was his background? Where did he go to art school? Who were his influences? Kirby was probably as stunned as Lee to receive all of these inquiries. These letters lavished praise on Kirby, treating him with the same respect afforded a true artist. As they continued to pour in, a funny thing began to happen. Kirby's art grew stronger.

Since Kirby was essentially self-taught and did not attend art school, he had never thought of himself as an artist. Sure, he knew he could draw, but creating comics was more the equivalent of being a master tradesman—like a highly skilled plumber or electrician. While all of this adulation translated into more money, it accomplished something even more significant. It fueled his work, encouraging him to take greater risks, which led to what the activist poet Amiri Baraka once said about jazz god John Coltrane—Kirby had entered "a scope of feeling." He had become an artist.

Those that admire the Pop figures of Kirby's era, who exhibited at Leo Castelli and other leading galleries, might scoff at the notion that Kirby was an artist in the same sense. *But he was.* Andy Warhol once put forth the proposition that the definition of an artist should not be limited to someone who could draw and paint well. Warhol decreed that an artist was anyone who was exceptional at what they did. By that definition, whether you were a pastry chef or a hair stylist, if you performed your job at a level of excellence—with a dash of panache—you were an artist.

By the early 1970s, comic books were becoming a serious collectible, their market largely driven by the revolutionary Marvel comics. The greatest demand was for the comic book where

Superman made his first appearance (*Action Comics* No. 1) and the debut of Batman (*Detective Comics* No. 27). In 1973, the year I graduated from high school, both of these issues in near-mint condition were worth approximately $5,000 each. While that number may sound quaint, it was a lot of money for a comic book. As for Silver Age comics, the most sought-after issues were *The Fantastic Four* No. 1 (drawn by Kirby) and *Amazing Fantasy* No. 15, which featured the initial appearance of Spider-Man (cover drawn by Kirby, story drawn by Ditko). A nice copy of *The Fantastic Four* probably traded at the time for $1,000 and *Amazing Fantasy* went for about $500 — a pretty penny for comic books less than a dozen years old that originally cost twelve cents.

The third most desirable Marvel book was *The Incredible Hulk* No. 1, penciled by Jack Kirby in 1962. The Hulk was drawn with gray skin, which quickly mutated to green by the second issue. The cover art was vintage Kirby. Its background was an indigo blue, with the diminutive scientist Bruce Banner superimposed in front of an eight-foot-tall monster resembling Frankenstein. You would have thought that with such a dramatic cover, the comic would have proved irresistible to a young buyer. Apparently that wasn't the case, as Martin Goodman killed off the series after only six issues. It wasn't until years later that Marvel's readership caught up with the Kirby-driven character, reaffirming the adage that a great artist is usually a step ahead of his audience. Lee brought the Hulk back in 1964 due to popular demand, when the character appeared with Giant Man as part of a double feature in *Tales to Astonish*.

I had always been a big Hulk fan. During my comic-collecting days, I had set my sights on owning the first issue. When I was seventeen and living in Cleveland, there was a lone comic book shop whose name has long since faded from memory. Yet I can

still recall the stunning visuals of the space. Rare comics packaged in clear plastic bags lined the walls, resembling a contemporary art gallery.

The store was owned by a skinny, stooped, thirty-five-year-old man with a nasty disposition named Jim Kovacs. He behaved as if he was doing you a favor by selling you his comics. And maybe he was, since I quickly spotted a newly arrived copy of *The Incredible Hulk* No. 1. I asked to examine the fragile comic—books were printed on newsprint and their glossy covers on paper only a notch above—and realized it was in almost perfect condition.

Trying to avoid appearing too anxious, I said to Kovacs, "That's a sweet copy of the *Hulk*. How much do you want for it?"

"A buck fifty" ($150), came his reply.

*Whew*, I thought. *That's more money than I had.*

When Kovacs saw the look of concern on my face, he taunted me, "Maybe you're not ready for *Hulk* number one. *Maybe you can't handle it.*"

Swallowing my pride, I said, "Would you consider a combination of cash and trade?"

Kovacs removed his newsboy cap, rubbed his forehead, and replied with a scowl, "It would have to be mostly cash . . . what books can you offer me?"

I responded, "Let me do this. Hold the *Hulk* for me and I'll run home and bring back some comics you might want."

An hour later, Kovacs looked over my group of books, mostly with disdain, muttering under his breath, "I've got this one," "Not bad," "This is a piece of shit," "I might be able to sell this," and so on.

Finally, he spoke and pointed, "I can use this pile over here. Can you come up with a hundred bucks?"

Fortunately, that's exactly what I was prepared to offer him and we consummated the deal. I walked out of his shop with

my treasure, planning to put it aside for resale once I graduated from college. Naturally, I never told my parents, who would have been appalled that I had spent that kind of money on a *comic book*. Unfortunately, I was a lot less disciplined back then. After holding onto *Hulk* No. 1 for only a year, I sold it back to Jim Kovacs right before going off to Miami University. Kovacs paid me $250 for it, leading me to believe that I was some sort of financial genius. While *The Incredible Hulk* No. 1 never became as expensive as the first *Spider-Man* or *Fantastic Four*, it shot up in value once Marvel Studios made the two Hulk movies. In 2009, Heritage Auction Galleries sold a perfect copy for $125,000. As the French say, *Tant pis*.

The value of rare very fine to near-mint condition comic books has grown steadily. The 2010/2011 *Overstreet Comic Book Price Guide* lists *Action Comics* No. 1 at $900,000, *Detective Comics* No. 27 at $787,500, *Amazing Fantasy* No. 15 at $68,000, and *Fantastic Four* No. 1 at $45,000—and all of these prices are conservative. In fact, ComicConnect.com sold a high-grade copy of *Action Comics* No. 1 for the magical sum of $1 million and Heritage upped the bar a tad by recording $1,075,000 for *Detective Comics* No. 27. The fastest-growing market, though, is for original comic book artwork. Individual black-and-white pages are now bought and sold like contemporary blue-chip art. And not surprisingly the most valuable sheets are those drawn by Jack Kirby.

In 1970, as Kirby fought with Marvel to renew his contract at a higher page rate, he became aware that a market was developing for his drawings. Not that it was yet much of a market. Kirby's art sold for only ten to fifteen dollars a page. But that began to change with the dawning of a new phenomenon: the Comic-Con. That year, the city of San Diego hosted the first comic book convention, which quickly caught on and became

an annual event. Armed with this knowledge, Kirby approached Goodman with what was considered an outrageous request. In the future, he wanted to retain ownership of his art. What's more, he wanted Marvel to return his early drawings.

At the time of Kirby's appeal, the individual pages of art— graphite-on-paper drawings which were usually inked—were stacked on shelves and left out in the open, since they had no discernible value. Anyone could walk off with whatever they wanted. And with the coming of comic book expositions, Marvel employees began doing just that, supplementing their income by selling these pages to dealers at the shows.

Once Kirby demanded the return of his original art, Marvel executives started to panic. Though Kirby had created thousands of pages, Marvel had no idea what had happened to most of them. The truth of the matter was that although some of the work remained in storage, much of it had been destroyed. Former Marvel employee Flo Steinberg claimed, "It was like an old script. I mean, I used to throw the artwork out when the shelves got too full. Imagine that. I mean, you threw out the old scripts; you threw out the old artwork."

It took Kirby almost two decades to resolve the ownership issue. By then he hadn't worked for the company since 1970, having been lured away by DC. Initially, Marvel told him they could only locate less than one hundred pages of his artwork. But with a little sleuthing, Kirby discovered the total of remaining pages was vastly higher. In 1987 Marvel came clean and he received approximately 2,100 pages of his original art. Still, it was a pittance. It was "less than what he'd drawn for the *Fantastic Four* alone during the 1960s."

Upon finally receiving the package, Kirby was ecstatic. Not only was he overcome by a wave of nostalgia as he sorted through the early pages of his career, but he could now provide

for his family's future. Though he spent the last ten years of his life semiretired (he died in 1994), it was nice to know he had some measure of security. Today, sheets of Kirby's art, from his most important series of Silver Age comics, sell in the $10,000–$50,000 range at auction.

Stan Lee's vision, Jack Kirby's artistic talent, and the Silver Age of comics kicked open the door to a breed of new comic book forms, both in terms of content and style. Some pushed the envelope, experimenting with aesthetic as well as mature content that verged on true literature. These books strove to entertain *and* provoke. People began referring to them as "underground comics" and the label stuck.

Perhaps the quintessential underground comic book was *Mr. Natural*. It was printed in black and white and the text was filled with satire, inside jokes, and innuendos. The quality of drawing appeared to be academically grounded. There was a knowing sophistication to the brittle line. Cross-hatching was used to good effect. The characters were extreme in appearance, exaggerated in their attributes and physicality. As opposed to DC's anatomically perfect but sterile Wonder Woman and Marvel's equally "dishy" but hardly erotic Invisible Girl, these newfangled comics depicted females as highly charged sexual beings. Characters like Devil Girl were downright provocative, with their thick legs, rear ends where you could set a table for six, and protruding nipples. One thing was for certain, these books would have given the old Comics Code Authority a conniption fit.

Welcome to the world of R. Crumb.

As anyone who has ever seen the devastating documentary *Crumb* knows, the artist came from a dysfunctional family that was off the charts. Despite Crumb's harrowing upbringing, his childhood was typical in at least one way: he followed comic

books religiously. While he admired Jack Kirby's work on *Captain America*, his real hero and greatest influence was Harvey Kurtzman, founder of *Mad* magazine.

Robert Crumb got his professional start designing greeting cards in Cleveland during the mid-1960s. Simultaneously, he tapped into the new phenomenon of underground newspapers, quickly finding an outlet for his uncanny cartoons and sketches. These underground papers were all the rage, capitalizing on the emerging counterculture and the need to promote the growing market for psychedelic posters, health foods, leather goods, records, and drug paraphernalia. Soon, underground comics were in fast circulation.

By 1967 Crumb had made his way to San Francisco, the epicenter of the hippie lifestyle. Here he connected with a publisher and beat poet named Charles Plymell, who a year later published Crumb's first issue of *Zap Comix*. Other books followed, including *Fritz the Cat*, a feline con artist always on the make. Each book's mix of LSD-influenced zaniness and antiestablishment attitude reflected the openness of the times. From newly freaky teenagers to postcollege adults, Crumb was becoming required reading. The mainstream media even got into the act, identifying him as a key player in the burgeoning youth movement.

In short, R. Crumb was a hit. A large part of his aesthetic look and success was due to his complete control over his work. Avoiding the Marvel collaboration paradigm, Crumb wrote the stories, penned the dialogue, and illustrated his own comic books. He also managed to cross over into other creative fields. Notably, Crumb connected the dots between the music industry and the underground art world. He expanded his following through his memorable album cover illustration for *Cheap Thrills*, by Big Brother and the Holding Company (Janis Joplin's

band). The Bay Area's Grateful Dead took notice and wrote the song "Truckin,'" inspired by *Zap Comix*'s one-page feature called "Keep on Truckin.'" Crumb would also go on to illustrate a set of thirty-six trading cards, Heroes of the Blues. These snappy portraits depicted blues musicians on one side and their biographical details on the verso. Many vital but obscure African-American bluesmen would have remained invisible if not for Crumb.

But it wasn't until the serious contemporary art world began to view Crumb as a legitimate artist that he became a star. Unlike Kirby, who was never invited to exhibit his work in a contemporary art gallery, Crumb found a dealer willing to do just that. The gallerist's name was Martin Muller, owner of San Francisco's Modernism.

By 1983, while New York was preoccupied with the paintings of Julian Schnabel, David Salle, and Jean-Michel Basquiat, Muller's gallery retained its independent spirit out in San Francisco, showing works that couldn't easily be classified as art. Previously, Modernism had shown architectural renderings by Richard Meier, who would go on to design the elaborate Getty Center campus. Outside of the Max Protetch Gallery, in Manhattan, exhibiting and selling drawings by architects wasn't done. Muller liked to take a counterapproach to his program.

Despite Muller's desire to work with Crumb, the artist was reluctant and certainly not looking for gallery representation. He was known for actually *giving* away his great pen-and-ink drawings to anyone who admired them. Since Crumb had little interest in money, Muller had to find another way to hook him. The bait turned out to be Charles Bukowski. Muller had befriended Bukowski's publisher John Martin, of Black Sparrow Press, who in turn introduced Muller to the renegade writer. Bukowski, who was already a good friend of Crumb's, told him

that Muller was okay—that he was in it for the art rather than the profit. Besides giving a thumb's-up on showing at Modernism, Bukowski urged Crumb to remain true to his work and famously said, "Stay away from the cocktail parties, kid."

Crumb's Modernism debut was largely written off as a gimmick, which was typical of work that had yet to be absorbed by the art world. It wasn't until Crumb's inclusion in *High and Low*, Kirk Varnedoe's still-talked-about show on popular culture at MoMA (1990), that he won mainstream acceptance. Simultaneously, Crumb began to make inroads into the literary side of comics. His quirky stories inspired many of his comic book colleagues into pushing themselves to go beyond their illustrations.

That reverberation became a sonic boom with the arrival of Crumb's contemporary Art Spiegelman. Like Crumb, Spiegelman was a veteran of the underground comic book scene. He had also spent time in San Francisco, working with Bill Griffith, a talented artist who would gain recognition for the character Zippy the Pinhead, and for coining the expression "Are we having fun yet?" In 1976 Spiegelman moved back to New York and married an architecture student named Françoise Mouly. Four years later she would persuade him to start his own comic book, called *RAW*, a magazine that would become as influential as *Zap*. One of the highlights of *RAW* was Spiegelman's serialization of a cartoon strip that told the horrific story of his father Vladek, a Holocaust survivor. Though Spiegelman was not as talented a draftsman as Crumb, his drawings were effective, especially when paired with his text.

In 1986 Spiegelman combined these strips and created a small book called *Maus: A Survivor's Tale*. This ingenious story portrays the Jews as mice and their Nazi guards at Mauschwitz as cats. In 1991 he completed the *Maus* saga and released a second volume. The story hit home because Spiegelman was able to intersperse

his father's tale with scenes from his current life, filled with his father's extreme neurotic behavior and his equally intolerant reactions to it. Anyone raised in a Jewish household could certainly relate to Spiegelman's exasperation—the equivalent of George Costanza dealing with his parents on *Seinfeld*, multiplied by ten.

By blending masterful storytelling with imagery that was deceptively simple, Spiegelman was able to draw in readers. The key to *Maus* was the author's economical yet empathetic, heartfelt approach to telling his story. The *New York Times Book Review* hailed the work as "a remarkable feast of documentary detail and novelistic vividness . . . an unfolding literary event." In 1992 it won a Pulitzer Prize.

Spiegelman's creation of *Maus* represented more than a personal triumph. It triggered a whole new literary genre, the graphic novel. In 1986, the same year that *Maus* was published, the comic book world was treated to *Batman: The Dark Knight Returns*, chronicling a middle-aged Batman who comes out of retirement to fight crime in Gotham City. That year also saw the release of *Watchmen*. Each of these books was published in a multi-issue format that could be assembled to form a complete novel. Even more surprising, both comics were brought out by DC, representing a staggering comeback for the company.

The *Watchmen* comic book series, written by Alan Moore and drawn by Dave Gibbons, featured a bunch of mothballed superheroes who return to action on an alternate version of Earth after one of their members meets a mysterious and ultraviolent death. *Watchmen* resembled the conceptual art that received a lot of attention in the art world during the late seventies—where the idea was more important that the physical object itself. Even its cocreator Dave Gibbons suggested, "*Watchmen* becomes more about telling the tale than the tale itself." Gibbons went on to explain that their intention was to provoke you into reading the

comic book four or five times to really understand it. In other words, the plots were complicated and confusing, and the dialogue was overwritten. Still, *Watchmen* developed a huge following. Its movie adaptation in 2009 grossed an impressive $200 million nationwide, despite having far less name recognition than the pacesetting *Batman* movie released only a year earlier. In 2008 *The Dark Knight*, starring Heath Ledger as the Joker, took in over $500 million in North America alone.

None of this was lost on the mainstream book industry, always eager for new sources of revenue. At the prestigious Book Expo America in New York, graphic novels were now given a prominent place on the exhibition floor, denoting their new status as a fast-growing niche in publishing—a lucrative extension of the humble comic book. With a focus on storytelling, comics were now crossing over into literature. They merged the art of the narrative with fine draftsmanship. The look of these graphic novels had long since been liberated from the conventional comic book look and ran the gamut from Chris Ware's *Jimmy Corrigan, the Smartest Kid on Earth*, to Neil Gaiman's *Sandman*. Stan Lee's vision of melding a good story with strong graphics seems obvious in retrospect, but monumental when viewed within the perspective of its influence.

Lee turned Marvel comics into a novel-quality experience that would extend into other corners of artistic culture. From spin racks to bookstore shelves to art gallery walls, comic book art had traveled a distance unimaginable back when it had its start. Rather than play to the lowest common denominator, as had been the tendency of comic books, Lee never underestimated his audience. Like most successful leaps forward in popular culture, his breakthrough was frighteningly simple. All he did was apply the golden rule. Stan Lee treated the reader the way he wanted to be treated as a writer.

Chet Helms (left) and Bill Graham.

Chapter Three
# Chet Helms, Bill Graham, and the Art of the Poster

SHEPARD FAIREY was now an art star.

By 2008 he had become a double threat, boasting two successful careers. He ran a commercial design business, which took on projects like providing graphics for skateboards and designing a mural for the side of an Urban Outfitters store. He was also a street artist hero to a growing legion of fans. But while the streets brought Fairey an audience and a platform, it was his political portraits that brought him mainstream recognition. Fairey had evolved a style that employed a combination of spray paint and stencils along with collage. He used this technique to create portraits of a rogues' gallery of twentieth-century political figures: Mao, Lenin, Fidel Castro, Malcolm X, Che Guevara, and others. As for more recent politics, Fairey had been a big Bill Clinton fan and always despised George W. Bush, but he was filled with optimism during the early days of Barack Obama's campaign for the presidency in 2008.

As Obama gained traction and appeared to have a good chance of receiving the Democratic party nomination, Fairey decided to get involved. There had been, of course, many precedents for artists donating their talents to raise money for candidates they supported. One of the best examples was Andy

Warhol's decision to create a limited edition print for George McGovern's 1972 presidential run. With his background as an advertising man, Warhol knew how to grab attention by hitting the viewer with the unexpected. He started out by silkscreening a portrait of Richard Nixon, selecting a particularly sneaky image of the thirty-seventh president wearing an awkward half-smile. Then Warhol covered his face with putrid shades of blue and green ink, making him appear rather unsavory. Finally, in a stroke of genius, he scrawled VOTE MCGOVERN in large letters directly below Nixon's image.

Warhol's effort was limited to an edition of 250 prints. Shepard Fairey was more ambitious. He wound up creating a blue-and-red collage depicting Obama in a three-quarter profile. Originally, he printed the word "Change" below the portrait. Once the painting was completed, Fairey got in touch with the Obama campaign and ran off 3,500 posters, which were sold on their official Web site for a seventy-five-dollar contribution. The posters moved quickly, netting an impressive $375,000. Fairey offered to do a second printing, but Obama's people became concerned that the posters were showing up on the streets illegally plastered on private and public property—only a misdemeanor, but against the law nonetheless.

Wishing to avoid any legal problems while not alienating Fairey, the Obama election committee found a way around the conflict. Because Fairey's posters received such a strong response, they looked the other way, while not sanctioning his work. Simultaneously, they informed Fairey that they would like him to create an official poster, but this time substituting the word "Hope" for "Change"—the version that was sold and sent out as e-mail blasts. Though Fairey was quoted as saying he preferred "Change," he went with the program. Once they hit the streets, the demand for the new posters skyrocketed. Both

the edition of 350 fine art silkscreens and 3,000 offset prints sold out in fifteen minutes. At that point, the Obama team decided they could live with the risk that some posters might end up crossing over into petty vandalism.

The Hope poster became the unofficial icon of the Obama campaign. It was virtually impossible to go an entire day without seeing one on a car bumper, television commercial, or wall in your neighborhood. Once Obama was elected, Fairey received a personal thank-you letter from the president, which succinctly summed up his work: "Your images have a profound effect on people, whether seen in a gallery or on a stop sign." Fairey had broken through mainstream channels with his personal blend of poster art.

The extraordinary popularity of Fairey's poster can be traced directly back to the innovative rock posters that concert promoters Chet Helms and Bill Graham commissioned during the 1960s. Theirs is a story of rock-and-roll hijinks and broken rules, where anything and everything was an opportunity to experiment. They brought together music, pop culture, and politics, all under the guise of art. Their posters, in turn, generated a whole new substructure of collecting: works of art with a commercial underbelly that achieved credibility through the streets.

Chet Helms might have been the ultimate hippie, with his long flowing hair, biblical beard, rimless glasses, colorful period garb, and mellow ways fueled by indulgence in the "herb superb." It was the sixties and San Francisco was the epicenter of the emerging rock world. Helms had just arrived via Austin and the University of Texas, where he had immersed himself in the college town's music scene. Upon arrival he moved into a loosely knit commune that went by the name of the Family Dog. They had a reputation for hosting wild impromptu concerts at their

house; joints were passed among a crowd tripping on fantastic bursts of light projected on the living room wall, while bands grooved till dawn. These events became so popular that they began searching for a larger venue for the musicians to play.

Helms and his cronies found a place called the Longshoremen's Hall, where he helped produce the area's first rock concert, starring the now forgotten Charlatans. The show was a roaring success and Helms appointed himself the official leader of Family Dog productions—apparently no one else wanted the job. Building on the strength of that event, he leased a still larger space, a former dance hall called the Avalon Ballroom. Helms then got to work booking local talent from the Bay Area's vibrant music scene, including Big Brother and the Holding Company, a group Helms would eventually manage and pair with Janis Joplin as their lead singer.

The Avalon shows became much more than musical performances; they were a gathering of the tribes. Since there were no fixed seats, people could circulate and socialize, get stoned, drop acid, and dance their hearts out to bands playing against a backdrop of a swirling light show. This nifty package of sights, sounds, and mind-expanding experiences created so much demand that Helms suddenly found himself in the concert promotion business. While he was in it for the art, not the money, he still had to make a living—and that meant figuring out how to successfully market the shows.

Helms had hit on the idea of hiring actual artists to create posters trumpeting his events. Unlike old boxing flyers, which were purely informative, Helms commissioned work that captured the psychedelic vibe of the times, provoking passersby into doing a double take and exclaiming, "Far out!" Artists lifted iconic images from books on America's past and combined them with typography whose letters were twisted and stretched to such

an extreme that it was as if the words themselves were high on LSD. They were artistically advanced and aesthetically pleasing, bringing more of a vibe to the event. Without even knowing it, many of the graphic designers were empowered by Graham and Helms to create real art. The zaniness of the posters' graphics reflected the exuberance of the times and dovetailed with the sensibility of Pop Art. Sometimes they crossed the line into bad taste, as when Stanley Mouse included a photo of a pathetic circus freak on a poster for the Charlatans. Then again, their ability to shock was part of their power. The posters may have been shilling rock and roll, but they became so much more.

Rather than problems with artistic license, it was money that would ultimately prove to be Chet Helms's undoing. According to Robert Greenfield's book *Bill Graham Presents*, despite the Avalon's modest two-dollar admission fee, they had a hard time collecting any cash. If you could convince Helms that you knew him or even once met him, he would let you in for free. Then there were the Hells Angels, the Merry Pranksters, and other "scenesters" who were also ushered in without charge. By the end of the evening, when Helms added up the gate, he often failed to make enough to pay the bands. Clearly, his business template wasn't working. Still, the community loved Helms and his shows.

Enter Bill Graham, whose personality, to say nothing of his aggressive approach to the concert business, was the antithesis of the laid-back Helms. As Grace Slick once said about Graham, "He was one of us and one of them." Graham's life story goes way beyond the classic American success yarn. He was born Wolodia Grajonca in Berlin, in 1931, only two days before his father died. His widowed mother had the foresight to send him and his youngest sister, who were still children, to an orphanage in France, as insurance against the ominous rise of the Nazis.

His mother's instinct proved spot-on, because she and the rest of her family were sent to Auschwitz, where she ultimately perished. Graham was more fortunate. As war broke out in France he was spirited away to America and placed in a foster home in the Bronx.

Eager to assimilate, he worked hard to learn English and changed his name to Graham, which he picked out of the phonebook. In 1951, after graduating from high school and earning a business degree from City College, Graham was drafted into the army and served with distinction in the Korean War. Upon his discharge he returned to America, where he found work as a waiter during the heyday of the Catskill Mountain resorts. This was the era so wonderfully portrayed in the movie *The Apprenticeship of Duddy Kravitz*, where Richard Dreyfus waits on tables, is handed half of a hundred-dollar bill by a guest, and is told, "You get the other half at the end of the season if I get good service."

Graham evolved an approach that would serve him well down the road: think big and work hard. He was only a waiter but that didn't mean he couldn't parlay it into something more lucrative. Case in point: while many of his fellow servers screwed around, chased women, and gambled their tips away on card games, Graham hustled extra money by *running* the card games.

Graham also learned the art of pleasing the customer and giving him his money's worth. Since his income depended primarily on tips, he did whatever it took to keep the resort's patrons happy: Need extra butter? Right away! Your filet mignon arrived cold? Back to the kitchen it goes! All that mattered was that the customer felt his waiter was genuinely concerned with his satisfaction. It goes without saying that Bill Graham left the Catskills with a pocket full of loot.

During the early sixties, Graham gravitated from New York to San Francisco to be closer to one of his sisters. During a free

concert at Golden Gate Park, he was introduced to the San Francisco Mime Troupe, known for its radical street theater performances. After one of the mimes got arrested on an obscenity charge, Graham organized a benefit concert to raise money for his defense. Like Helms and his early foray into concert promotion, Graham accidentally fell into the business.

The San Francisco rock scene was so compact that it was inevitable that the two budding impresarios would meet. One thing led to another and Helms and Graham decided to pool their talents. Their first joint venture was to put on a show featuring the Paul Butterfield Blues Band at the Fillmore Auditorium, a former Black Muslim venue. The two unlikely partners, Graham who was older and straighter, and Helms who was younger and hipper, managed to pull it off. They did good box office and after the production Helms suggested they do it again.

But Graham had other ideas. Bigger ideas. The legendary story is he got up at dawn the next morning and called Albert Grossman in New York. Grossman was the powerful manager of Bob Dylan and the Paul Butterfield Blues Band. Graham cut a deal with Grossman for exclusive rights to the group in San Francisco. Having aced out Helms, he then put on a second Butterfield concert at the Fillmore, which was an even bigger financial success. Not long after, Helms appeared at Graham's office, and he wasn't there to pay a social call. Seething, he told Graham, "That wasn't real cool . . . going behind my back to book Butterfield." Graham shrugged and laid it out for him by saying, "Chet, I've got one piece of advice for you—get up early!"

Needless to say, the proverbial line in the sand was drawn between the two promoters. Helms went on to rent the Avalon Ballroom, where he continued his loose admission policy along with other sloppy business practices. Graham took over the master lease at the Fillmore, ramped up his organization, furnished

it with a state-of-the-art sound system, and brought profession-
alism to the concert business. Musicians may have grumbled
that Graham was a hard-core capitalist while praising Helms
for being a righteous dude, but when it came time to signing
contracts, they usually preferred to work with Graham. As with
most things in life, it often came down to money.

As Helms and Graham vied for supremacy in the Bay Area con-
cert world, they ignited a healthy competition among the poster
artists employed by each organization. Early on, Helms brought
in Stanley Mouse (formerly Stanley Miller). Mouse was the pro-
totypical poster artist. He began his career during the late fifties
at the Society of Arts and Crafts in Detroit, where he studied art
and learned airbrush technique. Upon graduation, as befitting
someone who grew up in the Motor City, Mouse developed a
passion for cars. Only in his case, he looked beyond Detroit to
Southern California and its emerging Hot Rod culture.

Ed "Big Daddy" Roth was the prime mover behind this group.
He and his crew built exotic hot rods, distinguished by their lus-
cious candy-colored lacquer paint jobs. Simultaneously, Roth
gained a reputation for his artwork, specifically his sketches of
monsters, popularly known as Weirdos. A typical Weirdo was
drawn screaming down the road in a car with a protruding en-
gine, one hand on an extended eight-ball gearshift, the other
wrapped around a blonde. Eventually, Mouse and Big Daddy
met at a custom car show, where Mouse had been hired to air-
brush one-of-a-kind T-shirts. Mouse was also introduced to Rick
Griffin, another important Los Angeles car culture painter, who
years later would collaborate with him on rock posters.

According to Mouse, it was he, not Big Daddy Roth, who
invented the "monster hot rod" art form. Mouse also takes credit
for the famous Rat Fink, a creation long associated with Roth.

The Rat Fink was a potbellied rat with a superlong tail, who had a "shit-eating grin" on his face and eyes bugging out of his head, and was always surrounded by buzzing flies. Though Mouse may have indeed been the originator of Weirdo artwork and the creator of Rat Fink, it was Big Daddy who popularized the style—sometimes it's better to go second.

It was in 1965 that Mouse moved to Oakland, where he met the artist Alton Kelley, who was part of a group of hippies that would eventually move to San Francisco and call themselves the Family Dog—the same collective that welcomed Chet Helms. Once Helms assumed leadership of their concert productions, Kelley left the Family Dog team and started an art studio, forming a partnership with Stanley Mouse. One of their first customers was Helms, who commissioned the earliest rock show posters, allowing Mouse to lay claim to helping originate a second art movement. His aesthetic for exaggerated and edgy cartoonlike characters would end up translating from the page to the poster with great success.

Not long ago, I had coffee with Mouse, who was now almost seventy and living in Northern California. Though he sported a ponytail, keeping his counterculture credentials intact, I was surprised by his rundown appearance. To quote Neil Young, he looked like he had "seen the needle and the damage done." This proved to be the unvarnished truth, as Mouse told me about having undergone a liver transplant, after catching hepatitis many years ago from sharing a syringe.

I couldn't resist asking him, "Did you share it with anyone famous?"

Mouse grinned, then his grin widened into a full smile. "Janis Joplin."

Rather than turn nostalgic over the sixties, Mouse launched into telling me about his current artistic efforts and his desire to

be taken seriously as a fine artist. He was in the midst of securing a gallery for his recent paintings of skulls, ethereal ladies, and red roses. Though this work was brand new, it harkened back to his association with the Grateful Dead. Mouse faced a typical artist's dilemma: Do you recycle iconography that you're closely identified with or do you risk everything by evolving fresh imagery?

As Mouse continued showing me his small canvases, we got into the subject of the birth of the rock poster and Chet Helms. While Helms's reputation as a laid-back guy held, Mouse told me he also had something of an arrogant streak. "He was an asshole! But he did pay us a hundred dollars a poster." Despite being rough around the edges, Helms's generosity was unabated when it came to taking care of others—whether performers, audience members, or artists.

Once Helms began commissioning posters on a regular basis and they began to attract attention, Bill Graham hired poster artists of his own. But while Helms was liberal in his payment, Graham's business smarts led him to pay only seventy-five dollars a poster. "Graham was more like a gangster—ruthless and brutal. He had that killer instinct." But in either case, much of the original artwork was never returned to the artists. Included in this group were Victor Moscoso, Rick Griffin, Wes Wilson, and Bonnie MacLean (who became Graham's wife). Before long, all of the artists shuttled back and forth between both promoters. It wasn't about loyalty; it was about picking up work. What's more, two artists would often collaborate on a single poster. As time went on it became hard to distinguish who designed which poster for which organization. They all shared a similar look defined by the era.

Among the earliest surviving posters is a black-and-white print designed by Wilson for the "Tribal Stomp," featuring Jefferson

Airplane. Wilson invented a font where each letter took on a liquid form that appeared to be moving and separating like an amoeba. Rather than feature a conventional picture of the band, Wilson collaged a central reproduction of Native Americans on horseback, cribbed from a vintage Edward Curtis photograph. This unexpected combination of words and images jarred the viewer into seeing the world differently. Whether the young person on the street knew it or not, he was looking at art.

From black-and-white imagery, posters progressed to multi-color printing. As the concert business gathered momentum, Graham and Helms increased their promotional budget, allowing the artists to create more elaborate work. Mouse and company began taking more risks with their art, incorporating images from art history, such as Michelangelo's *David*, and folding them into compositions that bordered on surrealism. Every subject was fair game: octopi, scarab beetles, and one of the most popular designs of Stanley Mouse's career, the Zig-Zag man.

For those who can remember the sixties, which if you can, according to David Crosby, indicates "you weren't there," the most common rolling paper was called Zig-Zag. The tiny packet featured a stylized blue portrait of a man with a perfectly mani-cured beard, wearing a cap that resembled a hard-edge "do-rag," smoking a doobie, with a blissed-out smile on his face. Mouse, along with Kelley, appropriated the iconic Zig-Zag man for a Family Dog poster featuring the Quicksilver Messenger Ser-vice. Mouse obviously knew he was violating a copyright be-cause he included a line at the bottom of the poster that read, "What you don't know about copying and duplicating won't hurt you." Rather than pursue legal action against Mouse, the Zig-Zag folks went with the flow, convinced that the poster gave additional authenticity to their product. As a historical footnote,

this poster proved so popular in its day that it was one of the few Avalon Ballroom works to be counterfeited.

Mouse spoke fondly of the competitive yet friendly spirit that existed among his colleagues. As the artists upped the ante, pushing each other to greater heights, it produced a frisson that led to some of the period's strongest work. What's interesting to note is that concert posters, at least initially, met with plenty of resistance. When Bill Graham first tried to distribute them among local head shops to place in their windows, they often refused. But that didn't deter Graham. He focused on where the posters were popular—on the streets.

Like a man possessed, Graham "got up early" and zipped around San Francisco and Berkeley on his motor scooter, armed with his trusty staple gun, locked and loaded for attaching posters to telephone poles. And if he encountered a concrete streetlamp pole, he'd reach into his other holster for a roll of adhesive tape. Graham knew his posters were catching on because he'd observe people carefully remove them and take them home. It wasn't long before those very shop owners who once told Graham to take a hike were begging him for extra posters for their own use. According to Harry Tsvi Stauch (aka Tsvi Deer), who owned In Gear in the Haight-Ashbury, "The first poster was free. If you wanted extras, they were five bucks each—then we'd sell them for ten."

Today, those early posters have become highly collectible. Fillmoreposter.com lists a total of 147 posters commissioned by Helms and the Family Dog and 289 by Bill Graham. According to Mouse, a first-print copy of an early poster he designed for the Grateful Dead—with dancing skeletons and a garland of roses—now sells for $7,000 to $12,000, depending on condition. Lucky for him, he still has a few of them! I told Mouse that I had recently met someone with a shop in the lower Haight

who had one of those posters for sale and he was asking $15,000 for it. Stanley Mouse grinned away.

From the afternoon spent with Mouse, I could tell that he was pleased by the longevity of his work and that it was still considered relevant. I sensed that despite the frequent lack of appreciation by his employers and the competition among artists, he was still damn proud of all he and his colleagues had accomplished. Poster art went from street cred to art market cred in a matter of twenty years. If you look at the big picture, much like Ivan Karp and the Leo Castelli Gallery, and Stan Lee and Marvel, Chet Helms and Bill Graham created the environment that allowed Mouse and company to prosper. If not for the two kings of Bay Area concert promotion, we probably never would have heard of Stanley Mouse.

By 1969 Peter Max may have been the most famous artist in America—even more famous than Warhol. Thanks to a *Life* magazine cover feature with the caption "Portrait of the Artist as a Very Rich Man," Peter Max seemed to be everywhere. Ironically, on the day that issue appeared, Max was sitting in the boardroom of Time Life with various publishing executives— and Andy Warhol. When they passed out copies of the magazine, Warhol whined in his fey voice, "Oh Peter, now you're a household name."

The popularity of the rock poster had paved the way for Max's own style of art and allowed his work to leap into the mainstream. It's important to remember that the Fillmore and Avalon posters were "feral." They lived on the streets, but were soon housebroken and domesticated. While Mouse and his posse considered themselves artists and eventually won acceptance as such, Max was the first poster illustrator to be seen by the public as a fine artist first and foremost. Collectors connected with Max's love

of astronomy and his cosmic universe filled with winged surfers and skies throbbing with planets and stars, along with his philosophy of universal peace and harmony. If Warhol was about celebrity, death, and disaster, Max was about optimism, spirituality, and enjoying life. Max didn't reflect the times the way Warhol did. Instead, he created a personal iconography for the times as he wished them to be.

Peter Max Finkelstein was born in Berlin in 1937. Only a year later, his family left Germany for Shanghai, China, where they would spend the next ten years. Peter's father, Jakob, had a knack for retailing and established a small department store that specialized in selling Westernized clothing to fashion-conscious Chinese. As he began to prosper, he took his family on exotic vacations, including a visit to Tibet. Max would look back on that trip as his first exposure to spirituality, which would eventually lead him to bring Swami Satchidananda to America in the 1960s, helping kick-start the yoga craze and his personal connection to the "force" that he claims exists.

Peter's dad frequently bought him gifts, including a collection of American comic books. These early issues of *Captain Marvel* and other comics would also be counted among Max's early artistic influences. As he put it, "I read each book cover to cover and was fascinated by the beautiful colors and black outlines." Years later he claimed, "Comic books taught me how to draw. How to foreshorten, how to create a face and its expression in a few spare lines. I learned fundamentals without realizing it."

By 1953 Max was studying art in Paris at the Louvre. Three years later, he moved to America and attended classes at the Art Students League. Upon finishing school, he opened his own graphic design studio, where his exuberant style won a following among art directors. But like fellow commercial artist Andy

Warhol, he wanted more. Though Max befriended Warhol, and they had plenty in common, including a mutual interest in collecting cookie jars, their art went in divergent directions. By the Summer of Love (1967), Warhol was an established figure in the New York art scene, but Max's ambition went beyond exhibiting at Leo Castelli. He was after an audience as vast as the cosmos he portrayed, regardless of their level of sophistication or whether they could afford fine art.

Max had always been a big fan of Maxfield Parrish, whose paintings were translated into tens of thousands of inexpensive prints, primarily during the 1920s. Parrish painted romanticized versions of women in nature, often interspersed among classical architectural elements, like large amphoras, with a luminosity that seemed to emanate from deep within the picture. Parrish found a way to bring what was then considered to be highbrow (real) art to the masses. This revelation was not lost on Peter Max. He wanted his own paintings translated into posters in a similar vein.

Though printing techniques were relatively primitive compared to today's computer-driven miracles, Max was able to successfully collaborate with printers and bring his vision to life. He used what printmakers call a rainbow roll, blending a plethora of colors, so that one flowed into the next. The result was a kaleidoscopic effect that packed even more visual punch than his wondrous paintings.

Max's posters sold in the millions. By the time of his *Life* profile, it seemed as if there wasn't a college dorm room in America that didn't have a Peter Max poster taped to its walls. Although his posters were printed for roughly a nickel apiece, their quality was inordinately high. Since the average poster retailed for approximately two dollars, Max soon found himself a "very rich man" indeed.

The article in *Life* pointed out that Max had already earned $500,000 that year, in 1969, on posters alone. His posters went on to generate so much interest that he ultimately controlled a grand total of seventy-two licensing agreements for his designs. The galactic world of Peter Max burrowed even deeper into public consciousness once it appeared on General Electric wall clocks, scarves, watches, jigsaw puzzles, and on and on. He had succeeded in grasping an audience that went beyond art collectors.

I once visited Max at his studio in the Lincoln Center building that served as his headquarters. With Led Zeppelin pumping from the stereo and fueling his adrenalin, Max darted back and forth between canvases with a kinetic energy that I had never witnessed before in an artist. He'd dip a brush into a jar of acrylic paint and repeat the process until its sable hairs were loaded with a full spectrum of colors. Then he would swipe it across the canvas, echoing the rainbow roll effect that once set his posters apart. As Robert Plant moaned about being dazed and confused, Max continued to paint while explaining how influential rock music had been on his early work. There was no escaping how much cross-fertilization took place between Peter Max and the comic book, Peter Max and the rock poster, and Peter Max and Pop Art.

By 1971 Bill Graham had shuttered both the Fillmore West in San Francisco and the Fillmore East on the Lower East Side of New York. The twin closure was a result of the top rock acts and their management becoming aware of their growing financial clout, leading to ever-escalating demands for more money. Individual promoters like Bill Graham, who controlled relatively intimate auditoriums, were shoved aside for corporations that could deliver stadium-size audiences. What had once been a

"cigar box used as a cash register" mentality had grown into an industry of lawyers, accountants, and Ticketron. While Graham would go with the times and turn to putting concert tours together for mega-acts like the Rolling Stones, Helms left the business entirely to open an art gallery in San Francisco called Atelier Dore.

The demise of Chet Helms and Bill Graham signaled not only the end of the rock show as we knew it, but also the rock concert poster as a piece of art to collect. All of the cultural elements that made these posters so special were vanishing; the experimental nature of the times, the rawness of the artists, and the energy of the street movement had disappeared. Everything had grown slick and corporate. The edge was gone. Poster art had gone mainstream with Peter Max's work and lost its grass-roots, homegrown quality.

It wasn't until almost twenty years later that a new underground poster movement was taking shape on the streets. In 1988 I was driving around Venice, California, and couldn't help but notice familiar faces like Ronald Reagan's plastered on handbills everywhere—and I mean *everywhere*. Part caricature and part cartoon, the portrait was drawn with so many lines and wrinkles that the Great Communicator resembled a shriveled-up apple core doll. Every circular also carried a brief political message. Above Reagan's likeness was the word "Contra," below it "Diction." While there was no artist's signature or stamp, whoever made them succeeded in getting my attention.

At some point, I walked into a Santa Monica gallery that belonged to Robert Berman. We were discussing the art business when he said, "Do you want to see Robbie Conal's latest work?"

I shrugged. "I don't know who he is."

Berman smiled. "Yes you do."

"No, really—I've never heard of him."

"Yes you have."

Before we went another round, Berman produced a print with four faces and an inscription below that read "Men with No Lips." Along with Reagan were members of his cabinet, including Defense Secretary Caspar Weinberger, Donald Regan, and James Baker.

I cried out, "You're right, I have seen his work!"

Robbie Conal combined the artistic virtues of rock posters and blended them with a new political agenda. Conal's work was concerned with spreading messages of discontent with our government. As someone whose parents were union organizers, Conal knew a thing or two about propaganda. This background, combined with an MFA from Stanford, produced a potent mix that urged the viewer to open his eyes to what was going on in our country.

Conal continued to push his agenda through the nineties, painting Bill Clinton with the sarcastic words "Dough" and "Nation," and pushing the limits with an unflattering poster of California's celebrity governor Arnold Schwarzenegger. In 2003 Conal took him to task over being an alleged Nazi sympathizer. Under the headlines "Achtung Baby!" (also the title of a U2 album), the former Mr. Olympia grinned a horrible toothy grin. Below his face was a quote from the documentary *Pumping Iron*, which features a young bodybuilding Schwarzenegger: "I was always dreaming of very powerful people, dictators and things like that." By keeping his imagery simple but timely and his words few but concise, Conal returned the art of the poster to relevance again.

In the process of papering the streets with his iconography, Conal was setting the stage for an impressionable young art student named Shepard Fairey, who would follow in Conal and Max's footsteps to elevate the poster to a new plateau of public *and* art-world acceptance.

The art of Shepard Fairey was spawned by skateboard culture, which originated in Venice during the 1970s, but whose taproot extends deep into Southern California's surfing culture of the late 1950s and 1960s. Led by the charismatic Miki Dora, whose story was profiled in the book *All For a Few Perfect Waves*, the surfer lifestyle was eventually co-opted into a "designer" lifestyle by corporate America. By the time Body Glove apparel had gone mainstream, the next outdoor recreation trend was already under way. The seventies saw the emergence of a generation of kids who rebelled against the surfers to create a fast-paced lifestyle of their own centered on a newfangled invention called a skateboard.

Taking a cue from their surfer brethren, who obsessed over the design of their boards to the point of fetishizing them, skaters built what amounted to miniature surfboards with wheels salvaged from roller skates. Rather than ride the blue waves of the Pacific Ocean, they rode the black asphalt of Pacific Avenue. These young renegades included pioneer skater Stacey Peralta, who would go on to direct *Lords of Dogtown*, which profiled the lives of skaters in Venice before money transformed it in much the same way as surfing.

By the end of the 1980s, skating had infiltrated middle-class white suburbia while still maintaining its "cool quotient." Among those swept up in the skater way of life was Shepard Fairey. Upon buying his first skateboard he did what everyone else did—he slapped some stickers on the underside of his "deck." Stickers were a way of hijacking a mass-produced object and in theory making it your own. It was only in theory because the stickers themselves were fabricated by someone else, too.

Fairey, who later majored in art at the Rhode Island School of Design, decided to create his own stickers as an act of defiance. During 1989 he came across an image depicting André

the Giant, a gargantuan French professional wrestler. André suffered from a hormonal disorder called acromegaly, which enlarged his bones in length and width, causing him to grow to seven feet, four inches tall and weigh 520 pounds. Largely because of his immense size and exaggerated facial features, he became an international sensation, and at one point was the highest-paid wrestler in the world.

Fairey created a stylized black-and-white portrait of André the Giant's face, and along with listing his height and weight, included the words "André the Giant Has a Posse" (the posse being Fairey and his friends). Fairey adopted a rectangular format, with each sticker screened onto an 8½-by-11-inch sheet of paper with an adhesive backing. But rather than settle for just sticking them on his deck, Fairey turned them into a form of urban graffiti by peppering them all over Providence, turning every wall, telephone pole, and crosswalk box into a gritty canvas. He even blew up André's face large enough to cover a billboard promoting the candidacy of Vincent Cianci, who was running for mayor of Providence. One morning, the town awoke to André's enormous likeness in place of Cianci's, his outstretched arm asking for your vote.

At the beginning of his social experiment, Fairey was quoted as saying this was his way of "taunting and stimulating" the public. Soon the experiment grew legs, as friends and fellow artists requested André stickers to help spread the word. The fact that they were breaking the law only added to the rush of excitement. Some admirers even asked for permission to run off their own versions of André the Giant stickers, which Fairey always granted. Within months the grappler's mug went viral, as his image was disseminated all over the East Coast, including Boston and New York. Once the posters began showing up in San

Francisco's Haight-Ashbury, it made you wonder whether the "gray ponytail" crowd were having flashbacks to the Fillmore posters of their youth.

By 1995, with Fairey's André the Giant urban onslaught going full bore, he simplified the athlete's facial features almost to the point of abstraction. Gone were André's vital statistics and any mention of a posse. In their place was the lone word "Obey." Fairey began to think of André as a malevolent Big Brother figure looking down upon us from his inner city perch. Almost overnight, large-scale Obey *posters* began appearing all over urban America in rows of multiple images that would have made Andy Warhol proud.

Before launching his André campaign, Fairey had schooled himself in the history of the rock poster. He returned to them for inspiration once his street posters had blown up. While exploring the Fillmore and Family Dog archives, Fairey came across a poster of Jimi Hendrix by John Van Hamersveld, and within days reworked the image. Beneath the celebrated guitarist's electric afro, Fairey superimposed André's face. He was so pleased with the results that rather than turn it into a handbill, he ran off his first fine art serigraph. It was a turning point in the young artist's career with major ramifications for the art world yet to come.

With the dawning of the millennium, Fairey continued to develop his paintings and prints. And like the pre-1960s artists, who came up against Picasso and had to find a way to work through his influence, Fairey, being a post-1960s artist, eventually had to find a way to confront Warhol. Rather than avoid Warhol or steer around him, Fairey did what he does best— he appropriated him. In 2000 André's grim face was placed squarely under Marilyn Monroe's golden curled tresses, à la

Warhol's classic image. Just for good measure, the word "Obey" appeared below. And, in a final irony, Fairey utilized Warhol's photo-silkscreen technique to create the edition of prints. The work went on to find a ready audience.

By 2007 Fairey's art had been so widely disseminated that the mighty Led Zeppelin got in touch with him. Their manager explained to Fairey that bassist John Paul Jones was a fan of his work. Jones specifically pointed out how he liked its "propaganda feel" along with its limited palette. The result of that call was Fairey being asked to design a cover for *Mothership*, an album of Led Zeppelin's greatest hits. Fairey used their iconic airship logo in the design, reshaping it through his red, black, and cream chromatic filter — referring to their past but updating their image.

As to how Fairey's fellow urban artists felt about his work, there was predictable envy but also grudging respect. Banksy, his famous British counterpart, spoke about Fairey's breakthrough with the André the Giant works: "I found the Obey Giant campaign repetitive and nauseating. If Shepard Fairey comes to your town, every single graffiti writer gets uptight. We don't like Shepard because he makes us feel scared and lazy. I am absolutely positive he has made more reaches than any graffiti writer in history ever has done or ever will. And that means he's won."

As Fairey sees it, "I try to keep my eye on the big picture. I'm interested in how many people does my art affect and how long will it endure. I also try not to worry about whether it's classified as street art, high art, or commercial art. After all, street art is just 'art' with 'street' in front of it. But there's no denying street art has had an impact on design, movies, and fashion. What's interesting is the moment something goes from being unknown to

the early hipsters who get it just before it breaks mainstream—
that feeling something is bubbling up. But it doesn't last."

After President Obama took office, the prestigious National
Portrait Gallery in Washington DC purchased Shepard Fairey's
original artwork for *Obama Hope*. As a portrait artist you cannot
attain a higher level of recognition in America. Not only did
this cement Fairey's legacy, it also implied another level of ac-
ceptance for poster art that would have been inconceivable back
in the days when Chet Helms and Bill Graham were commis-
sioning promotional work for their shows. Had they lived to see
Fairey's breakthrough, an educated guess is that Helms would
have uttered, "Groovy," while Graham would have found a way
to parlay it into making more of a profit.

In 2008 the Denver Art Museum's department of design ac-
quired a full first-print set of every Family Dog and Fillmore
rock poster. In a single bold stroke the museum became the first
institution to lend its cachet to these incredible graphics. What
had been labeled a lowly collectible was now an acknowledged
art form. They followed up their acquisition with a show called
*The Psychedelic Experience: Rock Posters from the San Francisco
Bay Area 1965–71*, and flew in Stanley Mouse to participate in
a panel discussion. When he strolled into the opening reception
for the show, the first thing he saw was one of his own lobby
posters from an obscure dance hall called the Western Front.

The Denver exhibition was a revelation. It put the period at
the end of the sentence of how far concert posters had come.
They were beautifully framed and installed on the pristine walls
of an art museum, a far cry from being tacked on telephone
poles in the grubby Haight-Ashbury. The show was a veritable
retrospective of all the artists who worked for Chet Helms and

Bill Graham. Image after image recounted the triumph of the art to live beyond its original purpose. Seeing the vision of so many great artists, reunited through their work, not only kept the spirit of the rock poster alive, but the vision of Helms and Graham too.

John Ollman.

## Chapter Four
## John Ollman and Outsider Art

I F THE STORY of poster art is about trained artists who came from outside the mainstream and secured a niche inside it, then the tale of Outsider art is about individuals with no training coming from farther out—*much* farther—and connecting with someone on the inside who could convince the art world of their legitimacy. That someone was John Ollman.

To understand what Ollman had to overcome, let alone the artists themselves, you have to go back to Montgomery, Alabama, during the late 1930s—1939 to be exact. If you had visited the African-American section of downtown, you might have noticed an eighty-five-year-old ex-slave named Bill Traylor sitting on a wooden crate near a blacksmith's shop. Traylor was homeless—an extension of a long hard life with great responsibility, having fathered nine children along the way. He was tall, bald, with a thick gray beard and a stooped but still powerful physique from years of working on a plantation. His appearance never changed; he always wore the same pair of suspenders and threadbare clothes. What set Traylor apart from the rest of the town's poor was his uncanny ability to draw.

The Deep South, during the "might as well be slavery" days of sharecropping, wasn't the most hospitable place for an indigent black man. Traylor avoided trouble by spending his days

hunched over an improvised drawing board. Chances are that he was viewed as a town curiosity, considered harmless, and left alone. But that was about to change the morning he met Charles Shannon, a young artist who happened to be white, who had wandered downtown to run some errands.

Intrigued by his drawings, Shannon struck up a conversation with Traylor. Before long he was visiting Traylor on a daily basis, supplying him with colored pencils and sheets of discarded cardboard. Shannon stood mesmerized as Traylor sketched life as it unfolded before him: street corner preachers shouting out their sermons, drunks getting into arguments, churchgoing ladies with fancy hats, junkyard dogs, slithering snakes, and prowling tomcats. It wasn't that the subject matter was so remarkable; it was what he did with it.

With no training, Traylor managed to create works on paper that rivaled the most sophisticated modern art being shown in New York. The key was an unerring sense of placement of the figure on the page. Not only were Traylor's compositions sophisticated, they also captured the personality of his subjects. Once Shannon began furnishing him with gouache—mostly jars of blue and red—he began filling in the forms of his men, women, and critters, giving them further visual gravity. In a word, Traylor's narratives were extraordinary.

Shannon continued to encourage his new friend and eventually arranged a small local show at a noncommercial gallery in Montgomery called the New South. It's hard to know what Traylor, who never sought attention for his work, would have made of seeing his creations in a formal setting. Previously, whenever he felt like displaying some drawings, he would string up a few on a picket fence. Occasionally, a local would flip him a quarter for one. An incredulous Traylor was quoted as saying, "Sometimes they buy them even when they don't need them."

Charles Shannon's enduring legacy was his recognition that Traylor's work was worth preserving. Ultimately, Shannon amassed over 1,000 drawings out of an oeuvre of approximately 1,200 works, carefully storing them in light-tight boxes. Long after Traylor had died at the age of ninety-five in 1947, Shannon tried to interest various institutions in his work, including the Museum of Modern Art. During the 1950s, Shannon made an appointment to see Alfred Barr Jr., the museum's chief curator. Though Barr was extremely alert to the art of his times, he was perplexed by Traylor, perhaps because the Alabaman's work was so far removed from the recognized canon of modern art. Shannon's goal had been to secure a small show. Instead, Barr offered to buy a group of drawings for a token twenty-five dollars. Shannon felt patronized and turned him down.

Discouraged by that experience, Shannon put aside his crusade to gain recognition for Traylor in order to concentrate on his own painting. By the 1970s, after a career of intermittent success, Shannon was encouraged by his wife to try again to promote his friend. This time he connected with a new gallery called R.H. Oosterom, which in 1979 hosted the first Bill Traylor show in Manhattan. It had been triggered by a friendship between Shannon and the Outsider art collector Joe Wilkinson, whose artist wife Pat showed at R.H. Oosterom. Reportedly, sales and interest were slow. It wasn't until 1982 that Traylor broke through when the Corcoran Gallery of Art in Washington DC organized the traveling exhibition *Black Folk Art in America 1930–1980* and included some of his pieces.

I remember seeing that show, which included other significant Outsider artists such as Joseph Yoakum. I had approached the work as a tabula rasa; I wasn't familiar with a single participant. While all of the art I viewed that day was worthwhile, I was stunned by Bill Traylor. And I wasn't alone. Everyone who

reviewed the show, including Roberta Smith of the *New York Times*, gushed over Traylor, saying that he was "of course the best artist in the show."

That same year, John Ollman exhibited Bill Traylor at the Janet Fleisher Gallery in Philadelphia. Traylor had been on his mind for some time and he was eager to put together a solo show. Over the last decade, Outsider art had been his passion. His involvement can be traced to the day he joined the Fleisher Gallery staff in 1970, upon finishing graduate school at Indiana University. Though he had completed his master of fine arts degree in studio art, he had no real plans of becoming an artist. When he began his career as a dealer, the Fleisher Gallery was rudderless. Ollman felt no affinity for their inventory, which posed a big problem for him. His interest was flagging.

Then, in 1971, a woman walked in and offered to consign a substantial collection of Oceanic art, some of which had been gathered by none other than Michael Rockefeller (the Met has a wing of Primitive art named in his honor).

Janet Fleisher informed Ollman of the potential consignment, wondering aloud, "Who are we going to sell this material to?"

As Ollman explained it to me, "I looked at the work and said to myself, '*I can sell this!*' All I knew was the art was terrific. I felt a connection with the work—why it was made in the first place—why forty thousand years ago somebody took a charcoal stick and drew an antelope on a cave wall. It's a form of communication."

That was the eureka moment for Ollman—what Malcolm Gladwell would call the tipping point. Ollman had spotted something in the Oceanic works that he knew was the real deal. He discovered that the catalyst behind the work of untrained artists is rooted in the pragmatic. It starts with the humble materials

used to create the imagery itself. The people who carved the Oceanic figures selected wood because it was indigenous and readily available—as simple as that. Bill Traylor drew on the backs of old posters because that's what presented itself. Henry Darger utilized magazines and coloring books for his tracings because they were handy. Mose Tolliver painted on scraps of wood from construction sites because they were free.

Part of what gives the art of the unschooled and primitive cultures its power is that it was made with a purpose. The Oceanic tribesmen carved their objects for ceremonial use—to assure a successful hunt, guard against evil spirits, and so on. From our Western perspective, this approach was no different from the Italian Renaissance artists who painted for Christ and the church. With Bill Traylor, chances are it wasn't religious as much as it was spiritual. But that's just a theory. According to Ollman, "The truth is no one really knows how Traylor approached his art and why he did what he did. Back then, he was never asked questions about what influenced his drawings—no one cared. To me, it seemed to be based on information passed down through the years—folk tales—from one generation of the African-American community to the next. I do think the animals in Traylor's work can be attributed to symbolism based on folk legends. For example, it was believed that when you died your soul became a bird and flew back to Africa."

Janet Fleisher was so skeptical of Ollman's ability to broker the Oceanic art that she bet him lunch at an upscale restaurant that he wouldn't be able to pull it off. Ollman took the bet. So, of course, he immediately found buyers for almost everything. Over a gourmet meal at the Peale Club, which was part of the Pennsylvania Academy of Fine Arts, Fleisher told Ollman, "I'm turning the gallery over to you."

Ollman was flattered. He had only worked there a year. Once he got over the initial shock, he explained to her that he wanted to revamp the entire exhibition program—a complete house-cleaning. And Janet agreed.

Ollman had a specific direction in mind for his program. He also knew what sort of clientele he hoped to attract. While he was enough of a realist to understand that you had to make sales in order to stay in business—and was willing to broker blue-chip works from the secondary market by artists like Frank Stella and Ed Ruscha—his goal was to find those who understood that living with great art is about enlightenment as much as pride of ownership.

He described his personal collecting philosophy thus: "It is about coming down in the morning and looking at a Traylor hanging on the wall and getting that jolt that you might have gotten if you went to mass—whatever source of fortification that you need to get through another day."

Ollman began to share his discoveries of what he referred to as "contemporary spirituality" with Fleisher, who always seemed to be willing to go along with him. While the gallery technically belonged to her, it was rapidly being transformed by Ollman's vision. He held a deep belief in the surrealists, who wanted to divest themselves of the restrictions of formal art training. They were interested in getting back to the primal ways of making art. This led to Ollman's interest in artists who were self-taught, because they were "already there"—their visions were fully formed from the word go.

One of the first Outsider artists Ollman showed was Martín Ramírez. He was a self-taught artist, born in Mexico in 1895, who had been diagnosed as a schizophrenic and had spent most of his adult life in mental hospitals in California. Ramírez devoted almost all of his time to making fantastic colored-pencil

drawings of everything from pistol-packing banditos on horse-back to trains traveling through long, winding tunnels. He evolved a signature style of undulating concentric bands, which provided a hypnotic counterpoint to his imagery. By his death in 1963 he had created approximately three hundred works on paper that reflected the influence of both Mexican folk art and American modernization. Years later, the art critic Roberta Smith would refer to Ramírez as one of the greatest artists of the twentieth century—insider or outsider.

One day, in 1981, a well-dressed woman arrived at the new Janet Fleisher Gallery and began staring at a Ramírez. She turned around and said to Ollman, "Do you work here?"

"Yes, I do," he responded.

"These artists look like they're from the loony bin."

Ollman smiled. "Funny thing, some of them are. As a matter of fact, the artist you're looking at was in a mental institution."

"I knew it. I just knew it," she said. "You know, I was a volunteer in a mental institution and I just knew that this drawing was from one. Why do you have them on the wall?"

"Because we think they're art."

"You mean they're for sale?"

"Well, yes," said Ollman.

The woman was still standing in front of the Ramírez when she asked, "How much is this?"

Ollman explained that Ramírez drawings were in the $2,500 range. When she heard the figure, she gasped, "Oh, my God! I can't believe that. We used to throw things like this out every day!"

To which Ollman replied, "Well, you're the reason why they're $2,500."

After the success of the exhibition at the Corcoran, galleries were struggling with what to call this art form. Dealers tossed

around classifications like "self-taught," "naive," "visionary," and my favorite catchall, "folk art." The latter had been used to describe everyone from Grandma Moses to art of the clinically insane. The French preferred the term *art brut* when referring to artists like Jean Dubuffet, whose sophisticated "primitive" imagery was influenced by art from the periphery. In 1972 Roger Cardinal had curated a show in London called *The Outsiders*, which included Martín Ramírez and all of the usual suspects. The term was used with more and more frequency over the coming decades and eventually it stuck.

In 1984 my San Francisco gallery, Acme Art, held its own Outsider art show, featuring Bill Traylor. The work came from the Chicago dealer Carl Hammer, who was kind enough to consign a dozen drawings. Attendance was thin and sales were nonexistent, despite drawings priced at a modest $1,200. I sat in my deserted space, staring at these wonderful spotted cats and lone figures holding umbrellas. With only two days to go before taking the work down, I received a visit from a corporate art curator from Dallas. To his credit, he admitted he had no idea what he was looking at but appreciated them. He ended up buying five drawings and planned to hang them in the workplace, alongside a collection of the Austrian pseudo-primitive artist Hundertwasser.

Although the show didn't make the impression on my clientele that I had hoped it would, the demand for Traylor's work skyrocketed once the blue-chip gallery Hirschl & Adler began to represent the estate, in 1986, via Charles Shannon. Drawings that I couldn't place for $1,200 just two years earlier were selling briskly for five times that amount. Nothing about the work had changed; the context had. Bill Traylor was no longer seen as a savant or a country bumpkin. Instead, like a tiny tributary feeding into the mighty Amazon, Traylor's work merged into a

powerful river called the New York art establishment. Now the speculating could commence. Over the next ten years, Traylor's name gained recognition through word of mouth and a modest though steady stream of shows.

In May 1997 I received a phone call from John Ollman.

"Did you hear about the Traylor results?" he asked, his voice trembling with anticipation. He had been referring to an entire sale at Sotheby's devoted to twenty-one works from the Joe Wilkinson collection—the same Wilkinson who had recommended Traylor to R.H. Oosterom.

"No, what happened?"

"Are you sitting down?

"I am *now.*"

"A drawing brought $179,500!" said Ollman, filled half with amazement, half with fear—fear because he knew the days of acquiring affordable Traylors were over. The record-shattering drawing *was* exceptional: a figure of a blue farmer pulling a plow behind a muscular black mule. As usual, the composition was textbook perfect. Rumors flew that Oprah had bought it. However, the purchaser turned out to be the Museum of American Folk Art in New York.

"Shall I continue?" asked Ollman. With that he rattled off the results of another half-dozen auctions of drawings, with prices ranging from $40,000 to $100,000. If John could have watched me, he would have seen me flinch with each quote.

Being early to promote an artist who eventually succeeds makes you a prescient dealer, not an oracle. The real test of being in the vanguard is the ability to see the ship that's beyond the horizon. You know it's there, you know it's coming, and you know it's going to find you. Usually, you have to be out in the field to stumble upon greatness by visiting artists' studios, art fairs, and

the homes of pioneering collectors. True art-world seers have a way of letting revelations seek *them* out—not the other way around. Discovering artists like Ramírez and Traylor became easy for John Ollman once he let the art come to him.

Which is precisely what happened one day when a Philadelphia graphic designer darkened the doorway of the Janet Fleisher Gallery. It was 1982 and Ollman had just exhibited Traylor. The stranger was holding a cardboard box which contained a cluster of small sculptures, little tornadoes of wire wrapped around bits of urban flotsam and jetsam, including coins, batteries, pieces of plastic reflectors, folded matchbooks, bottle caps, and the like. They measured maybe four to ten inches tall and a few inches in circumference. The forms seemed to pulsate with energy. Ollman was mesmerized.

The designer painted a story that sounded fantastic but turned out to be true. He was returning from a party when his headlights caught the reflection of a mound of shiny objects near a street curb. He pulled over to investigate and began picking up these crazy little bundles of wire. Upon closer scrutiny, he realized they were purposefully made. And there were hundreds of them. Quickly deciding they were worth saving, he scooped up approximately seven hundred wire sculptures. Most were spilling out of corrugated cardboard boxes on the verge of collapsing under their own weight. Since they were found in an old black neighborhood in the City of Brotherly Love, the logical assumption was the artist was African-American.

As Ollman continued to examine the pieces, he noticed that some of the wire was heavy gauge, which would have required quite a bit of strength to bend. Chances were the maker was a man. Based on some of the tiny interior objects that could be dated—coins, campaign buttons, etc.—the work appeared to be made during the 1970s. The graphic designer who found the

constructions, who preferred to remain anonymous, explained that he discovered the stash the night before trash pickup day. Ollman deduced that the creator probably had passed away and his in-laws tossed out what appeared to be worthless junk. Ollman took them on the spot.

A less knowledgeable dealer than Ollman might have dismissed the discovery as a hoax. Had the owner of the assemblages shown them to another gallerist, there's a distinct possibility that we never would have heard of the Philadelphia Wireman. You can have the greatest eye in the world, but you cannot be a true art-world visionary unless you "know it when you see it"—even if you've never seen it before. When destiny called, Ollman answered by shaking hands on a deal to represent of one of the most significant finds of Outsider art of the twentieth century.

Almost immediately, Ollman began exploring the neighborhood where the pieces had been unceremoniously dumped, eager to solve the enigma of their origin. They were found fairly close to Harry's Occult Shop, the kind of place where you could get eye of newt and various other weird objects.

"We'd gone in there and asked around and everybody looked at us like, 'I don't know what you're talking about,'" Ollman said. "Then the writer Ann Jarmusch wrote a big article in the *Philadelphia Inquirer*, suggesting anybody who had any information about the material contact us. A couple people called saying they knew the Wireman or they knew the work. But every time we asked for proof, none of these leads panned out. People came down to the gallery with small wire sculptures—little figures that were fishing, playing baseball, stuff like that. I even showed someone an actual Wireman and he laughed claiming we didn't have the *real* Wireman."

Despite the stream of poseurs, no one credible came forward. Ollman even went as far as Xeroxing circulars depicting

Wiremen and posting them around the community surrounding the occult shop. But still no leads. Finally, Ollman realized that whoever made these sculptures was probably never going to surface. Instead, he decided to concentrate on gaining a consensus of acceptance within the art world for the Wireman. Letting the art speak for itself, he received a crucial endorsement from Lynda Roscoe Hartigan, a former curator at the National Museum of American Art in Washington DC and the world's leading Joseph Cornell authority, who said she was "electrified" by her first encounter with the Wireman's work.

Meanwhile, the Janet Fleisher Gallery hosted the debut show of the Philadelphia Wireman, pricing individual pieces between $150 and $400 at the exhibition. I was one of the buyers. Ollman was kind enough to let me in the back room so that I could examine at least fifty pieces. I marveled at each sculpture's authenticity. Unlike the contemporary art scene, where communications are so good these days that if there's an artist who's worthwhile he will eventually surface, the Outsider art world is much more dependent on serendipity and word of mouth.

Take the unlikely discovery of the reclusive Henry Darger. When Darger passed away in 1973, his landlord discovered an incredible cache of four hundred to six hundred double-sided watercolors on paper in his decrepit Chicago apartment. Darger had created a fantastical universe, inhabited by the Vivian Girls, who had come under attack by an adult force called the Glandelinians, who were trying to enslave all the world's children. Ollman explained, "The work was a person's attempt to deal with man's inhumanity to man, specifically to children. Darger's work pulled together a historical overview of all the twentieth-century hostilities we've lived through." Had the apartment's owner, who was a photographer for the *New York*

*Times*, not recognized the work's merit, it could have just as easily been thrown out. Without the fortuitous rescue of Darger's work, the art world would have been that much poorer. Ditto for the Philadelphia Wireman.

But as the Outsider art market gathered steam, it became more difficult to determine those artists who were the genuine item. Dozens of aspiring art dealers began combing the backwoods of Alabama, Florida, Georgia, Louisiana, and Mississippi, looking for untrained artists. Those suspicious of the dealers' motives need not apply. As Ollman put it, "It was kind of like, 'Let's go down south, find a black person who can hold a paintbrush, give him a piece of wood, and we've got ourselves a new artist.'"

During the mid-1980s, while vacationing in Miami, a dealer named Frank Kolbert told me about a recent local discovery. Someone had come across a homeless black street artist by the name of Purvis Young, who painted funky African-American figures and even funkier horses. Upon seeing the work, I was more impressed by his life story than his art—always a bad sign. Unlike Bill Traylor, who possessed not only talent but a clarity of vision, Young's work was essentially unformed.

Still, a few Floridian dealers, with good connections and visions of Bill Traylor dancing in their heads, decided that Purvis Young represented an opportunity. Given the times and the hot art market, their pursuit of him made perfect sense. The major Outsider figures—Traylor, William Edmondson, Ramírez, and Yoakum—were becoming expensive. Young was tantalizing to gallerists because his pictures could be acquired for next to nothing, yet seemed like the real thing. Still, when Kolbert showed me his collection of Youngs and offered me one in exchange for one of my Philadelphia Wiremen, I took the deal. I too had fallen victim to the hype, and didn't want to miss out if his career took off.

Not only were dealers "manufacturing" their own artists, but established figures, like the Reverend Howard Finster, suddenly came under intense pressure to produce. Finster had received a major career boost when his Bible-inspired imagery was featured on the cover of the Talking Heads album *Little Creatures* in 1985. Ironically, that event signaled the end of the serious portion of Finster's career. Rather than let the work spill forth from his imagination at its own natural pace, demand became so great that Finster began enlisting family members to help with its creation. The temptation of a substantial, steady income proved too great. Soon the work became a parody of itself. Much the same can be said of the Outsider movement through the late eighties.

While Ollman was getting the Fleisher Gallery up and running during the early 1970s, the dealer Phyllis Kind was developing a parallel market of contemporary artists from Chicago whose representational work was largely influenced by Outsider art. The press dubbed the group the Chicago Imagists. Among the best of these artists were H. C. Westermann, Jim Nutt, Roger Brown, and Ed Paschke. Though Nutt and his wife, the painter Gladys Nilsson, were significant Martín Ramírez collectors, they always denied being influenced by his work. Roger Brown also owned a considerable amount of Outsider art. And though Paschke was not known to be a collector, he took his cue from the Outsiders literally—he identified with their outcast nature.

Ed Paschke's paintings from the late 1960s and 1970s are best described as Pop Art meets carnival freak show. But unlike the (mostly) sunny iconography of Pop, Paschke focused on the dark side of his surroundings—grotesque figures depicting violence, alienation, and tawdry sex. The paintings made indelible visual statements, thanks to their hallucinatory, acidic color and

imagery, which resembled a broadcast from an old television that was slightly on the fritz.

Their weirdness was intentional; Paschke wanted to make the viewer squirm. He became part of a subset of painters associated with Outsider art who were sophisticated and trained but chose to live their lives somewhat off the grid. Paschke's work was also a meditation on the city of Chicago: he worked to create a "psychology of place." Much as you could look at a Bill Traylor and feel the oppressiveness of the Deep South, you could look at a Paschke and experience the howl of the windy city's disenfranchised.

Among currently working artists who picked up on what Paschke was after was his fellow Chicagoan Tony Fitzpatrick, whose artistic path would become a future template for those artists who elected to develop their careers outside the system.

Tony Fitzpatrick is a self-taught artist. While most successful artists today are spawned by MFA programs at prominent universities, and concentrate on a single discipline such as photography or sculpture, Fitzpatrick's artistic output is multifaceted: prints, drawing collages, poetry, screenplays, and bit parts in major Hollywood films. Fitzpatrick is also a swirl of contradictions. He is educated, but on his own terms; is savvy about how the gallery system works, but shows in spaces that intrigue him rather than advance his career; and makes art that isn't easily classified yet is readily identifiable. Just like his spiritual godfather Ed Paschke, Fitzpatrick is what I refer to as a Lou Reed artist; his work is about "taking a walk on the wild side." He represents the Outsider of today.

According to Fitzpatrick, art is largely about finding a muse to inspire your work. In his case, he is referring to a city rather than a woman, and that city is Chicago. Fitzpatrick draws strength from his hometown's streets and alleys, its bars and

strip clubs, its vanished stockyards, its fading blues clubs, and its professional sports teams (as long as it's not the Cubs). A typical Fitzpatrick drawing collage starts with a central image, perhaps an elephant. The pachyderm isn't really a Chicago icon, rather it represents the distant memory of a circus that his father once took him to. He'll surround the beast with bits of ephemera that depict historic Chicago: a matchbook cover from the lounge Talk of the Town, a reproduction of the grand old Wrigley Building, and a logo from a bowling alley that's long disappeared. His work becomes an intimate melding of personal and public nostalgia.

It was in the early 1980s that he met John Ollman, who would give him his first big break. The connection was made through the filmmaker Jonathan Demme, who had been a prescient buyer of Outsider art and a valued client of the Janet Fleisher Gallery. Demme had originally met Fitzpatrick on the streets of the East Village and kept in touch. One thing led to another and he gave Tony a small part in his breakthrough dark comedy *Something Wild*. Demme would later go on to greater recognition with his documentary concert film about the Talking Heads, *Stop Making Sense*.

When Ollman initially heard about Fitzpatrick, through Demme, he was showing at the Cavin-Morris Gallery in New York. At the time, Fitzpatrick had found his muse in Louisiana and he was exhibiting children's school slates, covered with imagery lifted straight from the bayou. Fearsome alligators patrolled his pictures against a backdrop of bald cypress trees laden with Spanish moss and the occasional water snake dangling from a low-hanging branch. You could almost smell the swamp.

Ollman took one look at these sacred objects, immediately bought a slate, and offered Fitzpatrick a show in Philadelphia. The works were priced reasonably, somewhere between $300

and $900, and the Fleisher Gallery exhibition sold out. Ollman then decided to roll the bones and offer him a $4,500 monthly stipend against sales in return for exclusive representation. Ollman agreed to support Fitzpatrick because he intuitively grasped that despite his tough-guy persona and his previous career as a professional heavyweight boxer, he had a fragile psyche. If he could alleviate Tony's worries about making a living, he was sure the work would grow even stronger, which proved to be the case.

Next, Ollman went to Chicago to visit the artist on his home turf and learn about his life and influences. Fitzpatrick, a great raconteur, regaled him with tales about his early years, his upbringing as one of eight kids in a working-class family, and perhaps his strongest formative experience—Catholic school. Fitzpatrick shared with Ollman an incident that he would later look back on as the irritating grain of sand that produced the pearl.

When he was in fourth grade, Tony was walking to school when he witnessed a skunk get hit by a car. As a young animal lover, he rushed over to aid the gravely injured varmint. Despite getting sprayed, he cradled the skunk and brought it to school. The previous week at services, he had heard the minister preach about how we were all God's creatures and deserving of love and respect. Eager to test that theory, Tony presented the dying critter to Sister Anisia. He innocently asked if she could arrange a blessing so the good Lord would know he was a "solid" skunk and let him into heaven. Screeching, the nun called the custodian, who removed both Tony and the offensive mammal from the premises. That night, Tony came to a life-changing realization: most of what he was taught was a bunch of lies. How could his school teachers be such hypocrites? From that moment on, he became his own man. Tony vowed to read, travel, and see

what was out there; a studio of the streets, so to speak. He'd learn about the world through a prism filtered by life experiences rather than more formal education.

As he grew older, Fitzpatrick found inspiration in American history. He especially favored tales of the underdog—from the poignant lives of train-hopping hoboes during the Depression to the trials of the great Lakota chief Crazy Horse. These stories would play themselves out years later in the form of drawing collages. Though Fitzpatrick went through some difficult times, battles with alcohol and the occasional scuffle with the law, he emerged as an artist.

Invited in 2008 to create work for Prospect 1, New Orleans's first art-world biennial, Fitzpatrick began spending more time in the city, digesting its pungent mix of spicy crawfish gumbo, sweet Neville Brothers music, and rich ethnic history. Within his new series dedicated to the Crescent City, Fitzpatrick's installation was called the *Chapel of Moths*.

I attended the opening of the event. Though New Orleans was clearly on the way back from Hurricane Katrina, a sense of unease hovered in the air. Prospect 1 was housed in various buildings spread throughout the city. Fitzpatrick's venue turned out to be a funeral parlor. However, Tony dispelled any lingering ghosts by hiring the local musician John Bouttè to perform. As Bouttè and his band launched into a soulful rendition of Neil Young's "Southern Man," attendees walked into a perfectly proportioned chapel filled with ten drawing collages.

As might be expected, the subject of every 13-by-12-inch work was a moth. Each was colorful, beautifully drawn, and often included a collaged face of a bright-eyed, raven-haired woman with protruding antennae, substituted for the insect's fuzzy head. All of the works on paper also included the numeral 9, an obvious reference to the Ninth Ward, which was singled

out for particular devastation by Katrina. While I wasn't certain what the moths symbolized for the artist, my own interpretation revolved around the expression "drawn like moths to a flame." As most people were displaced after the hurricane, they were now returning, guided by the glowing light generated by the city's reemergence.

It was clear that those who experienced the *Chapel of Moths* left feeling uplifted. By combining his unique blend of poetry and imagery with some Cajun-flavored music, Fitzpatrick created a philosophical construct whose sum was greater than its parts. It was as if all of the experiences he had processed over time, along with his struggle to find his humanity, had reached an apotheosis. After many trips to New Orleans, Fitzpatrick had woken up one morning on Chartres Street and discovered himself to be a part of the city. Outsider art had become about finding art as much as making it.

The first annual Outsider Art Fair, the final consensus in the maturation of the market, was held in 1993 in New York's Puck building. Ollman had been asked to exhibit at the fair and help anchor it. As someone who had always resisted labeling art, he was reluctant. But he signed on, lending his considerable cachet to the event. The show itself was relatively small by art-world standards; thirty-three dealers were invited. The Outsider designation was purposely kept loose in order to attract enough dealers willing to take a chance during an art market recession.

Attending was irresistible. But after walking up and down the aisles and browsing the wares, I left shaking my head. While a few galleries distinguished themselves and hung their booths with the genuine article, including Cavin-Morris and the Ricco/Maresca Gallery, the vast majority lined their walls with questionable work. Outsider art had become shorthand for anything

that looked like a day camp arts and crafts project. If I had a dollar for every "root snake" that I saw, I could have retired—or at least not worked for the next five years. It felt as if Outsider art had lost its way and sold out into an overwhelming embarrassment of kitsch.

In 1997 Janet Fleisher retired and John Ollman became the sole proprietor of the newly minted Fleisher/Ollman Gallery. His timing was opportune. The contemporary art economy was clawing its way back from a five-year fallow period and so was the market for Outsider art. At that point, the key artists in the field had been identified. There was now a hierarchy that resembled a theoretical pyramid of status. At the peak of the structure, you had the superstars: Henry Darger, William Edmondson, Horace Pippin, Martín Ramírez, and Bill Traylor. A few limestone blocks farther down you had the stars: James Castle, Felipe Jesus Consalvos, Howard Finster, William Hawkins, Frank Jones, the Philadelphia Wireman, and Joseph Yoakum. Lower toward the base were the journeymen: Eugene Von Bruenchenhein, Jon Serl, Jimmy Lee Suddath, Mose Tolliver, and Purvis Young. And then you had the hybrids who defied clear categorization, such as Tony Fitzpatrick, who straddled being an Outsider artist and a contemporary artist. Add that all up and it was relatively little material to satisfy both core collectors committed to the art form and a growing group of contemporary buyers willing to insert the occasional Outsider in their collections.

During the late 1990s, I visited the collectors Cliff and Mandy Einstein in Los Angeles. The Einsteins were known for their edgy taste and willingness to take chances with their acquisitions. While strolling through their home, I found myself thrilled by their Jean-Michel Basquiat, and an entire outdoor room devoted to an ever-changing, light-filled environment conceived by James Turrell. Then I walked upstairs and was

stopped dead in my tracks by a wonderful Bill Traylor, drawn in red and green pencil, depicting a man balancing a fence on his head, with a second figure standing on top of the fence, flanked by two dogs. It was a moment of affirmation that the art world had begun to recognize that it was all about quality, regardless of how it was classified. Though choice pieces were increasingly hard to come by, collectors were now willing to do whatever it took to own the best.

In 2001 Ollman elected to cease participating in the Outsider Art Fair. His withdrawal was met with derision by the other exhibitors. It wasn't so much that the battle had been won in bringing Outsider art into the mainstream from the periphery. There were still remaining hurdles, including the appalling lack of museum shows and the failure of a single university art history department to offer a course in Outsider art. Rather, the art world was entering a more pluralized era and Ollman wanted to focus his efforts toward further raising the profile of the true Outsider artists he greatly valued.

Perhaps the greatest indication of that was Matthew Marks's decision to show the Philadelphia Wireman in 2006. Here was a dealer considered one of the top three in New York, who handled the art gods Jasper Johns, Ellsworth Kelly, and Brice Marden. He now publicly acknowledged the brilliance of the Wireman by including him in the same program. It had been a long journey from the cardboard boxes found near Harry's Occult Shop to the most respected galleries of New York. John Ollman had been vindicated.

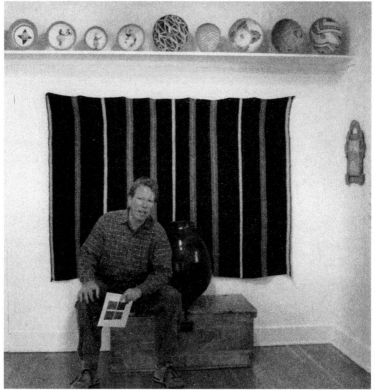

Joshua Baer.

# Chapter Five
## Joshua Baer and Native American Art

I F THERE'S ONE FACET of the art world that bears little correlation to the mainstream, it's Native American art. Not only is it misunderstood by curators, critics, and dealers, but by the very Indian artists themselves. They have never seemed clear about their role. Do you make what inspires you, but garner little respect from the "serious" art world in New York? Or do you pursue what the galleries expect of you, but create work that bears little semblance to your soul? Even when you put forth your best effort, it is condescendingly written off as crafts. But that was all to change in 1988 when Joshua Baer decided to open his own gallery dedicated to treating Indian art with respect.

Joshua Baer, the man most responsible for transforming classic Navajo blankets and Mimbres pictorial pottery from crafts to fine art, can only take partial credit for his vision. The rest of the equation can inadvertently be attributed to the Indian painter Fritz Scholder. The art market's initial embrace of Scholder, and its eventual rejection, would set the stage for Baer to exhibit early Indian art—the much-admired weavings and ceramics. Baer elevated those works into the category of "real" art through his contagious enthusiasm and unfailing commitment.

To understand this nonlinear trajectory, you have to return to the 1970s when Fritz Scholder became the most famous Native

American artist this country had ever produced. His career would come to symbolize everything that was right and wrong with Indian art. During the early years of the decade, the art market window opened just wide enough to allow Scholder to climb through, as he created work which rivaled anything being shown in the elite galleries of Manhattan. Scholder was that talented.

During the 1960s, against the backdrop of Pop Art, there weren't many Native Americans who were hip to what was going on in the New York art scene. If you wanted to make a living as an Indian artist, you were expected to produce turquoise-and-silver squash blossom necklaces for display on a blanket in Santa Fe's town square. Either that or pottery with geometric patterns that passed for authentic tribal designs. There was also an overabundance of Navajo rugs that were factory-made with synthetic dyes, having lost their handmade integrity years ago. As for serious painting, there wasn't any—until Scholder came along.

A member of the Luiseño Mission tribe, Scholder wound up studying art under the realist Wayne Thiebaud at Sacramento State. When he graduated in 1960, he stepped into an art world filled with expectations of what Indian art should look like. If you were Native American and hoped to exhibit at an actual gallery, your canvases had better include a plains landscape, a buffalo or two, perhaps a fierce warrior armed with a bow and arrow, and, better yet, a female member of the tribe who resembled the princess Pocahontas. It wasn't that Native American artists were incapable of producing Abstract Expressionist paintings—Scholder's earliest work was painterly abstractions—or even the nascent Pop Art. It just didn't work that way. When it came to joining the club, membership was restricted. Minorities and women had a hard time breaking in.

During the sixties, Scholder continued to develop, picking up a teaching gig here, an artist's residency there. His breakthrough occurred in 1969, when he visited the Tate Gallery in London and saw the work of Francis Bacon for the first time. As most people know, Bacon turned the figure into a vessel overflowing with pathos. His compositions isolated the figure and his masterful paint handling contorted it, discarding all but the essence of the moment. Here was something Fritz Scholder could use. Rather than inquire into the state of the tormented white man, why not paint the existential isolation of the Indian?

Fueled in part by the release of Dee Brown's book and cultural milestone *Bury My Heart at Wounded Knee*, Scholder loaded up his brush with oil paint and created a narrative of the massacre. He portrayed the raw, twisted bodies of the Indian dead, heaped in an open wagon, as if they were discarded slabs of meat. In the distance, he painted a lone survivor on horseback, who served to bear witness. It produced a chilling and haunting effect. Having processed the work of Bacon, along with the tragedies that befell his people, Scholder was ready to transform the preconceived notion of Native American painting from something quaint to something dynamic and worthy of taking its place inside the circle of contemporary artists.

From there, his art was directed toward making statements about life as a Native American, with a wry nod toward how the white man imposed his culture on him. Basically, Scholder deconstructed the Native American visual stereotype. He painted an Indian with braided hair, a protruding eagle feather, necklace, moccasins, and a ceremonial tomahawk. He wrapped the Indian in a chief's blanket, recalling his proud heritage. Only there was something different about this blanket. There were stars and stripes painted red, white, and blue. And if you looked closely, you'd notice that the Indian was grinning, as if to say, "The joke's on you."

Another favorite Scholder satire was his 1969 portrait *Indian with Beer Can* (owned by Ralph and Ricky Lauren). In what might be the artist's finest painting, he portrayed an Indian sitting at a bar, wearing a snap-button cowboy shirt, sporting a Stetson, while nursing a can of Coors. Native Americans had already been stereotyped as alcoholics and Scholder commented on the bitter paradox of an Indian dressed like the very cowboy who helped put him in this sad position. As a social observer of his people's diminished cultural status, Scholder had scored a bull's-eye.

As Native American activism came out in full force, Fritz Scholder was in the midst of producing some of his best work. From 1969 to 1971, American Indians, including students, occupied Alcatraz Island in San Francisco Bay. Based on a long-forgotten treaty, they claimed the land that once housed the infamous prison belonged to them. They also insisted that Washington fund a Native American Studies Center on the island. While their occupation ended without Washington acquiescing to their demands, they did succeed in calling international attention to the poor treatment of the Native American.

None of this was lost on Fritz Scholder. In 1972, when the landmark exhibition *The Navajo Blanket* opened at the Los Angeles County Museum of Art, Scholder was at the top of his game and receiving plenty of art-world accolades. Tony Berlant's eloquent catalog essay spoke of Indian cultural values— reverence for the land and human dignity—that Scholder tried to instill in his work. By tapping into these ancestral voices, Scholder's paintings also found the strength to convey what it was like to be a sophisticated Native American trying to live in the contemporary white man's world.

Ironically, Scholder's work became popular within the circles of the Southwest community of white collectors. While

there were other Native American artists who rode his coattails, including R. C. Gorman and T. C. Cannon, only Scholder was able to briefly penetrate the serious art world. Thanks to the slick sales approach of Scholder's main dealer, the Elaine Horwich Gallery in Scottsdale, Arizona, his work was purchased by affluent art buyers, intent on adding some local authenticity to their living spaces. By hanging a Scholder, a collector could decorate his home while demonstrating to his guests that he was politically aware.

Despite his legitimate talent, Scholder was conflicted about his personal and public identity. He would vacillate between denying his Indian heritage and being proud of it. Along the same line, he had a difficult time conforming to the rigid categories of artist and Indian artist. It turned out that his ambivalence was deeply rooted in his childhood. As a boy, Scholder's father was ashamed of being an Indian, resulting in a house bereft of any cultural accoutrements—baskets, rugs, or pottery. It was no surprise, then, that as a young student Scholder tried to hide his background and assimilate by painting outside his heritage. Years later, as a teacher at the Institute of American Indian Arts in Santa Fe, Scholder used to tell *his* students that they would never make it if they painted Indian subject matter. He knew how difficult it was for Native American artists to break into the mainstream. He was living proof of it.

Regardless of his uncertainty, Fritz Scholder continued to produce paintings and grew wealthy. His conversion to nouveau riche society was consummated the day he purchased a Rolls-Royce. He even arranged for a black-and-white publicity shot of himself standing next to his gleaming Rolls, holding a sleek Afghan hound on a leash, with a tall, multiarmed saguaro cactus in the background. This was no joke—he needed to remind himself that he had arrived. At the very moment the camera shutter

clicked, Scholder may have finally found inner peace. He had achieved the twin pillars of respect and financial success. Like most of us, he wanted it both ways. And for about a decade he had it. Native American art was on the up and up and was infiltrating the greater art world, which in turn only buoyed his reputation.

But despite the rush of interest in Native American art, once the 1980s rolled around, Fritz Scholder's work began to decline in popularity and he was labeled a "con artist." He went from making paintings that brought a neglected Native American perspective to the serious art scene to creating embarrassing Indian kitsch. Scholder began to produce tacky-looking pictures painted in garish colors — art that greed-driven Southwest dealers demanded and collectors devoured. As the siren call of money sang louder, he branched out into limited-edition prints, posters, and even postcards. Like many artists whose careers eventually fell into the commercial abyss, Scholder lost any ability for self-reflection. It seemed as if his work was destined for the same trash heap as late Salvador Dali and Joan Miró. He was pandering to his audience of collectors. The New York art scene quickly took note and his esteem in those circles declined.

Then, at the end of his career, when his appeal was on the wane along with his health, Scholder embarked on a final series of self-portraits. These paintings were dark, bordering on the demonic, and made you recoil. They were also unsalable. Yet they may have been the first honest things he had painted since *Indian with Beer Can*. The late pictures from 1996 (Scholder died in 2005) were individually labeled with such titles as *Heaven*, *Hell*, and *Purgatory*. Each was a storehouse of cathartic energy that Scholder had accumulated over a lifetime. And each was a powerful signifier of the artist's struggle to master his life.

In one of the catalog essays for Scholder's 2009 posthumous retrospective at the National Museum of American Indian Art in

Washington DC, aptly titled *Fritz Scholder: Indian/Not Indian*, Paul Chaat Smith summed up his career: "He was stubborn to the end, true to himself and his work—and to the confounding paradoxes that framed his life and enriched us."

As an artist who reflected his times, Andy Warhol always seemed to have his finger on the pulse of whatever was au courant in modern life. In 1976 he began a series of portraits of the Indian leader Russell Means. Warhol painted Means wearing his hair in traditional braids, looking stately but very much an Indian. These pictures found Warhol at his most painterly, laying down lavish gooey strokes of pigment that looked like finger painting. Though Warhol was a telepathic appropriator of images, few people gave him enough credit for also being a superb colorist. His palette reflected plenty of earth tones, as if he was creating a subliminal homage to the Native American love of the land and its myriad colors. The portraits of Means, a radical activist, reiterated Warhol's desire to paint controversial leaders like Mao—a series completed only three years earlier in 1973.

Not only did Warhol collect Navajo blankets, he was also a tremendous fan of Hopi kachina dolls, old pawn jewelry, and vintage ledger drawings (sketches made by Native Americans during the pioneer days, so called because they were drawn on sheets from ledger books plundered from settlers after a victorious battle). When it came to Indian material, Warhol was a veritable Jabba the Hut, gobbling up so much stuff that when he died Sotheby's devoted an entire sales catalog to his Native American collection.

The 1970s also found Roy Lichtenstein intrigued by the notion of painting Native Americans. In Lichtenstein's case, he was not interested so much in the idea of what it meant to be an Indian. Instead, he used his trademark primary colors, Benday dots, and

cartoonlike graphics to concentrate on the beauty of Indian designs. His attraction to Native American art forms was based on their clean linear elements and the simplicity of their patterns. He went on to paint a series of abstractions focused on these qualities. In a funny way, this group of paintings was among the least successful of his career. Perhaps the Native American series never quite worked because their art could not be improved upon. It was as if the deeper Lichtenstein dug into their bag of icons and images, the shallower his attempts to further distill them. As for the reason they sold poorly, one critic suggested that collectors weren't comfortable living with such loaded imagery, feeling guilt over the plight of its subject.

Despite the popularity of Native American influence in the work of certain artists and collectors, Joshua Baer's attempt to elevate Native American crafts to equal status with other contemporary art forms wasn't an easy road. In the beginning, Native American craft pieces were viewed as artifacts studied by anthropologists and displayed in natural history museums. Ethnographers were only interested in learning about how these indigenous people lived. The artistic appeal of their crafts was less important than their cultural significance. While there's no doubt that scholars who handled these objects were aware of their visual appeal, no one really thought of them as things you could acquire through an art gallery, let alone hang in your home like a painting.

Enter Joshua Baer.

Joshua Baer was always a great admirer of beauty. What's more, he could detect it in everything he saw. Though everyone likes beautiful things, few really understand the nature of aesthetics and its components: craftsmanship, color, composition, and originality. Taste can be acquired, appreciation can be learned, and a good eye can be honed, but an innate feeling is

something you're born with—as Ivan Karp would so often point out. It's a gift that's no different from Steve Jobs's uncanny instincts for developing high-tech consumer electronics.

The genesis of Baer's development as the arbiter of taste in the Native American art market began when he became a rare coin dealer in 1978. Coin collecting is a conservative hobby. Numismatists are generally men who appreciate history, investments, and the thrill of the hunt. Many are "completists"—accumulating a full set of a particular type of coin brings them a high degree of satisfaction. But aesthetes who are in it for the visual stimulation—after all, coins from the same series all look alike—there were few of that rare breed.

The entrepreneur Bruce McNall, who put ancient coin collecting on the map, was one such aesthete. Joshua Baer was another. Baer specialized in the most striking of all American coins, the twenty-dollar Liberty gold piece, also known in the coin business as the double eagle. These low-relief circular sculptures were a joy to hold, due to their heft, and candy for the eyes with their delicate lines and classic design. Still, unlike paintings, there was a limit to how much pleasure you could derive from a machine-made product—it lacked a soul.

Though Baer did enjoy coins, he dealt them for a livelihood and never lost track of the bottom line. While attending coin shows, he continually marveled at how 10 percent of the vendors did 90 percent of the business. It was all about controlling a market. Describing his dealings, Baer said, "I would visit these shows hoping to catch a few crumbs that fell off the table. The big dealers were so successful that they wouldn't bother with the relatively minor coins. So I was able to pick off the odd deal here and there, concentrating on coins that were really beautiful. I was making a living but not really getting anywhere."

During 1978, while seeking refuge from the daily pressures of scrounging an income, Baer and his wife Eliza began visiting Bluff, Utah. It was in that vicinity that Baer saw his first Navajo rugs and he was instantly struck by their beauty. Later that year, while in Santa Fe, he bought his first group of antique Navajo rugs at a shop called Rare Things. "I saw the landscape of Monument Valley in the weavings. Nothing had prepared me for that."

In 1982 Baer bought his first Navajo blanket from Don Bennett in Agoura Hills, California. As Baer tells the story, he was in Los Angeles to attend the Long Beach Coin Show and on assignment to do an interview for *Musician* magazine. When his interviewee postponed the meeting, Baer drove down Wilshire Boulevard, looking for a place to have lunch and kill time. Along the way, he spotted a store that had kachinas and contemporary Navajo rugs in its display window.

"I parked and went in, and asked the owners if they knew of any place in Los Angeles where you could buy *old* Navajo blankets. They gave me Don Bennett's number. I called him from a pay phone. Don said he had old blankets for sale but Agoura Hills was an hour from Wilshire Boulevard, and did I really want to drive all that way just to look at blankets? I said that I would be happy to drive all that way, as long as he had blankets. At that point, Don said, 'Well, I don't know you. I can't just have you come to the house.' So we agreed to meet at the post office in Agoura Hills. I got there in forty-five minutes. Don arrived ten minutes later, in a dark red Porsche 924. We shook hands, Don popped the hatchback, and there were two stacks of folded blankets, maybe ten blankets to each stack. The first blanket Don showed me was a Navajo manta with arrow pictorials. It is one of the best blankets I've ever seen. I bought three blankets from Don that afternoon, then we went over to his house and

he showed me his collection. We became good friends. That was some of the best beginner's luck I have ever experienced."

As Baer's interest in Navajo art grew, it led him to pursue the great chiefs' blankets. While they weren't specifically made for tribal leaders, at $150 (in 1880) a chief was the only person who could afford to buy one. Besides keeping their owner warm, they also served as calling cards. If you spotted an approaching rider in the distance who was wearing a chief's blanket, you knew he was someone to reckon with. These blankets made a personal statement. Baer was fascinated not only by the magnificence of these works but by the stories behind them.

Baer also pioneered collecting and dealing in an art form that really had no market at the time: the double saddle blanket. Traders would describe how a double saddle blanket was made to slide between the saddle and the horse. But it didn't just create comfort for the horse and rider, it was spiritual. Each double saddle blanket woven for a Navajo man was considered a "journey." The blanket was intended to leave on horseback, blessed with a prayer that it would always return. To ensure their return, Navajo women wove feathers, a few strands of their own hair, and threads from their husbands' clothing into the center of the blankets.

Joshua Baer grew confident in his knowledge of blankets. Sensing an opportunity, he decided to learn more and interviewed for a job at Santa Fe's Morning Star Gallery. As he looked around, Baer had a revelation. The gallery had quality inventory but wasn't presenting it properly. They overhung their space with choice blankets and bowls, rather than display them with lots of space around each piece so it could breath. Gallerygoers had trouble focusing on the sublime beauty of an individual object, which could only be discovered through careful focus. He decided to go for broke and speak his mind. Baer boldly told the owner that his approach was all wrong,

exclaiming, "Rather than treat this material like you're dealing in the American Indian market, why not treat it like you're dealing in the *art market*?"

He was hired and immediately got to work burnishing Morning Star's image by revamping its magazine advertising and re-installing the gallery's collection. Baer took his cue from the contemporary art world, where galleries hung work minimally and designed their magazine advertisements with eye-catching simplicity. He then spent the next two years "learning the Santa Fe retail trade." While doing so, Baer soon concluded that there were plenty of choice blankets available that could be stockpiled inexpensively. He coupled this conclusion with the belief that if you treated Indian blankets with the same respect afforded the work of Jasper Johns and Robert Rauschenberg, you could make a market and control it. That realization gave him the courage to go out on his own.

His decision to open a gallery in downtown Santa Fe, in 1988, was based on a romantic notion of art, which he believed would lead to economic success. Part of art dealing is storytelling. In the coin business he would have been hard pressed to come up with a few lively anecdotes about the history of certain coins. But the possibilities for stories about blankets, produced by the labors of Native Americans, were beyond ripe because the underpinning of their creation was almost mystical. Baer, who was a first-rate raconteur and a talented writer, quickly realized that the key to creating this market was to evolve a rigorous foundation based on historical fact, but with just the right dash of human drama. Not only would he exhibit what he believed to be important works of art, but he would ground them in the lore of how the West was won.

Telling a potential buyer that the blanket he now held in his hands may have been originally traded for a hundred buffalo

hides or twenty horses was downright evocative. Since the Na-
vajos chanted and sang while they wove, he claimed you could
run your hand across the stripes and feel the repetition and the
rhythm that flowed through those women into the blankets they
produced. Try doing that with a striped painting by the contem-
porary artist Kenneth Noland. Each blanket had an energy that
sprang to life when hung on a wall.

Even the wooden weaving combs that Navajo women used
to construct their textiles were pregnant with spirituality. Each
comb was under a foot long, and though it was utilitarian, its
shape often suggested a bird in flight or a landscape. I was told
Baer used to insist a potential collector feel the sensuous, smooth
surface, explaining how the combs also smelled like "wool, dirt,
and rain."

Perhaps Baer's greatest tale was reserved for discussing the in-
credible odds Native Americans overcame just to maintain their
very existence. Somehow, through all of this turmoil, including
being forcibly uprooted from their land, they managed to keep
their weaving tradition alive. He would explain to a client how
you could trace the history of the Navajo chief's blanket all the
way back to the 1840s. During the first phase, chiefs' blankets
were simplicity personified. They were decorated with stripes
that ran horizontally, from one edge of the blanket to the other.
Colors were kept to a minimum, perhaps alternating bands of
indigo and brown, depending on which vegetal dyes were avail-
able. Over the decades, the chief's blanket went through sec-
ond and third phases, each becoming slightly more complex in
design than the last. The Navajos continued to make blankets
for personal use but also came to recognize their considerable
value as trade items. During the second half of the nineteenth
century, despite being stuck on the reservation, Navajos used
blankets to "enhance the material value of their culture. They

accumulated vast herds of sheep and were known colloquially in the Southwest as 'the Lords of the Earth.'"

Anglos not only began acquiring these blankets but inadvertently influenced their design. Around 1860, with increasing contact between settlers and Navajos, the Indians noticed that they preferred more intricate designs. Settlers would pay more for these blankets, equating complexity with quality. Before long, the Navajos began incorporating crosses, triangles, and diamonds. Within ten years the majority of the buyers for blankets were white. By 1885, the Navajos upped the ante again, weaving blankets and serapes called eye-dazzlers, which resembled kaleidoscopic patchwork quilts.

While the eye-dazzlers appealed to many buyers, with hindsight they signaled the decline of the Navajo blanket. Trying to please buyers may have been good for the weavers' bank accounts, but the art itself never approached the simple beauty of the classic chiefs' blankets. As line gave way to pattern, the Navajo's unique contribution to art and design began to slip away.

The taste of settlers continued to change. Their expansion westward meant thousands of new homes and ranches were being built, each needing something to cover its wooden floors. The Navajo people, who were nothing if not adaptable, stepped in to meet this demand by creating "blankets for the floor." Thus, the Navajo rug became more famous during the twentieth century than the Navajo blanket had been during the nineteenth. Most of the great Navajo rugs were produced between 1900 and 1920. These rugs boasted more elaborate patterns, thanks to the influence of their Oriental "cousins," which were shown to weavers by Anglo traders. As the rugs gained in popularity, the blankets were becoming a distant memory, and the earliest examples were actually starting to trade as antiques.

With the coming of the Santa Fe railroad during the 1880s, and the creation of new attractions like Grand Canyon National Park, Fred Harvey Company gift shops sprang up to accommodate vacationing tourists. Native American arts became so popular that each store hosted its own specialized Indian Department, stocked with rugs acquired by a knowledgeable buyer. There was also an amazing assortment of increasingly popular silver-and-turquoise jewelry. Both Fred Harvey and neighboring trading posts handled the now scarce blankets, selling them at increasing premiums. Word of their beauty reached consummate collectors like William Randolph Hearst, who was smitten and went on to amass the greatest collection of blankets privately held—over two hundred, including thirty-nine chiefs' blankets, which were significant works.

Most of Hearst's blankets were purchased through Herman Schweizer of the Fred Harvey Company. At one point, Hearst became aware that the company was accumulating a private stash of superior blankets, which it planned to speculate on at a future date. As a man used to getting his own way, he sent the following slightly ominous wire to the Fred Harvey Company's manager: "I will bet you two huge Mexican dollars that you haven't shown me your real treasures. Out with them now Mr. Schweitzer [sic] or I shall feel that I am not being treated fairly."

As part of his sales presentation, Baer could point to Hearst as a precedent for great American collectors who had acquired Indian art. He could spin a story of history and allure, but Baer's greatest insight was how he intuitively grasped that no one would pay $100,000 for a blanket that was folded and thrown at the foot of a bed, or in most cases placed in storage inside a cedar box. Baer's "flashing lightbulb" revelation was to design his contemporary art gallery to display blankets like paintings

and ceramic bowls like sculpture. Native American arts would never again be seen as mere crafts—they were now fine art.

The history of the art business is filled with similar inspired moments. What was different in Baer's case was that his interest went beyond working with something that was just potentially lucrative. Instead, he became more of an evangelist for the art form. At its purest, art dealing involves exhibiting something that you believe in, to the point where you become obsessed with spreading the gospel. A farsighted dealer educates his collectors, recommending books, museum shows, and sometimes travel destinations, all tailored to expand a client's knowledge. The key is to bring out the buyer's passion and get him hooked. Those dealers who have a talent for "transference" find that collectors seek *them* out.

In 1984, while en route to see Walter De Maria's Earthwork the *Lightning Field*, I stopped in tiny Pie Town, New Mexico, and met an older rancher. He regaled me with stories about all of the amazing Indian pottery found on his property. We continued talking, and the next thing I knew he invited me to see his spread. While walking the land, I began to notice how the ground was littered with pottery shards, as if they were bits of ceramic dandruff. As I examined an ancient fragment, I grew curious about its creation. *Who made this? What was on his mind? What was his life like?*

The rancher explained that these fragments were from Native American Mimbres pots that were around one thousand years old, named after the people who had lived along the Mimbres River in southwestern New Mexico. Most light gray pieces averaged an inch by two inches and had a few black lines painted on them. Occasionally you could make out a representational form. I handed the rancher one that depicted something faintly

recognizable. He remarked, "Yeah, that's from the center of a pot. You know, when they buried someone they put a bowl over the head and knocked the middle out to let the soul escape." Sensing how thrilled I was by the pottery, he kindly encouraged me to keep whatever I found on the surface as long as I didn't disturb the ground. After I had picked up approximately 150 shards in little more than an hour, he glanced up at the rapidly darkening sky and yelled out, "Better get going, a storm's coming!"

Safely back in my motel room, I looked over a booklet on the Mimbres culture written by Tony Berlant, a Los Angeles artist who was one of the first collectors of the region's art. I came away thinking about the Mimbres as sophisticated painters. During the acme of their civilization (1000–1130), they produced illustrated bowls that rivaled the artistic achievement of the ancient Egyptians. Mimbres bowls were most likely produced by the female members of the tribe. Berlant speculated that since a number of them were found with depictions of women making pottery, these women might have been America's first great artists. As for the pottery itself, in a few simple lines it portrayed everything from turtles, dragonflies, and lizards to priests sporting antlers and priestesses holding parrots. Obviously, some of these bowls were of a ceremonial nature. Berlant wrote that "their highly complex geometric designs and arresting naturalistic images illuminate those qualities of human experience which are universal." In short, they were a collector's delight and an art dealer's dream.

Baer's philosophy on collecting Native American art had a practical regional underpinning. "If you collect Navajo blankets, go to the Four Corners. If you collect historic pottery, visit the Pueblos. By making the pilgrimage to the place where the art was made, you will renew the connection between the earth, the art, and the people who made it." So in 1989 I visited Joshua

Baer & Company in Santa Fe. My trip to Pie Town had inspired me to look into acquiring a complete Mimbres bowl.

I entered the upstairs gallery and found Josh standing near his desk, fiddling with a pair of vintage brass knuckles. He was tall, perhaps six-two, and looked like someone who enjoyed food. With his sandy-blond hair, ruddy cheeks, warm smile, and Western attire, he resembled a rancher rather than an art dealer—which I suppose was the point.

While we got acquainted, I couldn't take my eyes off the "knucks," as he referred to them. Then Baer did something unexpected: he deposited them on a custom-made black metal base. They went from being a crude weapon to a piece of sculpture. They took on all the characteristics of a successful work of three-dimensional art: beautiful curvilinear lines offset by fine organic shapes and handsome negative spaces. A fresh context had been created.

My eyes did a lap around the room, and I looked on with wonder at the display of Navajo chiefs' blankets from the 1880s, installed as if they were blue-chip works of contemporary art from the 1980s. They facilitated connections between abstract painting—think early Frank Stella—and Native American art. Baer's efforts to bridge the gap between art forms gave permission to the likes of Stella, Andy Warhol, Jasper Johns, and Donald Judd to collect these weavings. It also made them accessible to the likes of general art collectors.

We got to know each other that day. I even ended up buying a Mimbres bowl. Though I couldn't afford one with a pictorial, I was still thrilled to buy a piece with elegant concentric lines that circled its rim. I left Baer's gallery declaring, "If the art market continues to boom, I'd be interested in buying a few more things." Alas, the art market crashed less than a year later, and Baer and I lost touch.

During the spring of 2009, exactly twenty years later, I returned to Santa Fe. I thought about Baer, curious what had become of him. I had heard a rumor that he was out of business. Something about getting into trouble with the law. Regardless, I looked him up. Even after two decades he remembered me well, insisting that I come to his home for dinner. Over surprisingly good rosé champagne, Baer explained how he had been the "target of a government sting operation," and how the fallout led to the closing of his retail gallery. The laws determining who could own early Native American art and artifacts had grown onerous and complex.

In 1990 Washington had passed a law referred to as NAGPRA, which stands for the Native American Graves Protection and Repatriation Act. It "provides for protection of Native American cultural items, human remains, and associated funerary objects." The law basically leaves it up to the Indians to determine what happens to their sacred items, whether in a museum or a private art gallery. In practical terms it meant that a Native American can walk into a gallery like Baer's, see a bullroarer displayed as a work of art, and demand that it be turned over to the tribe.

A bullroarer is shaped like a knife, and makes a humming noise when swung through the air. It's used by a medicine man to slice an opening into the sky, allowing him to enter the spiritual world. But the kicker is that Indian children often play with them as toys, amusing themselves by creating sounds. It calls into question both the sacred nature of a bullroarer and who should be allowed to own one. The NAGPRA statute defines as sacred "specific ceremonial objects used in religious activities"—language open to interpretation. With NAGPRA on the books, it became virtually impossible for galleries to deal in Mimbres bowls, kachina dolls, or other Native American

ceremonial objects. Currently, the only art forms safe to deal are Navajo blankets and rugs. For that reason, Joshua Baer will probably remain the last major dealer to run a commercial gallery devoted to a full range of Native American art.

Despite losing his space, Baer had absorbed its teachings. When you are prescient enough to discover and promote a new art form, the life lessons learned along the way are applicable to everything. In 2003 Joshua Baer reinvented himself as a wine expert and began writing a column called "One Bottle," which appeared on a monthly basis in the Santa Fe arts publication *The Magazine*. Though he still does appraisals of Native American art and participates in the occasional Navajo blanket deal, he seems to have found fulfillment as a writer. He talks about wine using expressions that are as applicable to describing a wonderful pinot noir as they are to a first-phase chief's blanket. He's doing for the wine market what he once did so spectacularly well for the Native American art market—getting his audience emotionally involved by seeing the possibilities beyond the obvious.

During the 1990s, Adrian Saxe, an esteemed ceramicist and professor at UCLA's graduate art program, had a promising student who refused to push himself to go beyond the obvious with his art. Diego Romero, a Cochiti Pueblo Indian, was a potter with remarkable skills and a lot of upside as an artist. Apparently his professor didn't feel it was a viable skill set capable of breaking into the art market. Saxe claimed Indian pottery was only a craft. He didn't care for "Santa Fe" art. But the real problem was that Saxe thought Romero was intellectually lazy and not seeing the greater artistic picture beyond. According to Romero, his teaching philosophy was that if it didn't have an intellectual bedrock, it wasn't art.

Romero grew up in a middle-class Berkeley home in a mixed-race family. His mother was white, his father was Indian, and both were well educated. Once he moved to Santa Fe he had trouble moving beyond being an all-American kid. It was only after spending time at the tribal pueblo in New Mexico and learning his people's ways that he found acceptance in that community. It was there that he connected to his heritage and the artistic legacy of his ancestors.

In his graduate program, Romero was making pottery covered in traditional Anasazi designs. Asked by Saxe to dig a little deeper, Romero responded by switching to gold paint to glaze his pots—something no self-respecting Indian ceramicist had ever done. Adrian Saxe was still not impressed. Applying gold paint was merely a cosmetic makeover. Saxe then told Romero that unless he took more serious risks with his art, he could forget about seeing his master's degree.

Freshly motivated, Romero hit on a format derived from ancient Indian art, with a twist. He decided to paint his bowls in the Mimbres style, but with imagery that incorporated the daily Native American contemporary reality. Each piece had an outer geometric border and a central pictorial, maintaining its fidelity to Mimbres design. As the artist explained, "Most pueblo pottery, the historic stuff and even the contemporary work, addressed a dialogue with fertility, rain, growth, and animals associated with that, whereas my dialogue centers around postindustrialization, the commodification of Indian land, water, alcoholism . . ." Romero had found his signature style—blending social awareness with humor and ultimately a great respect for his ancestry.

A black-and-white bowl called *Mimbres Golfers* typified his mature work. Rather than a traditional Mimbres image of a hare, Romero drew three stylized Indian golfers, trying to play a white man's game while dressed in Native American garb. One

is teeing off, another is putting, and a third is hanging out with a bag of clubs at his side—all three look hopelessly out of character. A dark cloud hovers overhead: a metaphor for the foolishness they are engaged in. As Diego Romero himself told me, "I like to chronicle the absurdity of human nature and there's nothing more absurd than Indians playing golf."

Not only did Romero mine the distant past for iconography, he also exhibited some savvy for dredging up contemporary icons. In 1996 he painted a bowl called *Girl Waiting*. Using a bit of red slip for color, Romero paid homage to *Blonde Waiting*, a famous 1964 Roy Lichtenstein painting of a blond woman lying in bed, her eyes firmly fixed on an alarm clock. Only in Romero's version, the woman is a far cry from the idealized blonde. Instead, her dark hair and facial features clearly indicate her Native American heritage. Romero's bowl also provided an interesting parallel twist to the time Lichtenstein incorporated Native American symbols in his paintings.

Romero described the story behind the piece: "The girl I drew in the bowl was my girlfriend and the piece is about her frustration waiting for me to call. I didn't have a phone at the time (there were no cell phones then), so when I wanted to get in touch with her I'd have to find a pay phone. One day, right after she yelled at me and said, 'I'm sick of waiting for your calls!' I began thumbing through a book on Pop Art and came upon Lichtenstein's painting." While the relationship with the woman didn't last, the bowl became one of the artist's finest examples of bridging the gap between Native American art and contemporary art—Pop Art meets Mimbres.

As a young man, Romero was highly influenced by comics. Perhaps the imagery Diego Romero is most recognized for is a pair of fictional cartoon characters he invented called the Chongo Brothers (a Chongo is a male Indian who wears his hair

in a traditional bun). His drawings of the Chongo Brothers were an attempt to create three-dimensional comic book pages—one bowl at a time. Each illustrated bowl finds the boys in an unlikely situation. Romero might portray the Chongos out in the desert, drinking over the bones of their ancestors, which, as he puts it, "is where they belong, not in a museum." One bowl depicts the brothers running a casino. Still another finds the twosome in orbit, wearing Navajo-style space suits, physically and psychologically isolated—in this case: R. Crumb meets Mimbres.

By 2010 Romero had broken through the contemporary art world to show at the James Kelly Gallery, one of Santa Fe's most prestigious programs. Seen in this fresh context of significant artists who had shown at the gallery and also called New Mexico home, such as Bruce Nauman, Agnes Martin, and Susan Rothenberg, Romero became taken more seriously. His work began to sell to more important collectors, bringing higher prices. Romero also began to take more risks with his ceramics, increasingly commenting on changes he's witnessed in the local Indian community while staying true to his pottery's roots. A bowl in his James Kelly show featured Wonder Woman painted as a Native American—a metaphor for the strength Romero now saw in his people. And his own work.

When I had dinner with Joshua Baer in Santa Fe a couple of years ago, he told me he was a big Diego Romero fan. It was poignant, since Baer had contributed to the foundation for Romero's success by giving his work historical grounding through showing actual Mimbres bowls in a gallery rather than a museum setting. Still, for all Baer did for both Romero and Native American art, it made you realize that despite Fritz Scholder's brief flirtation with acceptance from the contemporary art world, its future was linked more to "crafts"—not painting.

Though the best of Indian crafts are now accepted as fine art, Indian painting generally isn't. If you look at the paintings of most Native American artists, the content of their work has different concerns from those of their contemporary artist counterparts. The reason Indian artists don't show at contemporary art galleries is no different from why Western artists don't show cowboy pictures at the same spaces—you have to fit into a particular image, their image. Besides, the contemporary art world isn't exactly scouring the Indian reservations for talent. Conversely, most Indian artists aren't looking to New York for validation. It appears that both sides are satisfied with the status quo.

Since the demise of Joshua Baer & Company, no other dealer has taken the baton and opened a space devoted to great Indian art, regardless of period or form—whether craft or painting. Baer was able to elevate Native American crafts to the point where they became popular with collectors, because he believed in them as true art. The potential had always been there, and he reconfigured the gallery landscape to accommodate that work in a way that needed to be seen by those in the art business. Through that filter, Native American crafts as art were embraced. Like Fritz Scholder's career as an artist, Baer's benchmark as a dealer has not been surpassed.

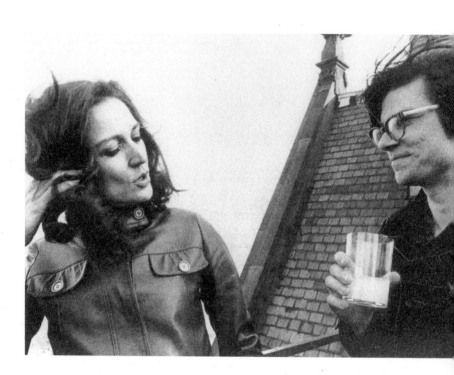

Virginia Dwan with Robert Smithson.

## Chapter Six
### Virginia Dwan and Earthworks

L ONG RETIRED as a dealer and living in New York, Virginia Dwan's years as a public figure are in the distant past. Given the art world's out of sight, out of mind mentality, Dwan has largely been forgotten. She's rarely mentioned in the same sentence as the other major art dealers from the sixties— Leo Castelli, Ivan Karp, Irving Blum, or even Richard Bellamy and his short-lived Green Gallery. Not that Dwan has sought the limelight. She's always made herself scarce for interviews, preferring to deflect attention to the artists she once represented.

Dwan's life is best examined through the stories of her artists, although some most closely associated with her are equally difficult to track down. Walter De Maria has hidden from the media since the 1970s, Michael Heizer is a bit of a recluse himself and hard to contact due to his far-flung travels, and Robert Smithson died back in 1973. The bottom line is if you want to learn about Virginia Dwan's remarkable influence on the period's art, you need to do a little legwork.

Regardless of Dwan's low profile, her unique role as a "visionary patron" is incalculable. As Dwan once said, "There are only a few people who are ready when the moment arrives and the work is there. They can see; they are able to see at that moment, and to trust their seeing, too." During her heyday from

roughly 1966 to 1972, she provided financial "trust" for Heizer and Smithson to acquire the land they needed to sculpt their Earthworks, along with enabling De Maria to create a miniature *Lightning Field* test site. Her enlightened efforts allowed them to realize the unprecedented concept of using the land itself as the main component of their art. Had Dwan not come along at the right time, we may never have experienced the majesty of Heizer's *Double Negative*, Smithson's *Spiral Jetty*, and De Maria's *Lightning Field*.

Without Dwan's support, both financial and creative, visual art might never have moved out of the gallery and into the natural world. The so-called Earthwork artists, who developed out of Minimalism, rebelled against displaying paintings on pristine white walls. Instead, they shifted their art to the great outdoors, incorporating the very sky, earth, and water. For them, art wasn't something that could be bought and sold as a commodity. Rather, it was something no one could truly own but all could experience. In that respect, their art was more spiritually aligned with classic Native American art than with that of their contemporary colleagues.

But not everyone was willing to acknowledge the significance of Dwan and the art she inspired. With Pop Art calling the shots throughout the sixties and beyond, most of the art world was unaware of the revolutionary discourse taking place in the desert. Even the few who were in the know, like Ivan Karp, offered a contrasting view of the Earthwork phenomenon: "It was not a consequential development. Their art was a legitimate pursuit, but they created something nobody saw—unless maybe you were a hiker. You couldn't experience aesthetic joy without traveling two thousand miles."

Karp joked that his strongest memory of Dwan was that she was the tallest female art dealer. There was little outside of her

work to reference. What *is* known about Virginia Dwan stems largely from a 2003 interview conducted by Michael Kimmelman in *The New Yorker*. As one of eighteen heirs to the 3M company fortune, she was able to open her first gallery in the Westwood section of Los Angeles in 1959. The great wonder was how she was able to show the likes of Robert Rauschenberg, Yves Klein, Ad Reinhardt, Franz Kline, Philip Guston, and Joan Mitchell—artists carefully guarded by their New York dealers. Her gallery prospered over the following three years and in 1962 she hired John Weber as an assistant, who proved to be a perfect fit. Weber became her partner in crime, sharing her aesthetic and eventually running the gallery when Dwan moved to New York in 1965 to open an East Coast outpost.

A few years later, with the New York gallery firmly established, Weber shut down the Los Angeles gallery and joined Dwan at her Fifty-seventh Street space. As the pioneering SoHo dealer Paula Cooper, who in the future would exhibit some of Dwan's artists, observed, "Her program changed a great deal. It became more cohesive—the philosophical ideas became clearer. She began showing Sol LeWitt, Carl Andre, and Robert Smithson. Dwan's new space was also a very good place to look at art. It was tranquil; you could concentrate on the work."

Typical of how the art world makes connections, she put together a stable of artists via those she already exhibited. According to Kimmelman, "Through Sol LeWitt she met Carl Andre and Robert Smithson. Through Reinhardt she met Agnes Martin." All were already well established, with Reinhardt's career dating back to the days of Abstract Expressionism. Before long these artists were joined by such greats as Robert Ryman, Dan Flavin, and Walter De Maria—an enviable roster by any standard.

The artists Dwan showed were first-rate but there was no market for Minimalism, let alone Earthworks. During the sixties,

a gallery was considered a winner if it managed to stay afloat. Dwan's gallery ran on messianic belief and her own largess. At the time, Leo Castelli was the only dealer with salable inventory. But even he could only count on Johns, Lichtenstein, and Stella for meaningful cash flow. Cy Twombly was considered incomprehensible and unsalable. Warhol was no slam-dunk. Rauschenberg wasn't exactly an easy sale. But at least these artists made paintings. It doesn't take much of an imagination to understand why the public held on to its collective wallet when they saw a Dan Flavin show at Dwan, whose fluorescent light fixtures looked like something you could buy at the corner hardware store! Still, Flavin worked with objects that could be sold as finished pieces. The Earthwork artists, whom Dwan put all her faith in, had little to offer for sale beyond their inexpensive studies on paper and photo documentation. Their work was carved out of and into the land, defying exhibition in the conventional sense.

Dwan was never a true art dealer in the tradition that a gallery is a business and a business should make a profit. Dwan admits to losing money from beginning to end. "I didn't like collectors much. I hated selling, although I knew it was important. The moment someone asked for a discount, I thought: 'You're getting this for $800. You've got to be kidding.' Unfortunately, the I.R.S. doesn't let you lose money endlessly. They can start considering the business a hobby."

In 1971, after six years in New York, the Dwan Gallery completed its memorable run. Though Castelli was certainly higher profile, and Marlborough and Sidney Janis were more prestigious, Dwan's roster of artists would be judged by history to be nearly as formidable. As Paula Cooper put it, "Just before she closed, it was almost the perfect gallery."

When it came to her public art-world persona, Dwan stymied any attempt to categorize her. She refused to compare herself

to Betty Parsons and Martha Jackson, the other important female dealers of her era. She claimed she wasn't antifeminist, even though she exclusively showed male artists. About the only thing she didn't deny was the collaborative nature of her relationship with them.

By the time Dwan relocated her gallery to Manhattan, only scant progress had been made in gender equality in the art world. There were just a handful of important women artists around, even if she wanted to include them in her stable. At the time, the top female artists were Joan Mitchell, Louise Bourgeois, Alice Neel, Louise Nevelson, Lee Bonetcou, and Agnes Martin. Georgia O'Keeffe was in a category all her own. Whether you were a woman who wanted to make art or promote it, your commitment had to be unflinching. When Dwan got her start, the prevailing attitude in the art world wasn't that far removed from a scene that takes place early in the movie *Pollock*. When Jackson Pollock visits Lee Krasner's studio for the first time, he looks over her work and comments, "You're a good *woman* artist." By art-world standards of the 1950s, Pollock was actually paying her a compliment.

But running a first-rate gallery, regardless of whom you represented, is one thing, encouraging your artists with unwavering commitment is another. From the Medicis' support of Renaissance painters to Peggy Guggenheim commissioning work and providing a monthly stipend for Jackson Pollock, patronage has at times been a crucial component in the creation of art. What made Dwan different was that she didn't just provide money; she participated in the fabrication process by visiting the site, providing feedback on materials, or simply being available when the artists needed to discuss their ideas with a kindred spirit. She believed in their visions at a juncture in art history where if she hadn't, the land artists might have

resigned themselves to making traditional art, exhibited within the confines of a gallery.

In 1993 word spread quickly that Robert Smithson's *Spiral Jetty* had reemerged. After being visible for only two years over the last two decades, the 1,500-foot-long coil of black basalt, which extended from the shoreline of Utah's Great Salt Lake, was above water again—but for how long? Constructed in 1970, the *Spiral Jetty* became Smithson's legacy, quickly achieving iconic status. But because of a miscalculation by the artist (the area was experiencing a drought during the work's fabrication), his piece had been submerged by the rising lake. Though Smithson's philosophy acknowledged the process of entropy, and how an Earthwork deteriorates over time, this clearly wasn't what he had in mind.

When Smithson first conceived of the project two years earlier, Virginia Dwan had agreed to fund the work to the tune of $6,000. What's more, she didn't see the *Spiral Jetty* until it was completed. Dwan said, "That was part of my faith in the artist: they'd sort of wave good-bye and take off and I just assumed that something worthwhile would come out of it; and did."

Even with money in hand, Smithson had a hard time finding a construction company willing and able to do the job. Creating a sculpture from bulldozed rocks was an alien concept within the art world, let alone the real world. He finally convinced the Utah-based Great Salt Lake Minerals to tackle what would turn out to be a six-day undertaking.

Although the owner of the company had agreed to the deal, he thought Smithson had rocks in his head. Fortunately, the project manager liked Smithson, but he still demanded the fee up front just to cover himself. When Smithson surprised him by producing a check, the project manager ran it by their

accountant, who was skeptical it would clear and reluctant to accept it. He also felt the job was too risky: the equipment might get stuck in the mud, the salt from the lake could corrode the machinery and actually cost them money in the long run. But the project manager had given his word and insisted they do the job.

Once things got under way, the construction went smoothly. The real issue became the spirit behind the piece. By the end of the first day, when everyone was exhausted and itching to go home, Smithson stood there surveying the work's progress. Apparently his moment of contemplation lasted a bit too long for the foreman, who mockingly called out in the hip jargon of the day, "It turns me on, it turns me on. Now turn me off, so we can go home." Smithson was not amused. He went to great lengths to convince the workers that they weren't just dumping a bunch of rocks in the water—they were making art. Once they saw how serious he took his work, their attitude improved, and they actually got into it.

Not long after Smithson completed the sculpture, the Great Salt Lake began to rise and the *Spiral Jetty* was soon submerged. It wasn't until 1993 that the *Jetty* mysteriously reappeared. In some ways, it never looked better. Because of the water's high concentration of salt, white crystals had formed on the volcanic rocks, causing them to glisten on a sunny day. During summer months, the algae-infused water sometimes turned a surreal tomato-soup red and corralled itself within the spiral. The stark simplicity of the jetty's sparkling line, and the unexpected combination of red and blue water, made for one of those rare sublime art experiences.

Not knowing how long the piece would remain visible, I immediately planned a pilgrimage. Visiting the *Spiral Jetty* required some effort. The essence of an Earthwork is its isolation;

they are intentionally located in remote spots. Since the trek to see each work is part of the art itself, your travel plans take on added gravity. You don't just casually hop in the car, spot a green metal sign on the freeway revealing its location, turn off, and there you are. By the time you finally discover the *Spiral Jetty*, your search begins anew for a pilot with a Cessna who's willing to fly you over it. Somehow, I managed to find one.

From the aerial view, the jetty revealed the full scope of its beauty, calling to mind the elegant cross-section of a chambered nautilus shell. The bands of water, in between the curvilinear lines of earth, were a shimmering terra cotta. My psyche felt eons away from the traditional gallery experience. Once on the ground, the *Spiral Jetty* made an equally strong impression on me. Earthworks have an overwhelming physicality that can only be felt when communing with the work itself. As I stood at the head of its coiling path, all of my senses came into play. I breathed in the briny air, my eyes flirted with the alternating bands of bright liquid and glittering stone, and my ears filtered the gentle sounds of lapping water. I felt alive.

The *Spiral Jetty* seemed prehistoric. Had Smithson stuck a life-size cast of a stegosaurus on its winding path, it would have looked right it home. The primeval connection was intentional. Smithson's ensuing film, *Spiral Jetty*, which was conceived as an independent work of art rather than a documentary, opened with footage from the Hall of Dinosaurs at the American Museum of Natural History. Interestingly, Virginia Dwan shared a lifelong interest in paleontology, even collecting fossils as a child. As an adult, she often accompanied Smithson to the museum, marveling at its otherworldly dioramas, unsurpassed dinosaurs, and fantastic mineral specimens.

Sharing their love of natural wonders created a soul-felt bond between Smithson and Dwan. Her admiration for his

intelligence was also part of her attraction to him as an artist. She would have accompanied him anywhere—and did. Smithson, along with his wife, the sculptor Nancy Holt, and Dwan, once journeyed to the Yucatán to study the Maya and Toltec ruins and work on a few of Smithson's site-specific pieces. As they were moving through the brush, Smithson and Holt sprinted ahead, while Dwan lagged behind and soon found herself stuck in quicksand. As she yelled out for help, the artist couple was oblivious. Smithson had found a spot to lay out a "mirror displacement" (small mirrors he placed in the landscape to alter the perception of the land) and never looked back for Dwan, expecting her to be right behind them. Somehow, she managed to pull free from the quicksand's viselike grip. In a subsequent interview, a journalist teased Dwan about Smithson. "So he let his dealer sink into quicksand!" She laughed, then turned serious, defending him by plainly stating, "He continued to work because he had to."

An overlooked component in a visionary dealer's support of a great artist is an understanding of what he is trying to accomplish and what compels him to do so. By traveling with Smithson to the Mexican peninsula, Dwan experienced firsthand his intentions to take art down an untraveled road. She wanted to participate and share the adventure in order to fully understand the inspiration and methods behind his work. If it meant a difficult travel experience, so be it. Dwan's support went beyond merely writing a check. Her willingness to get down and dirty had a profound effect on Smithson's confidence. A gallerist's support of an artist can be just as powerful as his art.

Smithson died at the young age of thirty-five, in a plane crash, while surveying a site to build *Amarillo Ramp*. Fortunately, he executed several other notable Earthworks in his short life, including *Asphalt Rundown*. Here Smithson explored the concept

of chance in making art. The artist filled a dump truck with asphalt, then released its sticky black cargo, letting it cascade down a hillside, its pattern of dispersion forming the piece. He also managed to execute *Partially Buried Woodshed*, exploring the connection between the man-made and nature. Smithson took an abandoned woodshed the size of a two-room bungalow, located on the property of Kent State University, and draped twenty truckloads of earth over half of the structure. Like all of Smithson's pieces, part of the work's "adventure" was how time and the elements would affect its appearance and meaning.

Unlike Smithson and his *Spiral Jetty*, the artist Michael Heizer isn't known for a work of singular fame. But if forced to choose Heizer's most important statement, you would prob-ably go with *Double Negative*—his first prominent Earthwork. Between 1969 and 1970, Heizer excavated 240,000 tons of earth and rock in the Nevada desert, cutting a pair of 1,500-foot-long trenches, fifty feet deep and thirty feet wide. In the spirit of tra-ditional sculpture and its insistence on giving equal weight to a work's positive and negative forms, *Double Negative* can be read as two opposing monumental negative spaces.

It was Dwan who green-lighted Heizer's project, providing ap-proximately $30,000 for its construction. Remarkably, it was all done on faith. And once again, Dwan never visited the work until after it was finished. She had originally met Heizer through De Maria, after learning about his initial forays into carving geomet-ric forms into the desert floor. Heizer had even produced "draw-ings" by riding a motorcycle, using its tires like a black Conté crayon to sketch figure eights and the like on the ground. Dwan was intrigued, but mostly she was offended that such an excep-tional artist hadn't personally revealed himself to her.

"I didn't know how it was *possible* that this person was un-known to me, making these works of art, particularly at the age

of twenty-three and twenty-four," she said. "So the following fall, I contracted to have a show of Michael's, and he said, 'I'll make a piece for you, Virginia.' That was as much as I knew. I didn't hear anything for what seemed to be about two months, and then I got a long-distance call that it was basically finished. And 'it' turned out to be the *Double Negative*."

While Heizer and his fellow land art artists were not concerned with producing art for the gallery system, Dwan pointed out that their work could still be acquired. In some cases, you could perhaps own the lease to, say, a Smithson. In other cases— the *Double Negative*, for instance—the Earthworks had always been for sale. At one point there were buyers, but she decided to hold onto it longer. Since Dwan put up the money, which often included purchasing the land, she could control the art's eventual disposition. But that doesn't mean Earthworks were an easy sell. The *Double Negative* never found a buyer and was eventually donated by Dwan to MOCA Los Angeles.

Among Heizer's other successful efforts was a cluster of five sculptures called the *Effigy Tumuli*. At a site eighty-five miles southwest of Chicago on vast acreage once ravaged by a strip mine, Heizer created a series of massive reliefs inspired by ancient Native American burial mounds. These Indian structures were simple raised ovals—not particularly complex. Some variations took on recognizable forms, such as the grass-covered 1,345-foot-long Serpent Mound in southern Ohio, shaped like an undulating snake trying to swallow an egg. In Heizer's case, he created five sculpted mounds based on indigenous creatures: stylized geometric shapes that resemble a catfish, frog, water strider, turtle, and snake. Their affinity to early Native American forms was deliberate. Or as Heizer put it, "These mounds are part of a global, human dialog of art, and I thought it would be worthwhile to reactivate that dialogue."

While Smithson was concerned with entropy, and Heizer permanence, Walter De Maria believed that a "work of art should make an unforgettable impact, comparable to that of a major natural event, such as an earthquake or hurricane," evoking extreme planetary phenomena as an aesthetic yardstick. Holding himself to this lofty standard, he completed the *Lightning Field*, one of the twentieth century's most significant works of art. Viewing the *Lightning Field* is tantamount to gaining an audience with the pope. By my estimate, fewer than five thousand people have experienced it. Located in the southwestern corner of New Mexico, it's composed of four hundred stainless steel poles, each twenty feet tall and two inches in diameter, sharpened at the tip and spread 220 feet apart over a grid measuring one mile by one kilometer. Another way to visualize the work is that it would support a tremendous sheet of glass, the length of over fourteen football fields, if placed on the plane of the poles' tips.

Between 1976 and 1977, De Maria sank his steel poles over an area known to attract a disproportionate number of summer electrical storms. In theory, if a lightning bolt scored a direct hit on the point of a pole, it would jump to neighboring poles, creating a visual spectacle. To my knowledge, only on rare occasions has lightning ever struck a single pole, let alone dance across its sister poles. The art critic Kenneth Baker, who has written the preeminent text on the subject, has made a (possible) record six pilgrimages to view the work and has only witnessed lightning once.

Those odds were just fine with Walter De Maria. He was more concerned with the psychological suggestion that lightning *could* strike. He considers the surrounding light as important as the lightning—it activated the work. Experiencing the *Lightning Field* is a matter of entering the piece and winding your way through the poles. As the day progresses and the sun

understand the piece, you had to witness it during every phase of the day, be it morning light or the evening's glow of the moon. A study once claimed that viewers spend an average of only seven seconds in front of a painting, whether in a gallery or museum. That was unacceptable with a work such as the *Lightning Field*, which was in effect what Earthworks were all about at their most symbolic.

By the early 1970s, the idea of using the very earth as source material for making art was no longer considered radical. The art world began to experience a new development—Environmental art. While the essential materials had changed, the work's dependency on being installed outdoors had not. A key difference was the art's visibility in areas that were readily accessible. No longer was the public expected to "put in the work" by flying or hiking to a distant location. Now, Environmental art was being handed to them on a silver platter.

During the 1960s, the artist Christo provided a philosophical counterpoint to Smithson, Heizer, and De Maria. His art consisted largely of wrapped objects, such as a magazine or a lantern, whose identity was partially obscured by translucent plastic and lots of cord, which were created to be exhibited in galleries. They were his first pieces to gain traction in the art world and catch the eye of collectors. But it wasn't until his breakthrough *Valley Curtain*, Christo's first monumental project in the American landscape, that he was recast as an Environmental artist and on his way to becoming an international name.

In 1972 Christo chose Rifle, Colorado, to erect a 1,250-foot orange fabric curtain across a mountain gap that ran perpendicular to a highway. The frenetic activity to bring the work to fruition involved an amalgam of artists, politicians, and landowners. Stretching from a center height of 365 feet and tapering

to 182 feet at either end, *Valley Curtain* sought to unify not only art and the land, but people as well as they drove underneath intentional gaps in the curtain. *Valley Curtain* offered a visual collaboration between the unfurled orange curtain and the lush green valley, deep blue sky, and distant mountain range. Though *Valley Curtain* was dismantled after only twenty-eight hours, due to sixty-mile-an-hour wind gusts that threatened to wreak havoc on the work and passing traffic, its impact was profound. For a brief moment, a state of perfect harmony between man and nature had been brokered.

Christo's democratic approach, versus the elitist bent of his Earthwork colleagues, was a tale of opposites. Although his art bore close affinities to the Earthwork practitioners, there were clear differences. Christo's work only temporarily altered its outdoor surroundings; the Earthwork artists permanently reconfigured it. His work was about being accessible to as many individuals as possible. For Christo, making art also meant playing art dealer. Or to be more accurate, it meant Jeanne-Claude, his wife and collaborator, playing art dealer. A large part of Jeanne-Claude's role was to find buyers for Christo's collage drawings of a proposed work in order to finance it. They always turned down offers of outside funding in order to exercise complete control over their projects. The key Earthwork artists wanted no part of any elaborate plan to raise money for their work, nor did they care about Christo's commendable desire to attract as large an audience as possible. It wasn't that the Earthwork artists were snobs. It was just that the spirit behind their creations required viewers and patrons to be willing to make the same commitment to their art as they were. Christo and Jeanne-Claude took matters into their own hands and found a way to strike a balance between creating art in nature and selling work in a gallery.

Following the *Valley Curtain*, Christo completed a number of incredibly ambitious projects. Among the more successful were the *Running Fence* (1976), a continuous white-fabric-covered fence that ran for twenty-four miles through rural Marin and Sonoma Counties in California, eventually culminating at the Pacific Ocean; the *Surrounded Islands* (1983), eleven natural islands in Biscayne Bay, Florida, which were encircled in floating fuchsia-colored fabric that resembled giant colorful lily pads; and *The Umbrellas* (1991), hundreds of blue umbrellas that sprouted from the ground in Japan with a large group of corresponding yellow umbrellas scattered in the hills and valleys of Southern California.

Over time, Christo's work became more commercial, culminating in his most recognized project, *The Gates* (2005). Approximately 7,500 saffron-colored vinyl "gates" were deployed along twenty-three miles of pathways in New York's Central Park. For Christo, it was the grand finale of an arduous and lengthy process to realize a project that had been on the drawing board since 1979. Given the politics, environmental studies, and permits required by the most populous and complex city in America, it spoke volumes about Christo's tenacity that he finally pulled it off.

It hadn't been easy. Jeanne-Claude had labored overtime to sell her husband's collages and drawings to accumulate enough money to finance the outdoor installation. Works ranged in price from $30,000 for a small study all the way up to $600,000 for an impressive four-by-eight-footer. Given that the budget for *The Gates* was in the $20 million range, Jeanne-Claude was under a lot of pressure to sell art. In an article that appeared in *New York Magazine*, Jeanne-Claude was interviewed by Adam Sternbergh, who arrived at Christo's studio only to be told by her, "Nobody comes up here unless they're buying!" Sternbergh's

feature referred to Jeanne-Claude as the Yoko Ono of the art world—a characterization she didn't dispute.

Critic David Bourdon recalled Jeanne-Claude's famous dinner parties, thrown to call attention to her husband's projects. "People were contemptuous of them. They were perceived as being very pushy. And then they served these god-awful meals. A lot of unpopularity they met with in the early days was directed against Christo's art; the rest was directed against Jeanne-Claude and her flank steak." But that was behind-the-scenes art-world gossip which ultimately didn't weaken their ambitions or deter their projects.

Beyond the insular art community, Christo's work was appreciated by the people. Tourists and locals alike strolled underneath The Gates, marveling at the sheer novelty of such a project existing in Manhattan, albeit for only two weeks (that's all the City Council would approve). The Gates had their good moments and bad moments. On sun-dappled breezy afternoons, they took on the shimmering quality of a river. On a calm overcast day, the lack of bright light and movement created a sense of inertia—the sculpture became static and dull. But the experience itself was transformative in the sense that such a world-renowned space had been transformed so dramatically overnight. The park was flush with visitors.

Despite public approval, many insiders viewed Christo's art as a sellout. The unrelenting pressure to raise funds in order to fabricate the project, along with the endless squabbles with the local bureaucracy, had begun to overshadow the results. Once the work finally came to fruition, it soon became overwhelmed by commerce. With vendors hawking T-shirts, postcards, and key chains, Christo and Jeanne-Claude's final major project (she died in 2009) became a circus. It was the Disneyfication of the art world.

While many would argue that anything that gets as many people as possible involved with art can only be a good thing, I seriously doubt the Earthwork artists saw it that way. Virginia Dwan, who had a park view and witnessed the piece on a continuous basis, referred to it as "a social statement rather than an art statement." Though she granted that *The Gates* were "good for bringing people together," at the end of the day it served more as a group experience than a work of art. Dwan's comment was no doubt meant to be gracious. But its undercurrent revealed that she saw little correlation between the carnival atmosphere that surrounded *The Gates* and the purity of the early Earthworks.

The successors to those first-generation Earthwork artists were Dennis Oppenheim and, to a greater degree, Andy Goldsworthy. Oppenheim originally struck pay dirt in 1969 with *Cancelled Crop*, an outdoor field planted in neat rows that was cut by a wheat thrasher with two crossing lines, forming a giant X. Many of Oppenheim's other early works focused on using his own body as the medium. Perhaps the best-documented piece is *Reading Position for Second Degree Burn*, where the artist lay down on New York's Jones Beach with an open book called *Tactics* placed horizontally across his chest. After five hours the book was removed, revealing a rectangular patch of white skin against the surrounding redness of his sunburned torso. In his later years, Oppenheim moved on to traditional, if eccentric, outdoor sculpture.

But it was Andy Goldsworthy who built upon the foundation laid down by Smithson and company. Goldsworthy's strategy was to return to nature, using the earth as source material and inspiration. Goldsworthy grew up near Leeds, England. As a teenager he worked on a farm, acquiring an early appreciation

for the natural world. After attending Bradford College of Art, he applied for further study at Preston, where he developed a fondness for working outdoors. In 1976, while walking barefoot along neighboring bays and rivers in Lancashire, he began to take notice of the imprints his feet left in the wet sand. Enchanted, he marveled at their beauty and impermanence. This became the genesis of his work's ephemeral direction.

Central to Goldsworthy's art was its noncollaborative nature; he preferred the solitude that came with working alone. Dwan observed, "he was a good second-generation Earthwork artist who found a vehicle that worked for him." That vehicle was self-reliance. Goldsworthy didn't need to mobilize a vast constituency of politicians, collectors, and installers to make art. Money was never a factor. Nor was finding a gallery space. All Goldsworthy needed to display his creations was a quiet stream or an open field. None of his materials was manufactured. His medium was leaves, snow, ice, slate, sticks, and thorns. It was as if the artist had returned to the rudimentary basics of the prehistoric cave painters, whose canvases were stone walls, whose brushes were twigs, and whose pigment was dug from the earth.

The entire history of painting is based on pigment. Through trial and error, Cro-Magnon man furnished his paint box from his own backyard. The evolution of paint itself was gradual. The ancient Egyptians mixed eggs with ground pigment and created tempera, using it to decorate mummy sarcophagi. By the fifteenth century, Italian Renaissance painters were blending pigment with flaxseed oil, creating a breakthrough known as oil paint. Oil paint remained the medium of choice for centuries. By the late 1800s it became available in tubes, freeing the artist from the time-consuming process of preparing it and offering the convenience of easy transport. With the invention of plastic-based acrylics, in the 1950s, artists now had the option of using

less expensive paint, with quick-drying properties, and an expanded range of colors. Over the lengthy course of time—from the earliest humans to the present—palettes have gone from the organic to the synthetic and from the gathered to the manufactured. Andy Goldsworthy brought the quest for pigment full circle, back to natural materials.

*Rivers and Tides*, the highly regarded documentary on Goldsworthy, treats you firsthand to his process-driven art and his natural inspiration. He walks along a riverbed and occasionally stoops down to pick up a smooth rock. To the naked eye, it might appear to be just another stone. But in Andy Goldsworthy's hands it is a storehouse of red pigment—simple, monochromatic, no mixing with eggs, oil, or polymer. In a scene that harkens back to primitive man, Goldsworthy finds a larger, heavier rock and uses it to hammer the color-laden stone on a large anvillike boulder. After thirty minutes or so, he produces a small pyramid of iron oxide powder.

Once Goldsworthy has enough of the granulate substance, he gathers it up and returns to the river. There he discovers several water-filled natural potholes, sunken into a grayish outcrop of rock. The artist stirs a handful of coarse red powder into one of the holes and soon transforms it into a blood-red liquid. Then he repeats the process in a second water-laden depression. When viewed from above, the two red circles blend seamlessly with the neighboring stream and foliage. An equilibrium has been reached between art and nature. However, unlike his Earthwork brethren, whose art played off the environment, Goldsworthy's work *is* nature, echoing Jackson Pollock's famous quote, "I am nature."

Another scene from *Rivers and Tides* finds the artist gathering a large stack of bamboo-colored reeds, along with a pile of long brown thorns. One by one he joins the hollow sticks together,

using his thumbs to press the thorns into place. Later a six-foot spiderweblike form emerges, with an open circle at its center, and three-quarters of the structure is braced against a large tree for support. As he works on his task, Goldsworthy speaks slowly and deliberately: "I often take a work to the very edge of its collapse—that's a very beautiful balance." As if on cue, he begins to force another thorn through two reeds, causing the whole construction to shudder for a moment—then fall apart. Goldsworthy clutches his forehead for a few seconds, his sense of frustration palpable. Still, while it lasted, the sculpture was thrilling. Unlike the ambitious land art of Heizer, De Maria, and Smithson, which required the use of heavy equipment to realize their visions, Goldsworthy's subtle approach brings an almost naive, hand-made quality to the picture. The fleeting nature of his work is part of its magic.

The original Earthwork artists valued permanence as a means of witnessing the effects of nature on art. De Maria had spare poles fabricated for the *Lightning Field*, as replacements for those damaged or dulled by lightning strikes, which no longer reflected light. Heizer became alarmed at the gradual erosion of the *Double Negative*, and sought ways to shore up its walls, even considering concrete. Smithson understood the *Spiral Jetty* would eventually deteriorate and disappear, and was completely comfortable with the process. But he intended for it to remain visible for enough years to watch it change with the elements. Even Christo's projects—though short-lived—were intended to be witnessed with nature as the backdrop. Goldsworthy's art, however, was a winsome beauty created from nature, while simultaneously about nature.

Today, as the green movement gathers momentum, the art of Smithson, De Maria, Heizer, and Goldsworthy takes on a

greater poignancy. Incorporating the natural world has once again become a viable art-making strategy. Still, in retrospect, of all the art forms to appear since the sixties, Earthwork art took the greatest leap of faith for dealer and collector alike, in both its approach and its defiance of art-world rules.

Dwan intuitively grasped that the art experience could extend way beyond staring at a painting on a wall. She found a small group of artists whose ideas coincided with her expansive view of what art could be. Dwan then performed an unheard-of mitzvah (good deed)—she wrote them checks with no strings attached. While Dwan did run a traditional gallery, in the sense that artwork was exhibited and sold, like De Maria's *Bed of Spikes*, underwriting Earthworks was closest to her heart—and her lasting legacy.

Leo Castelli had already followed Peggy Guggenheim's lead by putting artists on monthly stipends. Freed from the daily constraints of worrying about paying the rent and putting food on the table, his artists were liberated to make the finest work possible (or at least that was the theory). But Castelli expected something in return. The money was always repaid against future sales or given back in the form of paintings. Dwan financed the key Earthwork artists with no expectations of return on investment. As she once told me, "I take art very seriously."

Books continue to be published on the art world of the 1960s and the name Virginia Dwan continues to crop up. Despite her insistence that the dialogue center on the artists, and not her, there's no avoiding her contribution. Her gallery's presence and her own presence within the art world continue to resonate. For Dwan, knowing she helped expand the boundaries of contemporary art is reward enough.

Every time I see lightning, I think of Virginia Dwan.

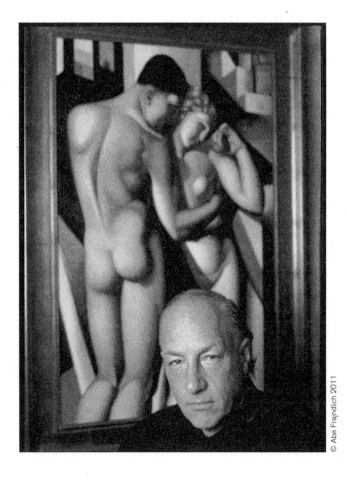

Tod Volpe.

## Chapter Seven
## Tod Volpe and Contemporary Ceramic Sculpture

THE EARTHWORK ARTISTS altered the ground and wound up with newfangled art forms that graced the hippest art magazines and inspired intellectual dialogue. Contemporary ceramic artists dug clay from the ground, reconstituted it, and ended up with art forms as old as civilization that were largely ignored by the art media and failed to trigger any discussion.

The early history of contemporary ceramics is one of disrespect. Works created from fired and glazed clay were classified as a craft—the kiss of death in the art world. It wasn't until the 1970s that contemporary ceramics assumed the form of sculpture and began to garner respect. Ironically, it took the resurrection of a turn-of-the-century art movement for it to happen. That and the emergence of Tod Volpe.

The Arts and Crafts movement can be traced back to the English designer William Morris. During the 1860s, Morris pioneered an enlightened philosophy that good design should be affordable to everyone. His dark oak chairs with their maroon oilcloth pillow seats—known as Morris chairs—were a bit bulky, but handsome and practical. His business was successful, encouraging the American Gustave Stickley to bring the Morris approach to American furniture during the 1900s. Stickley's

designs had a lighter touch, occasionally turning the decorative quality of his furniture up a notch by experimenting with inlays. There was also the Dutch-American Dirk Van Erp, who opened a shop in San Francisco dedicated to crafting elegant hammered copper lamps with translucent mica shades. Given the dark browns and hard edges of Arts and Crafts furniture, a complementary group of objets d'art was needed to provide balance and pull a room together. Art pottery was the perfect solution. Between the late 1890s and 1920, art pottery studios sprang up in the United States, creating bowls and vases in a startling variety of colors and themes. Among the better-known potteries were Rookwood, Newcomb, and Grueby.

Of the three, Cincinnati-based Rookwood, founded in 1880, was the most prolific and financially successful. Though Rookwood is still currently in business, its heyday was in the 1920s, when it employed two hundred people, making it far and away the largest art pottery in America. Their pottery was inexpensive to manufacture because most of it was mass-produced, created from molds, rather than hand-thrown. Interestingly, even a typical production Rookwood vase depicting a few rooks glazed in red would have a surprising amount of color variation—analogous to how Warhol would use the same photo silkscreen, but the appearance of each canvas would vary slightly based on the amount of ink squeegeed across the image. A beautiful Rookwood vase, placed on a Stickley desk alongside a Van Erp lamp, was considered the epitome of good taste during the twenties and thirties.

As for Newcomb Pottery, it originated at Newcomb College, an exclusive women's school in New Orleans that was eventually absorbed by Tulane. In 1895 the art department began instructing students on pottery decoration. Aspiring artisans were taught how to carve, in low relief, the romantic Southern imagery for

which the pottery would become known: landscapes with glowing moons and live oaks draped with Spanish moss. Newcomb pottery was often finished with a waxy semimatte glaze, painted with a minimal palette of green, blue, and sometimes a hint of pink. Interestingly, the instructors thought they were teaching vocational skills rather than art, since pottery decoration was considered an appropriate career for a young Southern woman. Newcomb pots were one of a kind, produced in limited quantity, and expensive. In the 1920s, when a small Rookwood vase might have run only a few dollars, a nice Newcomb bowl would have been closer to twenty.

The Rolls-Royce of Arts and Crafts pottery was Grueby, founded in Boston in 1897 by William Grueby. His company's hand-formed ceramics took their cue from nature, resembling simple vegetal forms, decorated with stylized leaves. But what distanced Grueby from all the other potteries was its unique glaze, known as Grueby green. Most vases were bathed in rich shades of matte green that often resembled the skin of a cucumber. Handling a Grueby pot was a sensuous experience, wonderful to the touch, with a pleasing heft. During the 1900s Grueby won many gold medals at international art pottery competitions, and an important vase could cost an astounding fifty dollars. Ironically, despite having substantial contracts to produce tiles for New York City's subway stations, Grueby only lasted in business for about twelve years, closing in 1909. Though it made a superior product, the firm was poorly managed.

After World War II, Arts and Crafts furnishings, along with magnificent Tiffany stained glass lamps, fell out of style. By the 1950s American design had undergone a profound shift. Furniture was evolving into sculpture. Companies like Heywood-Wakefield and Paul McCobb dominated the market by incorporating sleek modern designs, where form didn't always follow function.

Even the esteemed sculptor Isamu Noguchi tried his hand at furniture making and succeeded with his now classic Noguchi table. By the 1960s, mission oak furniture was completely forgotten. Its robust design no longer fit a world that was moving rapidly toward the space age. Art pottery was no exception. It was considered outdated, something associated with your grandmother's decor.

Enter Tod Volpe. Despite his humble background, he had always been seduced by beautiful objects. During his early-1970s flea market collecting forays, he began to notice oak tables and chairs and magnificent pottery that were virtually being given away. And there was lots of it—as much as you could cart off and afford to place in storage. Along with his cousin, Vance Jordan, the two future gallerists began to amass a significant inventory over the years. It was in 1976 that they launched the Jordan-Volpe Gallery on West Broadway in New York, the same street that housed Ivan Karp's O.K. Harris Works of Art. Volpe's enterprise was devoted to the long-forgotten Mission-style furniture and its corresponding ceramics from the same period. By the time they opened their space in SoHo, they probably controlled more Arts and Crafts material (1890–1930) than anybody in America.

The big question is why did Tod Volpe fixate on this "stuff," especially the ceramics, which had always been labeled decorative art rather than fine art? The key to Volpe's visionary prowess can be traced back to his obsession with celebrity. He really believed if he could champion something fresh and exciting, he would find himself in the same circles that Warhol navigated—a blend of art and Hollywood. If the art caught on, so would he. While that served as his motivation, he knew from the careers of his peers that he needed to rally around a movement of his own. Arts and Crafts seemed like a sure bet. It had once been

incredibly popular and he thought it might be due time for a revival as midcentury modernism was on its way out. Volpe took a gamble, which is what the art industry is all about. You never know what's going to take off. His audacious rediscovery and subsequent promotion of Arts and Crafts pottery triggered its rejuvenation, which in turn ignited a chain of events that led to contemporary ceramics finally being accepted as real art worthy of exhibition. Although it wasn't an easy journey to the top, Volpe had fought for that acceptance.

The biggest rap against art pottery was that it was created by studios, and rarely attributed to individual potters. The art market is based on artists rather than workshops. George Ohr, better known as the Mad Potter of Biloxi, became the first art potter who carved out an identity as a bona fide artist. The ultimate acceptance of Ohr as a significant figure in art history would pave the way for serious sculpture derived from clay. But first, someone like Tod Volpe had to arrive and set up a market for George Ohr.

During the early 1890s, ceramic vessels were decorative but functional; crockery was something you cooked in, vases were for displaying flowers. When George Ohr began making pottery, he turned the rules inside out. He insisted clay was as valid a material as bronze or wood for creating three-dimensional art. And he proved it by creating a body of work with no parallel before or since. With quirky art and personal looks to match, including a mustache long enough to belong in the *Guinness Book of World Records*, Ohr created ceramic vessels that were meant for appreciation, not practicality.

Like most major artists, Ohr came to his field steeped in fundamentals, having perfected his skills on the potter's wheel. The key to throwing successful pots is called centering. You learn

how to center a lump of clay by pressing your thumbs in the middle and exerting pressure, gradually hollowing out its interior as the pot spins on the wheel, while simultaneously creating the vessel's rising walls. The higher they get, the thinner they grow. Ohr's genius was to intentionally allow those walls to collapse on themselves. He then glazed them with unexpected but tantalizing color combinations. Some surfaces were covered with burst-bubble glazes, giving them an extraterrestrial appearance, as if they were of lunar origin. Occasionally he would add a pair of delicate handles or even the odd tiny snake. A few crumpled pots even had ruffled skirts. The results were ceramics that crossed over into sculpture.

From the word go, George Ohr knew how good he was. A sign in front of his shop read: GREATEST ART POTTER ON EARTH! The only problem was there were few takers for his work. His art was simply too far ahead of its time. Ohr grew so disgusted by the lack of sales that at one point he actually buried a group of his pots in the ground, hoping a future generation would come upon his "mud babies" and appreciate their brilliance.

It wasn't that he didn't have his share of admirers. In 1904, at his aesthetic height, Ohr was invited to participate in the Louisiana Purchase International Exposition, held in St. Louis. The judges awarded him a silver medal, putting him in the company of some of the great art potteries of his day, including Van Briggle, Rookwood, and Newcomb. But once again Ohr was disappointed, believing his recognition would translate into purchases. He didn't help matters by pricing his pots higher than any other pottery, discouraging the rare potential buyer. As Ohr saw it, "They were not willing to pay enough for it. It was high art, almost priceless."

During his later years, Ohr pretty much resigned himself to his fate. His work lost its zest and he supported himself largely

by teaching pottery on the wheel. With plenty of time on his hands, he constructed bizarre Mardi Gras floats, which he rode during the annual parade in New Orleans. Culminating a life-long commitment to eccentricity, he looked a bit like Father Time, sporting long silver hair and an even longer untrimmed white beard. As for his beloved pots, thousands of remaining examples were haphazardly crated up and stored in his young-est son's auto repair garage. A heavy smoker, Ohr died of throat cancer in 1918.

Just before he passed away, Ohr prophetically declared, "When I am gone, my work will be praised, honored, and cher-ished. It will come." And his moment did indeed come half a century later in 1968 when James Carpenter, an antiques dealer from New Jersey, journeyed to Biloxi, Mississippi, in search of old parts for classic automobiles. He had heard about an auto re-pair shop owned by George Ohr's sons, and decided to visit their warehouse. Along with old engines and carburetors, he spied a trove of over seven thousand pots stored in wooden crates— almost Ohr's entire output. Knowing something about art and antiques, Carpenter took a look at the pottery and realized he was standing in the midst of greatness.

After several years of negotiations, Carpenter closed a deal for the entire group. He paid approximately $50,000 for the col-lection, though Tod Volpe claims the amount was more be-tween $30,000 and $35,000. In 1972 Carpenter had the work shipped back east to his antiques shop. His plan was to sell off only enough Ohrs to cover his initial cash outlay. Once that goal was accomplished, he'd figure out what to do with the rest.

Word of the discovery grew. By 1975, rumors of these won-derful pots came to the attention of Volpe, who was about to open his own gallery. Through a middleman, he began buying up choice Ohrs, paying only ten to fifteen dollars apiece, since

there was no market to speak of for the pots. Interestingly, he claimed Carpenter couldn't distinguish the truly great examples from those which were merely good. A year later, as Carpenter's hoard began to enter art pottery collections, prices began to edge into the hundreds of dollars. By then, Volpe had amassed hundreds of pots. Once he opened his gallery, he pushed their price point over the magical thousand-dollar barrier.

How was Jordan-Volpe, in only a few short years, able to take an object they bought for as little as ten dollars and recycle it for a thousand? The answer lies in what Volpe describes as his "theater of art." Volpe's success can be partially attributed to his dynamic display tactics. Sparing no expense, he hired a lighting expert employed by the Metropolitan Museum of Art. The ceramics were so exquisitely lit, and perfectly positioned on pedestals, that they proved irresistible works of art. By creating the allure of museum-worthy artifacts inside a gallery setting, Volpe was able to develop a serious market for pottery. It was not unlike what Joshua Baer did for Native American art—fabricate the attraction through optimal presentation.

Thanks to a glowing review of Jordan-Volpe's inaugural show in the *New York Times,* which wrote enthusiastically about their rediscovery of Arts and Crafts furnishings, celebrities and collectors alike flocked to Jordan-Volpe. Rita Rieff's article trumpeted the forgotten beauty of Arts and Crafts pottery and furniture while praising Tod Volpe for his prescience. Validation from the *Times,* along with Volpe's showmanship, created an overnight success.

Before long, Volpe could count Andy Warhol, Dan Flavin, and Donald Judd among his George Ohr customers. Tastemaking art dealers like Irving Blum and Charles Cowles were also early buyers. Even Leo Castelli stopped by to purchase some Ohrs as a gift for Jasper Johns, for whom George Ohr was an

inspiration. Before long, images of Ohr pots began to take their place in Johns's mysterious iconography. His well-known painting *Ventriloquist* portrays no fewer than seven Ohr ceramics scattered throughout the composition.

With the art world firmly behind Volpe, he realized he had succeeded at almost everything he had set out to accomplish. He had respect, a successful gallery, and a group of admiring collectors. The only thing missing was celebrity status. It was a longing that Volpe was desperate to fulfill.

Before Volpe was able to seize the art world's attention by exhibiting George Ohr, ceramic sculpture was still in the fermentation stage. It would take the emergence of Peter Voulkos during the mid-1950s to bring acceptance of clay as a serious medium from which to make art.

Like Ohr, Voulkos was a superb technician. With his highly polished chops, Voulkos was able to expand the visual vocabulary of ceramics. Basically, he chose to think like a three-dimensional artist. Voulkos imposed his will on the clay, attacking it, gouging it, pounding it, and pumping up the aesthetic volume. He increased the scale of his vessels to the point where some actually reached life-size. These so-called ceramic stacks are best described as large clay pots piled on top of each other; a veritable totem pole of irregular forms with earth tone glazes. More important, they read as sculpture.

Born Panagiotis Voukopoulos to Greek immigrant parents, Voulkos began studying art at Montana State University in Bozeman, eventually gravitating to Black Mountain College in North Carolina in 1953, where he briefly taught. A year later he founded the art ceramics department at the Otis College of Art and Design in Los Angeles. Voulkos reached his peak of influence in 1959, when he set up another art ceramics department,

this time at the University of California at Berkeley. During those days, Voulkos also worked in steel, producing large-scale outdoor sculpture whose twisting linear elements and geometric volumes created a visual tension between line and shape. Significantly, these works were based on his earlier ceramic constructions. By being equally adept in a traditional sculpture medium (steel) as well as a traditional crafts medium (clay), Voulkos blurred the boundaries between them as materials to create fine art.

Nowhere was Voulkos's influence felt more heavily than in the art of his fellow Californian Robert Arneson. Early on, his work was respected for its technical virtuosity and cherished for its humor and irreverence. Arneson liked nothing better than to provoke his audience, going as far as fashioning a life-size ceramic toilet filled with—well, you get the idea. There was also a funky typewriter with human fingertips substituted for keys. As he matured as an artist Arneson turned to portraiture with an emphasis on his own likeness. One of his finest pieces, called *California Artist*, depicts the blissed-out Arneson from the waist up, his blue denim work shirt completely unbuttoned, atop a pedestal decorated with a large green marijuana plant, rendered so faithfully it made your eyes red just looking at it.

Arneson had his serious moments, too. In 1978, not long after the assassination of San Francisco mayor George Moscone, the city commissioned Arneson to do a monumental commemorative sculpture of him. Arneson's response was a stunning 500-pound bust, whose base was covered with graffiti drawings that commented on how the mayor lived and died—commentary that proved so controversial that the city rejected the piece. Arneson received an avalanche of publicity, instantly placing him on the art world's radar as an artist of consequence. But Arneson's real significance was that he served as a transitional

figure, maintaining Voulkos's fidelity to the clay medium and traditional sculpture while pushing ceramics in the direction of making more of a personal statement.

The artist who would lead ceramics into the mainstream was Ken Price, whose work had been marginalized for decades. What's so ironic is that his work's roots were steeped in a marginal culture—the peasant culture of Mexican folk art. During the late 1950s, when Price lived in Southern California, he immersed himself in its surfing milieu. His search for the perfect wave led to frequent junkets to Tijuana. Drawn to the local curio shops, he came upon its ubiquitous folk pottery. These ceramics were produced throughout Mexico in great quantity and sold to tourists. Most of the souvenirs were under a dollar. Their designs reflected the indigenous people and flora and fauna of Mexico: sombrero-wearing men crouched in siestas, agaves with their swordlike leaves, donkeys, and prickly pear cacti. Though somewhat crude, these plates and bowls had integrity. The best examples had an astounding clarity and an even more surprising sense of color; a combination of terra cotta with just a touch of "south of the border" fiesta. Price began buying this pottery, assembling an impressive collection. More important, the work's simple but effective design elements began to seep into his consciousness.

While Price was attending USC at the time, he began hanging out at the Otis College of Art and Design, where Peter Voulkos was teaching. Price eventually enrolled at Otis as a graduate student and studied under Voulkos—whom he later called his greatest influence. By 1960 Price was exhibiting his ceramics at the legendary Ferus Gallery in Los Angeles. His early work resembled large eggs with carved-out crevices that housed protruding wormlike forms. In keeping with the times and L.A.'s car culture, Price glazed his shapes with glowing colors.

He spent much of the 1970s designing wooden structures, the size of a small roadside cherry stand, that he called "death shrines," which displayed his sophisticated take on Mexican folk ceramics. Painted skulls on cups made frequent appearances, inspired by Day of the Dead religious imagery. In 1978 the Los Angeles County Museum of Art exhibited these pottery-filled installations, which came across as a strange hybrid of primitive church altars and marketplace stalls. The press didn't know what to make of them. Blending contemporary influences with folk art, it was the birth of the Ken Price mystique.

At the time of his museum show, Price was living in Taos. Made in relative isolation, away from a major art center, his ceramics continued to develop their idiosyncratic look. In some ways, Price was the George Ohr of his day. His art was well executed, peculiar, and oddly beautiful. Unlike Voulkos, whose ambitiously scaled work was clearly meant to be seen as art, Price's work, partly due to its modest size, relied on its uncanny presence to lift it from craft to art.

During the eighties and nineties, Price showed consistently in Los Angeles, while the New York art world continued to look the other way. Those adventurous collectors, who were early to grasp his work, treated it almost like a private club. His supporters would gingerly mention they owned a few pieces, but only drag one out when they met a kindred spirit who was also discreetly acquiring them. This led to a cult following for Price and the beginnings of art market respect.

At some point, Price's hard-to-classify forms devolved into being formless. In a feature article for the *New York Times*, Nick Stillman offered this pithy description: "[they] can look like a stack of soft internal organs, a gorgeous extracted tumor or a glittering lump of dung. The dialectic of attraction and repulsion is their motor." I preferred to think of them as geologic wonders;

molten forms extruded from beneath the earth's crust. A Ken Price was no longer construed as a mere, if quirky, vessel — it was *sculpture*. Harkening back to the Los Angeles–based "Finish Fetish" school of the 1960s, Price covered his creations with over a dozen coats of acrylic paint, sanding down each newly applied color to reveal phantoms of previous layers of pigment. This time-intensive process only increased the work's inscrutability.

In a scene reminiscent of the fortuitous gallery fate that befell the Philadelphia Wireman, Ken Price got "The Call" from Matthew Marks. During 2003, Price had his first show at the reputable gallery that represents Ellsworth Kelly, Brice Marden, and Jasper Johns. Dating back to Warhol's prescient early-1960s comment about how selecting a dress from Dior gave the buyer confidence in her purchase, collectors could now buy a Price from Marks with similar assurance. Once Price was seen in this prestigious context, the spotlight on his work increased exponentially. So did his market. At the ripe old age of seventy, Ken Price found himself an "overnight success."

One morning the actor Jack Nicholson, accompanied by his friend the actress Anjelica Houston, appeared at the Jordan-Volpe Gallery only a few minutes before they opened. At first, Tod Volpe was so intimidated that Nicholson had to say, "Hey there, Cutes. You gonna invite us in?" But within a few minutes, he got past his initial shock and sold Nicholson a variety of Arts and Crafts furnishings. Over time, they grew so close that not only did Nicholson become a valued customer, he also set up a half-million-dollar art investment fund that Volpe administered. The fund was used to buy Arts and Crafts period paintings, with the profits split between the two partners.

By 1986, after ten years of shaking up the art scene in SoHo, Volpe was ready to expand his horizons. He was egged on by

producer Joel Silver (48 *Hours, Lethal Weapon, Die Hard*), who called him and said, "What the hell are you doing? Get your ass out here. You're gonna live like a king!" Volpe took the hint and moved to Los Angeles. Under normal circumstances, relocating your gallery from New York to the West Coast had little chance of succeeding—even the mighty Pace Gallery's Beverly Hills branch couldn't turn a profit. The nature of selling to Hollywood is that no one trusts an outsider. Movie stars live in fear of being taken advantage of (probably with good reason).

Thanks to a nod from Nicholson and Silver, the velvet rope was lifted for Volpe. He arrived in Los Angeles with instant credibility. Soon he could count Barbara Streisand and Bruce Willis among his famous clients. But he really hit the jackpot when he met Linda Bruckheimer, wife of megaproducer Jerry Bruckheimer. With her sophistication and unlimited budget, she commissioned Volpe to fill her Brentwood home and Malibu beach residence with the finest Arts and Crafts pottery imaginable—including an incredible array of Grueby. Having once sold a painting to Linda myself, I can vouch for her taste and decisiveness. In other words, she proved to be the dream client.

Tod Volpe went from victory to victory. Don Simpson, Jerry Bruckheimer's volatile partner at the time, acquired an "instant collection" of ceramics. Producer Renny Harlin enlisted Volpe to source a $50,000 diamond engagement ring for Geena Davis. The *Hollywood Reporter* called Volpe to check on a rumor that he was romantically involved with actress Rebecca De Mornay. For a brief moment, Hollywood had fallen in love with Volpe and Arts and Crafts pottery. Having met Volpe during this period, in the locker room of the Sports Club L.A., of all places, I can attest to his charisma. That day, the man could have talked me into handing over my new Nike Air Max shoes—and I would have gladly laced them up for him as part of the bargain.

Had Volpe been content to remain the "art dealer to the stars," there's an excellent chance everything would have worked out for him. The problem was that he was a visionary with a bad case of megalomania. While other seers were content with the satisfaction of having changed art history, Volpe wanted more. He wanted to write and direct a period film about the life of Joseph Duveen, unofficially the most influential art dealer of the twentieth century. The next thing you knew, he was pitching his acquaintances in the film industry to let him in the game.

Hollywood rejected his advances. It was one thing to welcome an outsider as an expert in his own trade, but another to welcome him inside their trade. Feeling frustrated, Volpe began to focus more on his lifestyle, foolishly thinking that the only thing that separated him from making movies was the outward appearance of success. With that in mind, he began to live what he thought was the quintessential eighties Hollywood lifestyle. Volpe rented a luxurious home, stocked a pond with expensive koi, and hired a full-time landscaper to maintain the exotic Japanese gardens. But that was just for openers. He then proceeded to spend $8,000 for a year's supply of gilded and hand-embossed stationery, leased a Porsche Cabriolet, bought new designer clothes every day so he would never be seen in the same outfit twice, and replaced Casablanca lilies at fifteen dollars a stem the moment a flower showed signs of wilting. He even installed an expensive stereo system that piped fusion jazz into each room, so, as he put it, "people would know I had class."

It came as little surprise to me when years later I learned that Volpe had been arrested for embezzling money from Jack Nicholson, along with scamming a substantial number of dealers and collectors. Obviously, Volpe had gotten in over his head. Not only had he tried to keep up with his film-world cronies, he attempted to outdo them. In 1998 Tod Volpe was forced to leave

the art business and was sentenced to twenty-eight months in a federal penitentiary.

Once Tod Volpe completed his prison term, collectors predictably kept their distance and dealers shunned him. But there were always those willing to look beyond his past. In the early 1990s, a gritty, retired long-distance truck driver named Teri Horton stopped by a thrift store in San Bernadino, California, and spotted a large painting covered with countless skeins of tossed paint. Not knowing the first thing about modern art, Horton inquired as to its price. When she was quoted eight dollars, Horton told the woman behind the counter that she was buying it for a friend, but joked that she wasn't "*that* good of a friend." The woman told Horton, "Okay, so give me five dollars."

Sold.

Teri Horton's friend didn't have room for the painting so she kept it for herself. An art teacher told Horton that it could be a Jackson Pollock. She reacted by exclaiming, "Who the fuck is Jackson Pollock?" Hence the title of the 2006 documentary *Who the #$&% Is Jackson Pollock?*, which chronicles her ten-year quest to get the painting authenticated. Such noted authorities as the Metropolitan Museum of Art's Thomas Hoving were shown the picture and promptly rejected its attribution to Pollock. As the movie continued to unfold, it became apparent to the viewer that the painting wasn't a genuine Pollock.

Out of desperation, Horton hired a forensic scientist named Peter Paul Biro, who claimed to be a fingerprint expert. Naturally, he found a fingerprint on the alleged Pollock and matched it with a paint can from Jackson Pollock's studio in the Hamptons. Armed with "surefire proof" (at least in her mind), Horton visited a bookstore and stumbled onto Volpe's memoir, *Framed*. She read the book and quickly concluded that Tod Volpe was

the only man on this planet capable of selling her painting. Horton contacted Volpe, explained the situation, and lest he think he was dealing with someone ignorant of Pollock's market, told him she wanted $50 million for it.

Tod Volpe was back in the saddle. His first move was to create a business plan that called for putting together a consortium of investors to buy the painting and then sell it for $40–60 million, with Teri Horton to receive $20–25 million. Hoving commented, "I was astounded, knowing Volpe to be a slippery character who had served time for art fraud. Volpe had reportedly interested investors in the Pollock—one was Tiger Woods for a quarter of a million, or so Moses [Harry Moses, the film's director] told me." Needless to say, the painting to this day remains unsold.

Always thinking big, Volpe contacted Biro after deciding that the Pollock was just the tip of the iceberg. He envisioned hiring Biro to utilize his fingerprint technology to authenticate other questionable paintings, thereby creating a whole new paradigm for dealing art. Before long, Volpe was working on a number of Turners, a Frida Kahlo, and a Diego Rivera. For whatever reason, Biro then panicked and chose not to get involved. With Biro no longer on board, Volpe abandoned his plan to market paintings that lacked authentication. His days as a "power player," as he was inclined to refer to himself, had come to an end.

Currently, Volpe is trying to produce a movie version of his life story. If you access his Web site, it's filled with a list of big-name parties allegedly interested in making it happen. He also continues to stay in touch with the art market, mostly advising and consulting on Arts and Crafts and other forms, but no longer involved with sales. Yet you sense that despite all of his setbacks and misadventures, he still really loves art pottery, misses

being a major impresario in his field, and hopes for redemption someday.

Jane McDonald might be the least-known artist in this book. Check that, she *is* the least-known artist in this book. She lives in the Northern Californian town of Petaluma, once known as the Egg Capital of the World, thanks to the invention of the chick incubator, various poultry industries, and Charles Sheeler–like grain elevators. McDonald's smallish studio is located behind her home, in a converted garage. Much of her work is pretty ordinary, along the lines of the usual ceramic hearts and cookie jars. In that respect, most works of clay mimic the countless photographs that fall into the category of snapshots, rather than fine art.

Yet McDonald has every right to take her place at the table with other major figures in contemporary ceramics like Adrian Saxe, Ron Nagle, and Jun Kaneko. What's more, her position is based on a single body of work. For lack of a better description, I refer to them as Clay Succulents, since their organic forms are reminiscent of Arizona's giant saguaros. Rarely more than eighteen inches high, they're created from slabs of clay that have been scored with furrows and ridges and then tossed like pizza dough, stretching out their surface designs. Once their walls are joined, they're glazed in minty greens with hints of chartreuse, offset by touches of orange or red. There's a life force to them. They appear to be living and breathing organisms; it's as if you could stick one in the ground and watch it grow.

I had come across McDonald's work while it was being photographed at an art services studio called Digital Grange. I eagerly asked its proprietor, Bill Kane, "Whose work is that?" After over thirty years in the business, it felt so good to be surprised by something. Having thought I'd seen it all, I walked away wondering how to account for the emergence of McDonald.

What I concluded was that the current state of not just ceramics, but all the plastic arts, had evolved to a point where its creators had given themselves permission to think like artists rather than craftspeople.

When I talked with McDonald, she made the surprising point that the only thing holding her work back from serious recognition is that "each piece has an opening at the top." This allowed critics and dealers to classify her forms as vessels. If she closed up the hole, or even relocated it to the side of the piece, it would be called sculpture. Sighting Constantin Brancusi and Barbara Hepworth as her influences, McDonald hopes to move her work more in that direction. She had discovered the key to a career in ceramics: allowing her work to cross over into sculpture.

In retrospect, it was Volpe who helped pave the way for McDonald's work to move into fine art, through his promotion of Ohr, during an era that seems like an awfully long time ago. With Volpe's absence from the Arts and Crafts pottery world, its market grew stale. High-profile Hollywood collectors, feeling burned by his shenanigans, quit buying. His biggest rival, D. J. Puffert, also left the business years ago, and no one has stepped in to take the lead. While there's still strong demand for the finest examples from the top potteries, the vast majority of the material seems headed back to where Volpe originally found it—languishing in obscurity.

Remarkably, George Ohr's reputation continues to expand. In 1994 Ohr's hometown of Biloxi, Mississippi, opened the George Ohr Arts and Cultural Center, devoted to preserving his legacy. The institution attracted so much interest that an ensuing fund-raising drive enabled them to raise enough money to hire Frank Gehry to design an expanded campus. With only eleven months to go before the grand opening, Hurricane

Katrina blew away much of the construction. But thanks to the financial backing of Jerry O'Keefe, the city's former mayor, they were able to rebuild. In November 2010, the newly christened Ohr-O'Keefe Museum of Art opened with Gehry in attendance at the ribbon-cutting ceremony.

I remember selling the San Francisco couple Rick and Dana Dirickson a small group of George Ohr pots, around the year 2000—just about the same time Tod Volpe was released from prison. The Diricksons had been longtime collectors of Andy Warhol, Joseph Cornell, and James Rosenquist. While they also acquired sculpture and were big John Chamberlain fans, they didn't own any three-dimensional art derived from clay. After I showed them some Ohrs, thrilling them with his fantastic life story and pointing out his influence on Jasper Johns, the Diricksons quickly warmed up to the work and bought some.

Tod Volpe may have been guilty of allowing his lofty vision for himself to exceed his vision for art pottery. But by championing the great works of Arts and Crafts, in particular George Ohr, whose work transcended the label of art pottery and came to be seen as fine art, Volpe set contemporary ceramics on a course that is still reverberating. Some day soon, an artist will come along and pick up where Jane McDonald left off, taking sculpture derived from clay to the next level.

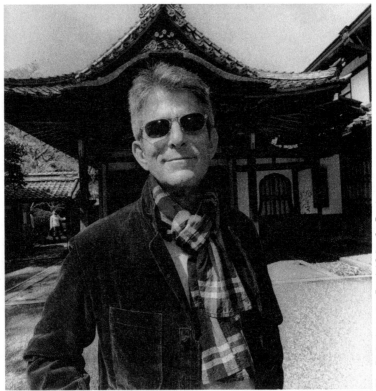

Jeffrey Fraenkel.

## Chapter Eight
### Jeffrey Fraenkel and Photography

L IKE CERAMICS, respect for photography was long arriving. The obstacle in its path, which prevented its acceptance as fine art, was the very machine responsible for its existence: the camera. Before Andy Warhol and his photo-silkscreen process, art was something made with a brush or a chisel. Casting bronze was also acceptable. But utilizing a device that recorded images on film was considered cheating. Real artists didn't take photographs.

Initially, photography was viewed as a tool used by newspaper journalists to give their readership a greater sense of "being there." The Civil War photographer Mathew Brady took many amazing battlefield photographs. Many historians refer to him as the father of photojournalism, and those images inform much of what we know about the war itself. But while the photographs were conceived as documentation, they are now revered as art.

Brady set the stage for Edward Curtis and his famous portfolios of vanishing Native Americans. In 1906 the wealthy industrialist J. P. Morgan offered Curtis $75,000 to undertake a project to document their way of life before it disappeared, which resulted in forty thousand photographs depicting over eighty tribes. Curtis's work has always been controversial because the poses of his Indian subjects were contrived—chiefs

were paid to don elaborate ceremonial war bonnets as if head-
ing into battle. By printing these pictures with a nostalgic brown
tonality, he further manipulated the viewer's heartstrings.

Documentary photography continued to evolve on its own
path into the twentieth century, but then the road took a fork,
separating from photojournalism and down the lane of fine art
with the arrival of Alfred Stieglitz. Though he had taken pho-
tographs as far back as 1892, it wasn't until the opening of his
Photo-Secession gallery, in 1905, that his vision for photogra-
phy found its footing. His obsession with the medium extended
to editing and publishing a highbrow magazine called *Camera
Work*. By 1908 his space came to be known as Gallery 291, the
first American exhibition venue to treat photos as real art.

Since Stieglitz was never under financial duress, thanks to a
fortunate marriage, he was able to take big risks and exhibit work
he believed in. He was early to grasp a concept that wouldn't be
fully realized until the late 1970s: in order for photography to be
taken seriously as fine art, it had to be exhibited alongside paint-
ings. What started out as a gallery dedicated to photography,
in particular the work of the great Edward Steichen, quickly
evolved into a program that included paintings, watercolors,
and drawings. Exhibited work ranged from Impressionist paint-
ings by Mary Cassatt to drawings by the sculptor Auguste Rodin.
Later, Stieglitz would also show the American modernist land-
scapes of John Marin, Marsden Hartley, and Arthur Dove.

But it wasn't until Stieglitz was introduced to Georgia
O'Keeffe, who became his muse and eventually his second wife,
that his own personal photography soared. Between 1918 and
1925 he shot a large number of nudes of O'Keeffe, along with
close-ups of her hands, that remain some of photography's most
compelling images. Perhaps the picture most closely associated
with Stieglitz was *The Steerage*, shot in 1907, which became

a cornerstone of modern photography. On his way to Europe, Stieglitz boarded the ship and aimed his camera at the passengers below deck, spread out in steerage-class squalor. His view was bisected by a gangway, which revealed the splendor of the first-class ticket holders, ensconced above their poor fellow travelers. *The Steerage* captured the poignant division of economic classes in a single image that said more than any written description ever could. Yet, what primarily made it a work of fine art was its complex composition.

In terms of pioneering modern photography in America, there were a number of other individuals who ignored the documentation mindset of the early twentieth century to produce work that's now highly sought after, among them Edward Weston, Walker Evans, Paul Strand, and Charles Sheeler, a switch-hitter equally adept at painting and photography. In years to come, the landscape photographer extraordinaire, Ansel Adams, brought the medium wider mainstream acceptance. His transcendent *Moonrise, Hernandez, New Mexico*, from 1941, was the photo-world counterpart to Miles Davis's *Kind of Blue*. Adams printed versions of *Moonrise* in so many formats and tonalities that it became the visual equivalent of Davis varying his phrasing every time he performed selections from his landmark album—no two prints or renditions were alike.

In 1959 Robert Frank's photo essay *The Americans* was published, once again changing our perception of what a photograph could be. His harsh black-and-white images of ordinary people, shot on a cross-country road trip, signaled the birth of modern street photography. It was no longer just about beauty; photographs captured the zeitgeist of a time and place. With an "on the street" approach, Frank was able to incorporate more of a photojournalistic feel without compromising his fine art standing—merging the two fields.

In 1967 John Szarkowski, MoMA's curator of photography and the medium's greatest advocate since Stieglitz, opened the pivotal exhibition *New Documents*. This was the show that brought the work of Diane Arbus, Lee Friedlander, and Garry Winogrand to our attention. The snapshot quality of their imagery was an extension of Frank's social observations. Each of these artists drew you into their world, sharing the catbird seat with the viewer as they explored little-known places and subcultures. Or as Szarkowski saw it, "The subject would now tend to become not the reason for the pictures, but its pretext; the picture's function was to reveal the *photographer*."

Szarkowski wasn't through shaking up our perception of photography. In 1976 he curated the show *William Eggleston's Guide*. Eggleston kicked down the door color photography cowered behind, having been previously shunned as commercial. When he shot an ordinary green garden hose against the backdrop of a canary yellow wall, he thought like a painter, focusing on the relationship between line and color. Possessing a dry wit, Eggleston's photographs were the equivalent of a David Hockney.

With the acceptance of William Eggleston, the time was finally ripe for the art market of the mid-1970s to welcome photography. Certainly the times were becoming more inclusive. But truth be told, the art market was ready to expand. Photographs were plentiful, grounded in history, and its greatest images were still cheap.

For photography to catch on, in a market that was the exclusive province of paintings, there had to be a dealer who had the eye of Ivan Karp, the convictions of Stan Lee, and the suave salesmanship of Joshua Baer. That individual proved to be Jeffrey Fraenkel. In discussing Fraenkel's contribution to the evolution of the

photography market, it's necessary to state that he does not con-
sider himself a visionary. Fraenkel insists on deflecting attention
to his colleagues who were first to recognize and show the work
of a number of photographers associated with his gallery. They
include the dealers Marlborough, in New York, which handled
Richard Avedon; Harry Lunn, in New York, which represented
the Diane Arbus estate; and San Francisco's Grapestake, which
initially brought the work of Richard Misrach to our attention.
Yet, building on John Szarkowski's ideas—the medium's true
avatar—Fraenkel was able to help collectors connect the dots
in such a way that they pursued photographs with the same pas-
sion as paintings. Sometimes a visionary dealer can simply be
someone who possesses a master salesman's touch for getting
the potential buyer emotionally involved with the work.

Fraenkel's love of photography is infectious. What separates
him from his colleagues, who have an equal love of the me-
dium, is his ability to articulate his feelings about an individual
picture. He strikes just the right tone between reverence for the
artist, respect for the collector, and a sure grasp for closing the
deal. Like Szarkowski, who was a great teacher, you sense that
Fraenkel derives the most joy from his profession through edu-
cating his collectors. The bottom line is he's good at facilitating
the migration of photographs from his walls to yours.

When Jeffrey Fraenkel arrived in San Francisco in 1976, via
Baton Rouge, Louisiana, there were already several pioneering
photography dealers on the local scene. One was Simon Lowin-
sky. The other was Grapestake Gallery, led by the brother-and-
sister combination of Tom Meyer and Ursula Gropper, whose
space was named after the family's winery business. Fraenkel
had come to the Bay Area to seek his fortune in the arts. At the
time, he was a photographer looking to exhibit his work. While
making the rounds, he showed his portfolio to Tom Meyer

while also mentioning he was seeking employment. His timing was excellent. After reviewing his work, Meyer mentioned that a current staff member would be leaving in two weeks. Sensing Fraenkel had more of a future as an art dealer than as an artist, he hired him on the spot. After two years of paying his dues at Grapestake, Fraenkel was given a few clients of his own to develop. As Meyer put it, "He knew how to bring the work to life and change the whole experience for the collector. Jeffrey was a real scholar with a rich self-taught background of knowledge."

In a classic rendition of how "the Lord works in mysterious ways," an announcement for an auction of forty-nine Carlton Watkins photographs had been tossed in the gallery's trash— somehow it caught Fraenkel's eye. Galvanized by the ravishing beauty of Watkins's nineteenth-century landscapes, the twenty-four-year-old went to New York to try his luck at the sale. This was 1979 and the market for vintage photographs was still in its infancy. But the unique opportunity to own a rare collection of Watkins brought out a surprising number of buyers. Once the bidding opened, it quickly zoomed beyond what Fraenkel was prepared to pay.

Fortunately, Fraenkel had a plan B in place. Only a few days before the sale, he realized he had underestimated the level of interest in the material and recruited the dealer George Rinhart as a partner. It was a good thing he did, because the collection sold for a then outrageous $98,000. Fraenkel now owned his first collection of photography. The next morning, Fraenkel awoke to find out how outrageous. The *New York Times* ran a story on the sale, with the blaring headline "Spectacular Bidding Defeats the Met." His intuitions about the desirability of the Watkins photos were on the mark; the Metropolitan Museum of Art had been the underbidder.

While he was still in Manhattan, Fraenkel decided to do some advance reconnaissance for a gallery he planned to open later that year in San Francisco. Already confident in his artistic judgment, he approached the respected but little-known photographer Lee Friedlander, and asked to become his West Coast representative. The much older artist was taken with Fraenkel's youthful enthusiasm and readily agreed. With a commitment from Friedlander in hand, Fraenkel pursued handling Diane Arbus and Garry Winogrand, who also lacked West Coast galleries. And once again, Fraenkel was able to clinch a deal with their East Coast representatives. It's easy to forget that Friedlander, Arbus, and Winogrand were barely considered salable at the time. When Fraenkel started out, it was beyond comprehension that a photograph would someday sell for $100,000, let alone $1 million. At the time he opened his gallery, a $5,000 purchase was considered a sale of substance.

To put things in further perspective, when Grapestake went into business in 1974, they offered original 16-by-20-inch Ansel Adams prints for $500—and that included copies of *Moonrise*. As Tom Meyer reminisced, "People would look at the Adams prints and marvel at their beauty but they'd balk at writing a check. Back then photographs were unnumbered and technically printed in unlimited editions. For that reason, collectors couldn't wrap their minds around spending $500 for a photograph."

During these formative years of the photography market, there were a few independent-thinking collectors who got in on the ground floor. Among them was Graham Nash. By the mid-1970s, he had already acquired more than one thousand prints by such photographers as Diane Arbus, William Weegee, and Henri Cartier-Bresson. In 1990 Nash sold his entire holdings of

over two thousand pictures at Sotheby's, with the sale becoming the highest-grossing private photography collection ever auctioned. He used the proceeds to start Nash Editions, the first digital fine art printing studio.

As a celebrity, Graham Nash was given preferential treatment by art dealers—but not always. In what has to be one of the more humorous incidents in the history of art dealing, Nash's business manager found himself answering an advertisement in the *San Francisco Chronicle* classified section. The three-line ad offered prints by the painters Chagall, Picasso, and Cézanne. Knowing his client was looking to diversify his collection, he dialed the listed number. His call was taken by Foster Goldstrom, a private dealer in San Francisco who primarily handled prints.

The manager pulled up to Goldstrom's apartment in a limousine, with a fellow scruffy hippie in tow. Judging by their long hair and ripped jeans, Goldstrom was not optimistic he'd do any business that day. In fact, thoughts of a holdup skittered across his mind. But to his pleasant surprise, they purchased lithographs by René Magritte and Francisco Zuniga. Monique Goldstrom, Foster's outspoken wife, walked into the room and asked the one with the goatee, "What do you do for a living?"

He responded, "I'm a musician."

Monique smiled. "You know, my Women's American ORT club is having a dance next month and I'm in charge of finding a band. If you play your cards right, I might give you an audition."

"Well, that's very nice of you. But my group's kind of expensive."

Monique flippantly replied, "We're willing to pay five hundred dollars."

The shaggy character stood there bemused, saying nothing.

Finally, Monique broke the silence, sarcastically asking, "What's the name of this group of yours, anyway?"

"Crosby, Stills and Nash."

By 1979 a host of collectors, besides Graham Nash, began to recognize the value of photography. That same year, Jeffrey Fraenkel opened his eponymous San Francisco gallery. His first show featured Carlton Watkins, with prints pegged at an average of $8,000 apiece. His pricing was based on having paid more than he expected at auction, indicating a market that might be ready to pay an even higher price for vintage material from the early days of photography. Though he did respectably well with contemporary works, his ensuing exhibitions were a tough slog; the gallery remained semidependent on Watkins sales to stay afloat. Many of the photographers he had taken on hadn't surfaced yet as hot properties.

Collectors are generally more comfortable paying a little more for an artist, knowing he's on his way, than paying less for someone with little recognition. By bringing photographers of the caliber of Diane Arbus to the West Coast, Fraenkel was ahead of the curve, but behind the eight ball in terms of profitability. True, he was showing work he believed in, but that's what every dealer does. His credentials as an art world visionary would surface with the success of his artists.

Diane Arbus has acquired a mythological status that's been bestowed upon only a handful of twentieth-century artists. This exclusive club includes the likes of Georgia O'Keeffe, Jackson Pollock, Frida Kahlo, Andy Warhol, and Jean-Michel Basquiat. An artist's mystique is grounded in the work itself, but is also about being a larger-than-life figure. In Arbus's case, the same fierce curiosity that informed her art was offset by an equally

fierce personal life—an inability to harness her demons. When Arbus's prodigious talent rubbed up against her self-destructive behavior, it produced a frisson that created an enduring artistic icon.

During the fifties, when Arbus prowled the streets of New York looking for subjects to photograph, she found herself drawn to marginal types. Though she came from a privileged background, Arbus saw her life to be as harrowing as theirs. Each time her camera shutter clicked, she captured her quarry's likeness as if she was shooting her own. The work's power came from the commingling of the subject's and photographer's interior lives.

Like many artists, Arbus had been photographing for years without gaining recognition for her work. Her career breakthrough occurred when John Szarkowski included her in the *New Documents* exhibit at MoMA. Four years later, in 1971, Arbus was dead, having committed suicide at the age of forty-eight. In those few years, her potent images, including *Identical Twins, Jewish Giant at Home with His Parents in the Bronx*, and *Child with Toy Hand Grenade in Central Park* were already on their way to canonization in art history. A year after her death, MoMA honored Arbus with a retrospective that broke the institution's attendance record for a solo photography show. The *Aperture* monograph *Diane Arbus*, which featured *Identical Twins* on the cover, became one the biggest-selling art books of all time. That same year, Arbus's work appeared in the prestigious Venice Biennale—the first American photographer to be included. Interestingly, the genius of Arbus was seized upon by museums and international expositions before galleries.

The Jeffrey Fraenkel Gallery showed Diane Arbus in 1980, in an exhibition titled *Unpublished Photographs*. Included in the show were *Two Ladies at the Automat, N.Y.C.*; and *Barber*

*Shop, N.Y.C.*—depicting a pinup collection at a neighborhood barber shop. Fraenkel printed up a poster to commemorate the event that reproduced an Arbus image of a seated headless mannequin, extruding a conical antennalike structure from its neck. He explained his thinking behind the show: "I realized the public was only familiar with the eighty or so photos in the famous *Aperture* book. That's all anyone knew about Arbus. But it hit me that no artist who was that great could *only* have taken eighty great pictures. There had to be a more complicated story."

More of her photographs would surface over the coming two decades. Perhaps the most talked about and controversial series were from Arbus's early career, vividly portrayed in Gregory Gibson's book *Hubert's Freaks*. From 1926 until 1965, Times Square housed Hubert's Museum, a freak show open to the general public. Visitors were treated to the usual assortment of oddball performers, including sword swallowers and wild men from Borneo. When Arbus discovered Hubert's in 1956, the institution was already on its way out, thanks to the early stirrings of political correctness and the city's increasing desire to sanitize Times Square.

Arbus, who had been partners with her husband Alan in a fashion photography studio, had recently struck out on her own to find her voice as an artist. Ever since she could remember, she was attracted to the bizarre and forbidden fruit of the world. Coming upon Hubert's was a revelation. Here was a group of ready-made subjects. Rather than exploit these poor souls, Arbus invested the time to get to know them as human beings, looking beyond their eccentric appearance to connect with their inner beauty. She began hanging out with Charlie Lucas, the unofficial spokesman for the freak show. They would have dinner together, see each other's places, meet for coffee—they became good friends.

Before long, the denizens of Hubert's were asking her to pho-
tograph them. Arbus proceeded to do so, shooting their portraits
in costume, or in the case of Woogie the snake charmer, inter-
twined with her performing serpents. Experience garnered from
interacting with sideshow characters served Arbus well as she
matured as an artist. She insisted that "getting the story" went
beyond a cursory overview of your intended subject. It meant
becoming emotionally involved. Arbus demonstrated the wis-
dom of making a commitment to your work that went further
than merely executing it; she lived it.

In 2003 Bob Langmuir, a neurotic antiquarian book dealer,
ferreted out a cache of props, posters, and personal journals from
the long-gone Hubert's. Sorting through the memorabilia, Lang-
muir discovered a group of photographs depicting Hubert's fam-
ily of entertainers. Most likely they were given as gifts from the
photographer to the performers. Already possessing a strong eye
for collectibles, Langmuir instinctively knew some of the photos
were good. But others were exceptional. With a little research,
he came to the startling conclusion that he had stumbled upon
a number of Diane Arbus prints that had been lost to the world.

Langmuir struggled with the totalitarian ways of the Arbus
estate to get his find authenticated. In the end, the majority of
the prints were approved. In 2008 Langmuir consigned the pho-
tos to auction at Phillips in New York. Having seen the auction
catalog, I was shocked by the high estimates given the pictures.
There was a circa 1959 image of a sword swallower, a precursor
to Arbus's great *Albino Sword Swallower* from the 1960s, esti-
mated at $70,000–$90,000, when $20,000–$30,000 would have
been more like it. In the art market, the difference between for-
mative work and mature work can add a couple zeroes to the
price. Only a few years earlier in 2006, Arbus's iconic *Identical
Twins* had brought almost $500,000 at auction.

On the day the Langmuir sale was supposed to take place, the *New York Times* reported that Phillips had canceled the event, claiming a mysterious buyer had approached them the day before and bought the whole collection. That, in itself, would have been highly unusual in the auction world. In over thirty years in the business, I had never heard of an entire sale being withdrawn for that reason. But the story grew stranger. In weeks to come, word trickled out that the alleged sale had never taken place. The scuttlebutt that began to circulate was Phillips had placed such absurd estimates on the Arbus photos, the sale attracted little serious interest and would have been a disaster.

Phillips's willingness to create unrealistic expectations for the work was indicative of the demand for Arbus. But the failure of these photos to even make it to the auction block revealed a more basic truth: the art market had evolved to a point where only the best would do. As art photography found a steady stream of collectors, the standards of connoisseurship became firmly established. Smart collectors realized you rarely lost money by buying the best. By the time of the Langmuir fiasco, Edward Steichen's *The Pond-Moonlight* (1904) had brought $2.9 million at Sotheby's in 2006, Alfred Stieglitz's *Georgia O'Keeffe (Hands)* (1919) had achieved $1.4 million that same year at Sotheby's, and Richard Avedon's *Dovima with Elephants* made $1.1 million in 2010 at Christie's.

While Arbus began exploring photography through her husband's fashion photography studio and then transitioned into fine art, Richard Avedon followed a similar path. As in any field, there were artists who managed to cross over into other visual genres, moving beyond the territory they initially staked out. Fashion photography was one of those categories, producing artists like Irving Penn, who slid seamlessly into fine art photography. Though fashion photography had been around for quite

a while, and included such early-1950s stars as Louise Dahl-Wolfe, it was Avedon who drove it to new heights in the 1960s. While the obvious goal was to sell the latest designer clothes, he insisted on choreographing poses where the model dominated the picture—not what she was wearing.

Avedon broke away from the stale European approach of having each model posed to showcase the clothing. Instead, he encouraged his women to express themselves in their couture outfits, move around, create a mood and impression. Fashion magazines loved the vitality of his work. They were also be-guiled by his Minimalist aesthetic. Avedon shot his subjects straight on, in front of a white backdrop, and developed each print with the rich black edge of the film framing the subject. From *Harper's Bazaar* to *Vogue*, Avedon became the industry's "go to" photographer.

With Avedon's growing success, he soon gained ready access to celebrities from the world of politics, film, art, and music. In 1968 he photographed the Beatles, channeling the psychedelic style of the day into solarized prints, which looked like they had been filtered through a surreal kaleidoscope of acidic color. But Avedon's biggest moment may have come in 1969, when he took his famous portrait *Andy Warhol, Artist, New York City, 8/20/69*. Avedon had Warhol peel back his black leather jacket, revealing a roadmap of scars across his naked chest, the result of an attempt on his life only a year earlier. The photo blended grittiness with formal elegance. Like Arbus, he managed to translate the sitter's personality into a visual language. Unlike Arbus, Avedon's per-sonality remained detached. With the print *Andy Warhol, Artist, New York City, 8/20/69*, he had crossed over from an extremely successful fashion photographer to an artist.

By 1969, even though photography itself hadn't been ac-cepted as fine art, Avedon's Warhol portrait was one of the key

images that helped the public to finally see its possibilities. By combining the accessibility of Warhol's name and likeness with an aesthetic portrait, Avedon moved photography one step forward on the path to acceptance for the medium. Even though people turned out in droves for Arbus's MoMA show, few could envision the work hanging on their walls—most saw it as a peephole into a curious world. You could live more easily with an Avedon than an Arbus.

In the late seventies, Avedon embarked on a six-year project commissioned by Fort Worth's Amon Carter Museum, which resulted in a book containing 125 images called *In the American West*. It was an opportunity for him to stretch out from the boundaries of fashion photography. During 1979 he hit the road in search of outsiders who called west of the Mississippi home. Avedon photographed a cornucopia of blue-collar, hard-scrabble types: oil-field roughnecks, unemployed drifters, carneys, slaughterhouse workers, miners, and the like. They were portrayed in their daily costumes, clothing stained with sweat, blood, and grease. Avedon's genius was to place them in front of his signature white backdrop, lending them the same sophistication as his fashion models. His large-scale prints (three feet high) imbued his subjects with a certain grandeur.

Interestingly enough, Fraenkel's pursuit of Richard Avedon came late in the game and through the back door. During the late 1990s, Fraenkel had been looking at some Avedon books and discovered that his talent had been underestimated. "As well known as his name was, the seriousness of his vision wasn't as clearly understood. Avedon was one of the world's greatest undiscovered photographers."

In 1999, Fraenkel mounted his first Avedon show, which concentrated on his unknown work. He printed up an exhibition announcement that featured a stark portrait, titled *Dick*

*Hickock, Murderer*. Hickock had been one of the subjects of Truman Capote's true crime masterpiece *In Cold Blood*. Other portraits included David Eisenhower, Henry Miller, and Truman Capote himself. The range and scope of Avedon's non-fashion work surprised the audience at Fraenkel's show; there was more to Avedon than fashion. Seeing the work in this new context also allowed people to see his fashion photography in a fresh way. They finally began to see it as art.

Avedon and Arbus took their audiences to places they were unlikely to stumble upon on their own, enabling them to experience a slice of America's underbelly. Given most art collectors led safe, sanitized lives, the unflinching reality of their pictures gave them an alternative world to ponder. Still, each artist always allowed his or her subjects' humanity to shine through. But their work had its differences. Arbus gave us a look at her dark side—Avedon was all light.

The mindset of an adventurous painting gallery during the eighties was to occasionally mount a photography show. It was a way of giving a nod to photography without risking income. The Robert Miller Gallery, one of New York's more progressive spaces, would bracket a Robert Mapplethorpe show with exhibitions of the painters Joan Mitchell and Lee Krasner. The gallery also mounted an exhibition of Andy Warhol's "stitched" photographs created during the mid-1980s, when the validity of his late work was under fire. Here, the Pop artist employed his multi-image format, utilizing a sewing machine and white thread to stitch together four or more of the same black-and-white images in a grid pattern, further blurring the boundaries between art and photography.

The Jeffrey Fraenkel Gallery also introduced painters who took experimental photographs. They exhibited the clever photo

collages of the British expatriate David Hockney, who brought a painter's sensibility to photography by assembling a cluster of snapshots, whose overlapped edges functioned like energetic brushstrokes. Fraenkel showed Chuck Close's giant Polaroids, too. During the late 1960s, Close blew the art world's collective mind with his hyperrealist airbrushed portraits, each based on a photograph, that exposed every pore, blemish, and wrinkle of the sitter's face. Now, he employed an enormous Polaroid camera to do the same thing—only to an even greater extreme with tremendous (7-by-5-foot) prints. These faces were so lifelike that you'd swear you saw one blink.

Besides showing the camera work of Hockney and Close, Fraenkel found other ways to shake up the viewer's perception of photography. With the coming of the first in a long-running series of annual shows, *Several Exceptionally Good Recently Acquired Pictures*, gallerygoers were treated to a veritable graduate course in perception. Fraenkel sprinkled these displays of rarely seen images by famous artists with some remarkable anonymous photographs. He hung new discoveries that turned up in flea markets or simply fell into the hands of receptive collectors and dealers.

By juxtaposing a Richard Avedon image of a man parading through an Italian street on stilts, alongside a wonderful anonymous photo of a female contortionist, posed on two hands with her legs bent over her back, Fraenkel demonstrated that quality was not determined by reputation; good was good and beauty was where you found it. Looking at art in its purest sense is not about responding to work just because it was created by a familiar name. It is about seeing the work for what it is, rather than letting yourself be persuaded by the marketplace.

Here was where Fraenkel broke through as someone who was more than a dealer. He was able to influence the emerging

audience for photography, helping collectors break their addiction to buying only paintings. With his beautiful announcements, museum-quality exhibitions, and devotion to publishing historical photography books, he altered the art world's preconceived notions of photography.

In 1985 Frish Brandt joined the Fraenkel Gallery, having come from the Imogen Cunningham Foundation. She came with extensive experience, having worked with a number of other artists, including future Fraenkel Gallery mainstay Robert Adams. But more than anything, Brandt contributed a fresh perspective, giving Fraenkel a reliable second opinion. He reflected, "She became a huge part of the gallery as well as the glue that holds the place together. The primary ingredients she brought to the table were vision and soul." Five years later, she was made a partner. With Brandt taking over greater responsibility, Fraenkel was freed to focus more on up-and-coming artists.

Richard Misrach's career became his pet project. Fraenkel returned to his Grapestake roots when he approached the Bay Area photographer with an offer to handle his work. If there was one artist that Fraenkel can be credited with discovering, it would be Misrach. During Fraenkel's Grapestake days in the late seventies, he had seen a show at the Oakland Museum of his early pictures of Stonehenge and the Sonoran Desert. Fraenkel recognized that Misrach represented a continuum of the Ansel Adams tradition of revealing subliminal beauty in the landscape.

Misrach's earliest pictures were printed in black and white, but he went a step further by toning his prints with selenium, a process that brought out warm deep browns. While the prehistoric British megaliths and towering saguaros had been photographed countless times, Misrach found a way to refresh

them. He would hit them with a strobe light during nighttime, illuminating their mysterious forms, while creating a theatrical tableau. Though far removed from Adams's views of Yosemite, these photographs were on the same wavelength when it came to revealing treasures in the landscape.

From there, Misrach moved on to full-blown color in the eighties, which included his studies of the Egyptian pyramids. One of Misrach's best works, *White Man Contemplating Pyramids*, depicts the Great Pyramid of Cheops, flanked by a lone man with his hands on his hips, staring in awe, as if to say, "Behold, the greatness of humankind." Misrach's show of Egyptian photos at Fraenkel proved to be the rare "double-dip" in the art market, both a critical and a financial success. A later Misrach exhibition at Fraenkel, devoted to color studies of the Golden Gate Bridge, shot at twilight from the vantage point of Berkeley, sold over one hundred prints.

Last I spoke to Misrach, I asked him how he came to take the remarkable photograph *White Man Contemplating Pyramids*. He told me, "I had gotten there early in the morning, to avoid the crowds and get the best light, and saw this solitary figure staring up. The view reminded me of the historic nineteenth-century pictures by Francis Frith, with great light and a figure for scale. My picture both retained the timelessness of the place and made it current with cues from the fellow's dress and use of color film."

Not long after, Misrach began shooting another pyramid that was a world away: the Luxor Hotel in Las Vegas. By contrasting a giant sleek black pyramid with the urban sprawl of surrounding hotels and buildings, telephone wires, and vacant lots, he created a meditation on what has become of Western civilization. Misrach's Giza and Las Vegas images were only the latest examples of what had become the central theme in his work:

human intervention in the landscape. Viewing the photographs from Giza and Las Vegas side by side offers a poignant demonstration of how photo emulsion and paper can convey emotion as readily as oil and canvas. Misrach was so pleased with *White Man Contemplating Pyramids* that he printed a few 60-by-72-inch oversize images, encouraging his audience to view it as a painting.

Large-format photographs made it psychologically easier for collectors to view photos on par with paintings, since they were accustomed to typical canvas sizes. Nowhere was that felt more acutely than in the work of Andreas Gursky. For years, Gursky's iconography has centered on the landscape of man-made spaces: hotel interiors, stock exchanges, and big-box retailers. His work was grouped with other conceptually based German artists such as Bernd and Hilla Becher, and their disciples Thomas Struth, Thomas Ruff, and Candida Hofer. What also united them, besides their nationality, was the substantial scale on which they worked, often utilizing computer technology to enlarge and manipulate their images. Gursky, who was the son of a commercial photographer, would alter a digital image on the computer, often combining separate photos into one panoramic shot. By dramatically scaling up the print, adding a substantial white border, and mounting it to a clear sheet of Plexiglas, Gursky gave his pictures the visual heft of major paintings. At the risk of using a cliché, the scope and presence of a Gursky have to be seen to be believed.

The best description of his art belongs to Calvin Tomkins, who said that "Gursky's huge, panoramic color prints—some of them up to six feet high by ten feet long—had the presence, the formal power, and in several cases the majestic aura of nineteenth-century landscape paintings, without losing any of their meticulously detailed immediacy as photographs." In

practical terms, Andreas Gursky is the latest great contender in photography's claim to be painting's equal.

His masterpiece, which not so coincidentally holds the record at auction for a photograph at $3.3 million, sold at Sotheby's London in 2007, is *99 Cent II, Diptych*. Here, Gursky depicts the fluorescently lit interior of a bargain store, whose garish rows of candy, soda, and cheap products read as a cross between a photorealist canvas and a color field abstraction. Just the top panel of the diptych measures 6½ feet by 11 feet. The work's large format and mesmerizing color hit hard, leaving you overwhelmed by pigmentation and pattern.

Andreas Gursky's 2010 inaugural show at the Gagosian Gallery's expanded space in Beverly Hills displayed what might be his true legacy, *Ocean I–VI*. Here, Gursky jettisoned his camera and worked with satellite photos of the oceans. Gursky created a group of six 8-by-11-foot pictures showing vast expanses of indigo blue water edged by landmasses. Michael Govan, the director of the Los Angeles County Museum of Art, compared them to the sublime experience of communing with the Mark Rothko paintings at the Rothko Chapel—then acquired a group for the museum. The dramatic impact of the *Ocean* series was equal to a large-scale painting, if not more so due to its real-life depiction. The inky blues are so saturated and distinct that you forget you are actually looking at a photograph. Painting? Photograph? With the *Ocean* series, Andreas Gursky had pushed the boundaries of photography beyond anything Ansel Adams could have imagined.

Though the physicality of Gursky's work convinced the art world that photography was painting's visual equal, it was Cindy Sherman's work that leveled the playing field as far as the art market was concerned. It was her eventual inclusion in a major

New York auction house sale of paintings and sculpture that did the trick.

Sherman's artistic journey began in 1977, when she moved to Manhattan after studying art at Buffalo State College. Through her boyfriend, Robert Longo, Sherman found representation with the cutting-edge Metro Pictures Gallery, which represented Longo along with fellow painters Jack Goldstein and John Miller.

In 1980 she had her first solo show at the gallery, exhibiting her 8-by-10-inch black-and-white *Film Stills*, a series of sixty-nine photographs where Sherman herself is the subject. Sherman's strategy was to alter her appearance by using makeup and a diverse wardrobe, creating distinct personas. Most of the work comments on female stereotypes in America. Sherman appears as a housewife slaving over a stove, a nouveau riche lady surrounded by her gauche living room furnishings, and a woman with a forlorn expression on her face as she opens what appears to be a Dear Jane letter. In one of the finest works from the series, a youthfully dressed Sherman stands along a highway, a suitcase by her side, gazing ahead at the road's center stripe, which fades into oblivion. Her character is running away—but from what and to where?

Each of the photographs has a "B movie" sensibility. A press release from MoMA summed it up: "Her film stills look and function just like the real ones—those 8-by-10-inch glossies designed to lure us into a drama we find all the more compelling because we know it is not real." MoMA later acquired a complete set of the *Film Stills* for a reported $1 million in 1995.

Sherman's *Film Stills* caught on in a big way, catapulting her to the forefront of the eighties SoHo art scene. She began working in color, enlarging her prints while continuing to invent new roles for herself. Then she upped the ante by taking a tour

through the grotesque, photographing her body covered with fake appendages. There was also an elegant side to her work, as evidenced by a series where she dons elaborate costumes and appears as Renaissance royalty.

While Sherman gained recognition and popularity, it wasn't until her auction crossover—from the photography sales to the painting sales—that she gained art market leverage. During the early 1990s, when the art business was in dire straits, one of the experts in charge at either Sotheby's or Christie's quietly slipped a Cindy Sherman *Film Still* into a contemporary art auction of painting and sculpture. Not photography, but *painting and sculpture*. At the time, it was an innocuous move that was scarcely noticed. Regardless, the symbolic act of including an inexpensive contemporary photograph—not a vintage work of great monetary value by Adams, Weston, or Evans—further transformed how the art world viewed photography and closed the financial gap between photography and painting.

The question, of course, was why Cindy Sherman? There were plenty of other worthy photographers whose recent work resonated with the collecting public. But a good bet as to why Sherman was chosen to be the Jackie Robinson of the contemporary art auction world was that her work was grounded in the conceptual. The creative ideas behind her art were as important as what the photographs looked like. The auction houses decided they could hold their own with painting. It also helped that Sherman showed with conceptually based painters handled by Metro Pictures. Once again, having an established painting gallery handle a photographer provided the context the art market was looking for to justify its actions.

In 2010 Sherman achieved her auction record when *Untitled #153*, a large-scale color print of a stupefied Sherman, lying on mossy ground while staring up at the viewer, her face and

shirt soiled with dirt, brought $2.7 million. Her photography was now selling in the same range as works from Andy Warhol's vaunted *Mao* series.

The Fraenkel Gallery began sharing in the financial success brought on by the triumphs of Sherman and other major photographers. The art market had finally embraced photography as a viable medium to collect. The problem had now become getting high-quality material—just like the dilemma facing the market for blue-chip paintings. In fact, the greatest problem facing the entire art market, from old masters to modern art, was that collectors were holding onto their best works of art, viewing them as financial assets that stayed in the family—much like real estate and more traditional investments. Now, Fraenkel found himself trying to identify new artists, in an effort to supply his growing collector base with available work. The future of the photography market belongs to those dealers who discover the next round of Richard Misrachs.

"The problem with photography used to be that people looked too quickly. Since photographs generally take only a fraction of a second to make, many believed they required only a fraction of a second to see. Serious art people were slow to understand that a photograph could contain the depths of a painting, even if it has always been true that great photographs can be as complex and rewarding as any other great work of art," said Fraenkel.

Collectors have learned to devote as much time to looking at a photograph as to a painting. The medium now commands that respect. Exceptional photos bring you back again and again—just like outstanding paintings. Learning how to look: that's what the Jeffrey Fraenkel Gallery's thirty-year journey has been all about. Or as Jeffrey succinctly put it, "Photography has a peculiar, insoluble connection to the real world."

Peculiar or not, as photography continues to grow in market stature and photographers continue to ratchet up their aesthetic ambition, the key figures that Fraenkel has consistently exhibited—Friedlander, Arbus, Avedon—will become even more sought after as investments. The quest to own the best never seems to change. With the continued disintegration of art market categories, Jeffrey Fraenkel, who is considered one of the finest photography dealers around, will eventually be ranked as simply one of the finest art dealers around. Period.

Louis Meisel with his wife, Susan P. Meisel.

## Louis Meisel and Photorealism

LOUIS MEISEL was seated behind his desk, surrounded by treasures gathered from a lifetime of collecting art. An impressive Richard Estes urban landscape hung to his left, a small Chuck Close portrait of his wife Susan was situated to his right. At sixty-eight, Meisel is still rakishly handsome. His accomplishments are betrayed by a perceived arrogance; a permanent grin seems to be etched on his face. And Meisel really doesn't care if you see it that way. His success was achieved in spite of an art world that never completely bought into his vision. Even today, a broad swath of collectors, critics, and museum curators give short shrift to Photorealism.

Since 1964, when Robert Bechtle painted the first true Photorealist painting, the movement has been on the defensive. Photography, while a fine art in its own right, has also been used as a tool to help painters see and remember. Referring to photos as source material is a proven strategy for many. But once artists wanted to "copy" their photographs and turn them into "look-alike" paintings, the art world cried foul. Painters ranging from Malcolm Morley to Chuck Close were busy creating an intense form of realism that not only drew inspiration from photography but strove to reproduce it. Yet if an accurate transference of information was the goal, how could a hand-rendered

picture compete with a machine-perfect photograph? Where's the creativity in copying an image?

Louis Meisel has been battling for Photorealism's rightful place in museum collections and art history books for over forty years. He was introduced to the art world with a flamboyance that would mark the rest of his career. He had grown up in Brooklyn to parents who owned a fine-paper business, selling to publishers, stationers, and all sorts of printers. Though Meisel knew little about art, he knew enough about celebrity to know he wanted to be where the famous gathered. As a fifteen-year-old, he managed to hang out with the Abstract Expressionists at the Cedar Tavern in New York. Meisel recalls, "It was 1957 and I had this precocious friend who was into art and somehow knew that the top painters congregated at this bar on Eighth Street. The problem was they didn't show up until late at night and I had a ten o'clock curfew—but I decided to blow it off. We walked into the bar and there was de Kooning arguing with [Franz] Kline! Unfortunately, Pollock wasn't there—he had died only months earlier. But I did befriend Theodoros Stamos, who introduced me to Mark Rothko."

Though the teenager became a regular at the pub, Rothko consistently ignored him. A few years later, in 1960, Meisel enrolled at Tulane University in New Orleans, largely because Rothko was the artist in residence. He would occasionally run into Meisel on campus and give him the briefest of acknowledgments—a cursory nod. But it was not the last time their paths would cross.

While majoring in business, Meisel decided to take a course in art history, the equivalent of Art 101. He enjoyed the class immensely, while also savoring the ratio of female coeds to male: approximately one hundred to four. But despite his genuine interest in art, he had trouble memorizing the slides and wound up flunking the course. This led to a major epiphany. Without

knowing what he was going to say, he approached his instructor and blurted out, "Look, I intend to have a career in art—I just have trouble with dates and titles. But I know my stuff and can prove it. How about if you pick ten art objects that relate to what we studied, created over the last three thousand years, and if I correctly identify seven of them you give me a passing grade." The professor was dubious, but taken in by Meisel's charm, agreed to his proposition. He got eight out of ten right and passed the course with a grade of D. More important, it led to a commitment on his part to enter the art world.

During his college years, Meisel laid the groundwork for becoming a dealer. He approached a number of architecture students, many of whom were also painters, and cut a deal to sell their work for twenty-five dollars a pop (Meisel's commission was ten dollars). He then solicited Tulane's fraternity houses with a sales pitch that carried an irrefutable logic: instead of cheap posters from the French Quarter, for the same money they could have original art in their room. Since Tulane had an affluent student body, the future gallerist found plenty of takers.

In 1962 Meisel graduated and returned to New York. He looked up his old Cedar Tavern buddy Theodoros Stamos, who promptly hired him as a studio assistant. He started out as a gofer, stretching canvases and running errands. One day, Rothko appeared and Meisel wound up driving him and Stamos to an art supplies manufacturer, where they purchased a carton of expensive paper. Meisel drove Stamos home, dropped off half the carton, and then took Rothko back to his studio. During the drive, the young man remained silent, too awed to make small talk with the maestro.

When they arrived, Rothko left him alone to deal with the heavy box. Once he had schlepped it inside, Meisel found the Russian-born painter sitting in his favorite Adirondack chair,

staring intensely at a painting. And again Meisel was too intimidated to say anything. After twenty minutes, when no instructions were forthcoming as to what to do with the paper, he quietly slipped out. About a month later, Meisel's phone rang. The person on the other end didn't say hello. All he heard was this gruff voice say, "It's Mark." Meisel's first thought was, *Who the fuck is this?* Then the voice barked, "I need more paper—get it!" That's when Meisel realized it was Rothko. He was stunned. So he went out and bought 150 sheets of paper. Rothko used them to paint his small oils—eventually he'd mount them on canvas. Meisel returned with the paper and sheepishly told Rothko he owed him $300. Rothko just glared at him and yelled, "Take one of those!"

"One of those" turned out to be a painting on paper. Meisel walked over to a table and quickly picked out a 22-by-30-inch picture with two cloudlike forms, one black, the other gray-brown. Meisel recalled, "I had no idea what it was worth at the time. All I knew was I owned a Rothko!"

Emboldened by the experience, he decided to buy a Stamos for $600, agreeing to pay the painter five dollars a week. When Meisel's father heard what he had done, he was livid, pointing out that he himself earned only $200 a week. But his father changed his tune when he showed up at Meisel's place with some friends, one of whom spied his recent acquisition hanging on the wall and asked, "Where did you get the Stamos?" Meisel seized the opportunity and made an appointment to take them to Stamos's studio, where they proceeded to spend $3,000 on a large canvas. According to Meisel, "Stamos gave me $1,000 as a commission for making a sale. This was when I knew I could make a living as an art dealer." Louis Meisel, now all of twenty-one, owned an original Mark Rothko and a Theodoros Stamos—only five years removed from hanging out with them as a teenager at the Cedar Tavern.

In 1969, after seven years of working for artists and setting up the odd deal, Meisel felt he was ready to set out on his own. He leased a tiny 200-square-foot Madison Avenue storefront on one of the best stretches, near Seventy-ninth Street. The biggest problem he faced was not the size of the space but what to hang in it. Large-scale paintings and sculpture were out. So were many of his favorite painters, because they were already represented by Ivan Karp's new SoHo venture, O.K. Harris. While Karp is generally associated with Pop Art, few remember that in 1969, when he left the comforts of Leo Castelli to open his own gallery, his plan was to show a diverse range of artists. He had a drawer full of slides, gathered over the years, from artists looking for representation. Several of the best painted in a highly realistic style, including Robert Bechtle, Ralph Goings, John Salt, and Richard McLean. Then there were their sculptor counterparts, specifically Duane Hanson and John DeAndrea.

As a growing number of galleries began to move to SoHo, Meisel realized something radical was happening downtown and knew he wanted to be part of it. Taking a space on Prince Street, just around the corner from O.K. Harris, Meisel put together a stable of his own realists. He realized Karp didn't hold a monopoly on the genre. While Karp gravitated toward artists whose main subject was situated in a specific environment, such as a rusting jalopy in a junkyard, Meisel preferred those painters whose subjects were "more in your face, close-up, and intense." With that in mind, he decided to pursue Charles Bell, Audrey Flack, Ron Kleemann, Tom Blackwell, and others. All were artists whose work placed an emphasis on tightly cropped compositions, such as those by David Parrish, who would highlight the cross-section of a motorcycle's glistening chrome engine rather than the entire bike. Though Meisel would go on to work with Theodoros Stamos, his former mentor, and Mel Ramos, a Pop

artist in good standing, he devoted most of his energy to Photo-realism. One might say he became obsessed with the art form.

At the time, the movement didn't have a name yet, so there was little to galvanize the artists. The term "Pop Art," put into play by the critic Lawrence Alloway, went a long way toward helping the public anchor that group of artists in their imagination. When it became clear that a number of painters were emerging who derived inspiration from the photograph, no one knew what to call them. Critics began throwing around terms like "Super Realism" and "Hyperrealism." Ivan Karp suggested the tag "Radical Realism." But nothing seemed to stick.

Meisel was exhibiting a group of realists when the critic Gregory Battcock walked in. Deciding to write about them, he asked Meisel, "What are we going to call these guys?" Meisel mused they were realists who worked with photographs, so he threw out, "What do you think of Photorealism?" Sure enough, Battcock used the term in his review. In 1970 the Whitney Museum hosted its first show of the new decade and called it *Twenty-Two Realists*. In the accompanying catalog essay, the writer referred to a group of seven artists as Photorealists—Meisel's term had stuck.

The Whitney show was followed by an exhibition of realism at Documenta 5 in Kassel, Germany (1972). Documenta took place every five years and was considered one of the international art world's premier events—possibly more prestigious than the Venice Biennale. After the show, Ivan Karp wound up selling almost all of his Photorealist inventory to Europeans, leaving little available back in the States. As a result, many of Photorealism's "greatest hits" remain in Germany, specifically at the Ludwig Museum. The market for the work grew increasingly competitive.

Photorealism sales remained steady for the next six years. But one of the most gratifying moments in Meisel's career began

in 1973 when he was commissioned by Stuart M. Speiser, an aviation attorney, to put together a "world beating" Photorealist collection. Speiser gave Meisel a then generous budget of $150,000. The only catch was each of the pictures had to feature an airplane in some capacity. Meisel went to work, commissioning paintings from both his artists and Karp's. The long list included Richard McLean, Charles Bell, and Ron Kleemann. The completed collection was sent on a world tour, spreading the Photorealist gospel. On its return to America, it stopped at Tulane, Meisel's alma mater, where he gave a talk that concluded with the story of how he almost flunked art history. It was a poignant moment for Meisel. Eventually, he arranged for the Speiser Collection to be donated to the National Gallery of Art in Washington DC.

An art movement is only as good as its artists, and Photorealism's high-water mark was Chuck Close. Though Malcolm Morley's early ocean liner paintings represent the formative stages of the movement and Robert Bechtle's early work the historical breakthrough, Photorealism began in earnest in 1969 with Close's imposing *Big Self Portrait*—the one with the cigarette dangling from his mouth, emitting a wisp of smoke. The artist let it all hang out, displaying no shame over his thick Coke-bottle-lens eyeglasses, receding hairline, and unshaven face. Working from photographs, Close wielded an airbrush to create seven other giant, black-and-white, highly convincing portraits of fellow artists and friends. By "giant," we're talking about a typical painting measuring over nine by seven feet. By "highly convincing," we're speaking of being able to examine every minute detail of the subject's face—even what we *don't* want to see. And by "friends," we're referring to portraits of rather mundane faces, not distinguished by fame or beauty—their ordinariness was part

of the shock value. Close's work was extreme, and extremely good.

From his early black-and-white portraits, Close progressed to a handful of airbrushed giant color portraits, followed by some incredible works on paper made from the artist's fingerprints, a group of equally astonishing woodcuts, and even a few pressed paper-pulp prints—including one of his young daughter that functioned as a low-relief sculpture. It was as if Close was reinventing the portrait with each change of medium.

But his strongest subject was always himself. Eventually, he learned how to use an industrial Polaroid camera and began taking oversize black-and-white self-portraits—once shown by Jeffrey Fraenkel—bringing his work full-circle to its photo-based origin. Still, Close was first and foremost a painter. He believed that a painting and a photograph are made in different ways and it was crucial to understand the difference. Close demonstrated that Photorealism may have been based on the camera, but it was the steady hand of the artist that differentiated it. His biggest annoyance was being referred to as a Photorealist. He simply wanted to be seen as a painter.

At the height of his career, tragedy struck. Only forty-eight, Close experienced a collapse of his spinal artery, instantly paralyzing him and putting him in a wheelchair. His tragic story read like fiction. It was a tale about the disintegration of an artist's personal life, hopelessness over never being able to paint again, and the eventual resurrection of his career as he relearned how to paint with a new technique that miraculously allowed him to continue his art.

Close's postdisability pictures are still constructed as a grid, one small square at a time. But rather than blend seamlessly like his early airbrushed portraits, the grid pattern is readable up close. At a distance your eyes fool your mind and pull the dots, circles,

and squares together into a single image. With this body of work, the viewer was more focused on the work itself, rather than how closely the painting resembled a photograph. Though he would always be referred to as arguably the greatest Photorealist, thanks to his later work Close was now seen as a pure painter. While Meisel never represented him, the two developed a personal friendship. This led to an interesting trade between dealer and artist. As Meisel recalls, "Chuck was visiting me, and had admired my fully restored red-and-black 1964 Austin Healey, worth $15,000. One thing led to another, and I offered to swap the car for anything he might create and deem appropriate. Not long after, to my great surprise, he showed up with a portrait of my wife, Susan. Startled, I said, "This isn't a fair trade. Your painting is worth $50,000." Chuck laughed and said, "No, it *is* a fair deal. Here's why: when I sell a $50,000 painting at Pace, I end up with $25,000. After taxes, I end up with about $15,000."

The Photorealists Richard Estes, Robert Bechtle, Ralph Goings, and Richard McLean provided a counterpoint to Close and to one another. Each of them staked out very specific imagery, creating boundaries of subject matter no other artist dared cross. Richard Estes captured the intensity of New York's urban landscape, emphasizing storefront windows and how their reflections created miniature abstract paintings. Bechtle's niche was the banality of suburbia, specifically stucco homes in San Francisco's outer districts, complete with the family station wagon in the driveway. Goings's territory was initially old pickup trucks, often parked in front of a restaurant or diner, and then later, Goings ditched the trucks to concentrate on diner interiors, especially close-ups of ketchup bottles and other condiments. McLean painted thoroughbreds flanked by the occasional jockey, in what were considered the finest horse paintings since the eighteenth-century British artist George Stubbs.

With Chuck Close unavailable (he was represented by the Pace Gallery), and Richard Estes long ensconced at Allan Stone, Meisel craved a powerhouse Photorealist he could call his own. In 1969 he got his wish when Charles Bell walked into his Madison Avenue gallery with three 8-by-10-inch still life paintings under his arm. Meisel said, "He asked if I could sell them so that he'd wind up with $100 each. I handed him a check for $200 each and told him to go home and make some more. After six months of selling two of his paintings a week, for $500 each, I suggested, 'Why not go bigger?' I didn't see him for six months and then he showed up with a Raggedy Ann and a Tinker Toy painting—each five feet high. I immediately sold them for $1,800 a piece."

Though they proved salable, Bell's earliest Photorealist forays depicting children's tin toys tended to be a bit on the slick side; they looked slightly commercial. During the 1970s Bell developed a far stronger group of paintings—magnified views of gumball machines. Like Estes, Bell played with the visual properties of glass, specifically how it distorted the colorful gumballs housed within it. Bell's vending devices became more than penny candy dispensers; they were meditations on the overlooked objects that surround us. Painting whimsical objects from one's childhood was risky business in the art market, but Bell's Renaissance touch and brilliant compositions prevented these works from slipping into nostalgia. Bell later turned his attention to glass marbles, emphasizing the abstract qualities of their fanciful swirls, and a series—the *Pinball Machines*—that to this writer's eye made him (outside of Close) the genre's strongest practitioner. However, he remains one of the underacknowledged Photorealists compared to Close, Estes, and Goings, who are generally considered the big three of the genre.

One of the offshoots of Photorealism was the sculpture of John DeAndrea and Duane Hanson, who both showed with

Ivan Karp. Hanson's work strove to alter our perception of everyday subjects. Anyone who viewed a typical Hanson, such as a life-size bank guard wearing his official uniform and sidearm, was duped into thinking the sculpture was a real person. The artist's technique was so dazzling that you'd swear you saw the sculpture move. Hanson accomplished this illusion by using actual people for his polyurethane casts and then painting them with the same fanatical attention to detail as Chuck Close; blemishes, freckles, veins, and scars were all revealed.

Hanson's post-1970 sculpture portrayed ordinary people: a black cleaning woman holding a duster, flanked by a large plastic trash can on wheels with cleaning supplies arrayed on its side; an overweight supermarket shopper with her hair in curlers, pushing a shopping cart overflowing with TV dinners; a pair of elderly tourists, the man decked out in a Hawaiian shirt and Bermuda shorts with a camera dangling from his neck. They were a slice of Middle America, revealing boring, if slightly desperate lives. As Hanson was once quoted as saying, "I'm not duplicating life. I'm making a statement about human values."

If anything, Hanson's work offered a little too much reality. Confronting his figures was unnerving. You expected his people to come alive and walk away. Many a collector contemplated owning one, but often backed down because he couldn't handle the idea of living with it. Those collectors who bought Hansons probably did so partially for the fun factor, imagining the reaction of their guests at the next cocktail party. I once observed a gallery visitor approach a Hanson sculpture of a seated gray-haired secretary taking dictation, and ask her a question about the exhibition. When no answer was forthcoming and the visitor realized she had been fooled, she caught me looking at her and left the gallery in embarrassment.

Hanson's extreme realism inspired a new wave of artists who became interested in material illusionism. This development is

well illustrated by the work of Marilyn Levine, who used clay and paint to create objects that looked like they were made out of old leather. When you came across one of her bomber jackets hanging on a coat rack, you would have assumed it was left there by a visitor had it not been installed in a gallery. Shows were soon organized around the theme of material illusionism, including the groundbreaking *Reality of Illusion*, curated by Don Brewer at the Denver Art Museum in 1980. Though the exhibition garnered a lot of attention, most of the featured artists, including some of the bigger names, like James Havard, eventually fell by the wayside. Despite the brevity of the movement, it set the table for what came next for painters like Dan Douke (pronounced Do-*kay*).

The story of this Los Angeles–based artist illustrates the full evolution of Photorealism. He went from creating pictures of hyperrealistic suburban scenes, to shaped canvases that appeared to be sheets of rusting steel, to lifelike paintings of the latest computer boxes. Douke's transformation from being a Photorealist, to a material illusionist, to his current work, which comments on Pop and Warhol-inspired consumerism, is revealing.

During the seventies, Douke exhibited Photorealist canvases of L.A. backyard swimming pools, whose shimmering sun-dappled water symbolized the city's glitz and allure. Often he'd toss in an inflatable raft and a beach ball for good measure, reminding us of our material culture and the growing mountain of "stuff" in our lives. Though these paintings were highly attractive, Douke arrived a little too late to be swept up in the first wave of Photorealism. He realized he had to move on if he hoped to receive lasting recognition as an artist.

Turning his attention to what he referred to as "icons of expendability," Douke found his métier. He decided to paint the disposable and overlooked, specifically cardboard boxes, like

those that once contained the rafts and beach balls in his pool paintings. He eventually settled on generic cardboard cartons with a patina, particularly those with interesting markings, handling scuffs, and shipping tape. Douke re-created these "cartons for the wall" by stretching three-dimensional canvases, leaving the backs open, then utilizing an airbrush to render the container on five sides to the point of perfection. A typical picture projected out from the wall a good six inches or more, reading as an object as much as a painting. Douke's *Cardboard Box* paintings went beyond mere reproduction. As the critic John Yau explained, "His celebrations of the ordinary make it apparent that the everyday world is stranger and more disturbing than any fiction."

Not long after completing the first works in the series—Douke would go on to execute 193 *Cardboard Box* paintings—he received a break when Ivan Karp phoned, inviting him to exhibit in New York. Douke told me, "My wife and I immediately hugged each other—I felt like a Saturn rocket that was about to lift off!" In 1979 Douke arrived at his Manhattan debut to discover his exhibition had already sold out. This sort of thing currently happens in Chelsea on a regular basis, but in SoHo, during the seventies, it was unheard of. Karp took Douke into his office, handed him a piece of O.K. Harris note paper, and said, "See this, kid? This is a waiting list for your work." Douke stood there stunned, drinking in a remarkable moment in his young career. Then Karp said, in his inimitable fashion, "So what are you doing here? Get back to California and paint!"

Which is exactly what Douke did. Over time, he turned his attention to the surfaces of weathered sheets of steel: the sun-faded paint and rust on the back panel of an old pickup truck, the rough edges of industrial steel cut with a welding torch, and the chalk markings on steel plates that covered street repairs. In short, he turned his skills from packaging which held things

to steel which held our world together. While these paintings also met with immediate market success, Douke wasn't entirely satisfied. He recognized that "an artist has to respond to the cultural record of his time." Douke sought the solution by referencing Warhol's *Brillo Boxes*. While Warhol drew on an intentional mass-production style, which was being churned out by his Factory, Douke elected to take the opposite tack. He wanted to create an intimate object that looked like it was fabricated on a conveyer belt, but in reality was one-of-a-kind.

Combining Photorealist style with his cardboard box format, he added a new twist—iconography that had its finger on the pulse of our times. Douke began to paint discarded iMac and iPhone boxes. Though people were familiar with Apple products and the graphics that defined the boxes they came in, Douke used that familiarity to provoke you into thinking about where all of this personal technology was going. His imagery was future-oriented. He wryly observed, "Computers and their packaging offered assurance that life is going to be 'greater later.'" Douke's journey saw him take Robert Bechtle's earliest Photorealist pictures of suburbia, which commented on where we lived, and Marilyn Levine's lifelike objects, which spoke of how we lived, and combined them with imagery from a contemporary computer icon, which wondered aloud where our lives would go next.

The Louis K. Meisel Gallery would always be associated with Photorealism. When it came to the movement in general, Meisel offered a persuasive argument for the integrity of the work and its long-term prospects. In an interview with David Lubin, he discussed how the artistic journey of Photorealist painters differed from other artists: "In the eighties, artists came in to show me work and said, 'We are taught that we don't have to study art history, and we don't have to spend years learning how to draw. We

just have to express ourselves.' And I would tell them, 'You should do that on a psychiatrist's couch, not on a canvas that you stick in front of my face.' The idea was that if we use this word 'quality,' it's elitist and eliminates so many people from being able to call themselves accomplished artists, because it requires four or five years of learning to draw and learning about art history and whether the paint is going to stick to the canvas and that sort of stuff. Very few people want to do that, are capable of doing that, have the discipline or the skills, or the genetic makeup to do it. Therefore, it's—well, you know, not politically correct or democratic, but then why should art be?"

A good question. And one Meisel was willing to address by writing a book about why Photorealism mattered. In 1980 Abrams released a large coffee-table volume written by Meisel called *Photorealism*. The book offered a comprehensive overview of virtually all of the genre's artists of consequence. Though the financial benefits to Meisel and his large holdings of related material were obvious, the book also made a statement and placed the movement within the larger context of great art, where it deserved to be recognized.

With the publication of *Photorealism* and two follow-up volumes to update recent developments, Meisel established himself not only as one of the founders of the movement but its leading authority. Rather than rely on critics to cement the art's relevance, Meisel took matters into his own hands by giving scholars a set of definitive reference books that went a long way toward assuring the historical staying power of the work.

Louis Meisel never played the game as it was supposed to be played. To begin with, he dressed unconventionally. When he started in the business, male art dealers wore coats and ties. If you wanted to appear nonconformist, perhaps you sported a tie with too much personality. Leo Castelli, the industry standard

for fashion, always wore beautifully tailored Italian suits. The erudite André Emmerich also made a dapper appearance. Gallerists dressed formally for a reason. The message they wanted to convey to their clients was that this was a place of business and distinction. Meisel, ever the contrarian, would arrive at work in blue jeans and cowboy boots.

For another thing, Louis Meisel was accessible. Taking a cue from Karp, he gave an audience to artists who wandered in off the streets with hopes of showing their slides. Collectors eager to learn more about Meisel's roster of artists were not only shown around the gallery, they were invited upstairs into his loft to enjoy his personal collection. Sure, this was good business, and Meisel valued prosperity, but he also seemed to derive equal joy through sharing the work he loved.

As for art-world politics, Meisel never joined the ADAA (Art Dealers Association of America), an organization composed of many of the nation's leading dealers. It was an elitist group; membership was by invitation only. Among the necessary credentials was that you had to have been in business for at least five years. The ADAA cites the statistic that 90 percent of all galleries close within that period of time. While Meisel's swashbuckler image hurt his chances for membership consideration, he probably wouldn't have joined even if asked, because he never bought into their hypocrisy. The ADAA's bylaws make a lot of noise about upholding the highest ethical standards in the profession—a dubious proposition at best, given there are no standards. Meisel understood that being an important art dealer wasn't about impressing your colleagues; it came down to working with great artists.

Yet if you decided to do it your way, and not join organizations or pay homage to the most prominent dealers, critics, and museum curators, you might find that your best artists didn't

receive the attention they deserved. Meisel's controversial status in the business may have cost Charles Bell a few votes in recent elections for inclusion in the hypothetical artists' hall of fame. But the sands of art history are always shifting. In future balloting, based on the quality of his art rather than his outlaw gallery representation, Bell's quest for status as a top-tier Photorealist is likely to turn into a landslide.

But even more important than being an art-world rebel, Meisel set a template for maverick dealers by insisting the profession is about taking a position. Most galleries, my former space included, took a supermarket approach, offering a wide variety of styles and subjects. With many dealers now handling at least some photography, the diversity has grown. As a gallerist, my decisions over what to show were motivated by work I responded to—as simple as that. I would have liked to believe that the coherent thread that ran through my program was quality.

Meisel's approach was that he wanted you to know what he stood for, rather than avoid being pigeonholed, which most galleries feared. He chose to represent Photorealism exclusively. His forty-year commitment to the movement reminded me of a scene from the movie *The Big Chill*, where the actor Kevin Kline admonishes someone for questioning why he always plays soul music. Kline grows semiserious and says, "There is no other music—not in my house." When it came to the Louis K. Meisel Gallery and Photorealism, there was no other art—not in his space.

Today, Meisel has managed to retain his fidelity to Photorealism's origins, continuing to show its founding artists. In an act of defiance, he remains one of only two major galleries left in SoHo. He shares the neighborhood with his longtime Photorealism supporter O.K. Harris. Meisel is also partners in an uptown gallery space, on Fifty-seventh Street, called Bernarducci Meisel. He

never considered migrating to Chelsea, believing those collectors interested in his program—specifically his secondary-market material, which consists of early Photorealism and Mel Ramos paintings from every decade—will seek him out.

In conversation with Meisel, we discussed how the influence of Close, Estes, and company has been felt in later developments in the art world. According to Meisel, "Photorealism affected the thinking of artists like Jeff Koons and Richard Prince, who blew up photographs rather than painted them. Just look at Koons's *Made in Heaven* series (the billboard-size pictures featuring Cicciolina, the Italian porn star and the artist's former wife) and Prince's *Marlboro Men*. Then there are all of the photographers who work like painters, including Andreas Gursky and Thomas Struth. People are writing about Photorealism again. It's in the air."

There's talk of Meisel doing a fourth and "absolutely final" book in his Photorealism series. This volume would explore the movement in the digital age. With current access to high-quality megapixel cameras, artists are utilizing photographs that display a greater range of visual information than ever before. Meisel wants to write about how that has influenced recent paintings and show where technology has taken the work.

As for the current state of the Photorealist market, Meisel emphasizes that all of the living major artists continue to paint, producing only three or four paintings a year—all of which are sold. He says, "We're talking about one of the slimmest bodies of work available. There's no material. The market has come back around to the days of Documenta 5, where once again you have an international group of collectors competing for paintings. These days, I sell far fewer pictures, but for a lot more money. The bottom line is people buy Photorealism because they want to take it home and look at it. It's that simple."

And that complex.

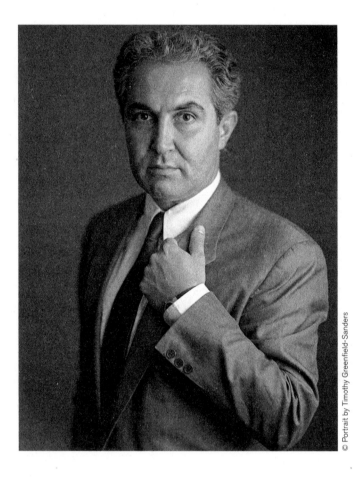

Tony Shafrazi.

## Chapter Ten
## Tony Shafrazi and Street Art

L ET'S GET the 800-pound gorilla in the room out of the way. In 1974 Tony Shafrazi, an aspiring artist, brazenly walked into the Museum of Modern Art and spray-painted red graffiti on Picasso's masterwork *Guernica*. Shafrazi called it an act of protest; the police called it vandalism. *Time* magazine's Robert Hughes, one of the most erudite and widely read critics in the world, reported it best: "For some reason the trustees of MoMA did not prosecute Shafrazi; he soon reemerged as a prosperous dealer in graffiti art, in a dazzling act of chutzpah."

Shafrazi's indiscretion would put every future development in his career under the microscope. By spraying the words "Kill Lies All" over the twenty-five-foot-long surface of *Guernica*, he sealed his fate as someone perceived as both reckless and gutsy. This lone act of infamy would attract certain artists and collectors to him and repulse others. Still, it may have helped him more than it hurt him; the nature of the art world is that many of its participants get a vicarious thrill out of dealing with the bad boys of the industry.

Shafrazi's edgy reputation would hold him in good standing during the 1980s, when the artistic energy bubbling up in the East Village exploded in a wealth of street art. This outpouring of wildly uneven painting would have happened with or without

Shafrazi. His achievement was providing a coherent gallery environment that let us see the work of painters like Jean-Michel Basquiat and Keith Haring with clarity. He also brought his own sensibility as an artist, perhaps the only art-world visionary to do so. It was a point of reference he would call upon repeatedly throughout the years.

Most people forget that when street art emerged, it was considered a passing fad and unlikely to survive the test of time. Street artists were viewed as uneducated ruffians, who "painted" with one finger on the nozzle of a spray can, one eye on the wall, and the other peeled for the cops. Established SoHo dealers didn't take these urban "taggers" seriously, seeing little possibility their work would translate from the decrepit walls of boarded-up buildings to the pristine walls of their galleries.

To understand the studio of the streets and the world of graffiti art that Tony Shafrazi stepped into, it's important to know two words about the East Village—real estate. During the early eighties, rents in SoHo had grown so exorbitant that young people who wanted to open galleries or lease studios were frozen out of the action. However, the Lower East Side of Manhattan remained affordable, luring artists, followed by a raft of aspiring dealers.

My own introduction to the East Village came in 1984; too early to observe its fermentation but just in time to enjoy its full-blown moment. Steven Leiber, an eccentric but alert San Francisco private dealer, had piqued my interest by turning me on to the work of Jean-Michel Basquiat. He showed me about twenty sheets of typing paper where the artist used crayons and ink to scatter skulls, crowns, and distorted figures. But what was really intriguing was Basquiat's use of language. He jotted down the word "Bird" (a reference to Charlie Parker) and repeated it five or six times, then canceled one out by drawing a line

through it so you'd notice it more. Basquiat's work was the visual equivalent of his jazz idol's riffing and improvising on the alto saxophone.

Leiber also exposed me to the work of Peter Schyuff, whose combination of surrealism and Op art—compositions that often had tight concentric wavy lines that fooled the eye—enjoyed brief notoriety. There were also the diamondlike sculptural forms of John Torreano, the disturbing self-portraits of David Wojnarowicz, and the regrettable paintings of luaus and roasted pigs by the Hawaiian artist Kieko Bonk. All of these artists were working in the East Village or ran in that circle. I decided it was time to see for myself what was going down in lower Manhattan.

On the morning that I walked east, all of the galleries were still closed at 10:00 a.m. It turned out that the East Village liked to sleep in. It wasn't until noon that most spaces bothered to get it together. My first stop was Gracie Mansion, run by an African-American, who went by Sur Rodney Sur. I recall saying to him, "Everywhere else is open by ten." He looked me in the eye and said, "The East Village isn't everywhere else." True enough. Realizing that the gallery standards I was used to didn't apply, I thought nothing serious would come of all this. For one thing, given the area's forbidding street vibe, I had my doubts that wealthy collectors would feel comfortable shopping here for art. Case in point: I saw two rough-looking guys working on a car, who appeared to be switching one engine for another. Later that day, I walked over to SoHo and told Ivan Karp about it. He laughed, "They weren't changing an engine—they were stealing it!"

Despite my suspicions, the next day I returned to the East Village for a second look. This time, I hung out with the up-and-coming artist Louis Renzoni. We went back to his place so that he could show me some paintings. His figurative work had

a film noir quality—dark and forbidding, but strangely compel-
ling. But what made a bigger impression on me were his liv-
ing quarters. A lone wall that separated the bedroom from the
dining room had been half destroyed by blows from a sledge-
hammer. He was attempting to turn his apartment into a loft
space—minus the super's permission. Renzoni demonstrated
his technique, handed me the weighty tool, and said, "Here,
want to take a few swings?" It was an anything goes mentality
that infused the whole neighborhood.

Later, Renzoni took me to meet his dealers, Lisa McDonald
and Doug Milford of Piezo Electric. They looked like they were
in their twenties and sounded like they were in their teens. As
they tried to impress me with hip patter about the brilliance of
Renzoni's work, I was both amused and appalled by the gallery's
immature talent. My guess was only one in a hundred emerging
East Village artists had what it took to make it in the long run—
and that was a generous assessment.

Still, like most developing art scenes, the cream floated to the
top on the Lower East Side. Jeff Koons, Peter Halley, and Philip
Taaffe were soon pursued by some of SoHo's top dealers. So
were a group of second-tier figures including Ashley Bickerton,
Haim Steinbach, and Meyer Vaisman. The work of all of these
artists offered a fresh perspective, untainted by commerce. The
nice thing about the East Village painters was they lacked pre-
tension and were equally at home in a sledgehammered apart-
ment and in an Upper East Side dining establishment.

There's a remarkable photograph that appeared in Phoebe
Hoban's book *Basquiat* that captures the downtown "it" crowd
at the time. The group shot was taken at Mr. Chow's in New
York—a composite of three distinct cultures of artists. You had
the current wave of hot painters being shown in SoHo, including
Julian Schnabel, Francesco Clemente, and Sandro Chia. The

established uptown artists were represented by David Hockney, John Chamberlain, and Alex Katz. And of course Andy Warhol was there, ironically posed in Schnabel's shadow. And then there was the raw talent coming up in the East Village, including Keith Haring mugging with his mouth wide open, Kenny Scharf grinning away, and Jean-Michel Basquiat holding a tray, as if he was about to serve his fellow artists. And lurking in the background was Tony Shafrazi, positioned to take advantage of the changing art milieu.

Art-world visionaries often have role models. As they say, it takes one to know one. During the mid-1960s, while studying art in London, Shafrazi came under the spell of the dealer Robert Fraser, also known as Groovy Bob. During the days of Mary Quant and Swinging London, the Robert Fraser Gallery was the place to be. Fraser showed the work that was already shaking up New York—Warhol, Ruscha, Dine—to an audience of rock-world royalty. Though Fraser failed to sell art to the overly suspicious Mick Jagger, he did develop a close relationship with Paul McCartney. There's a famous story about Fraser leaving a small René Magritte painting of a green apple propped up on McCartney's kitchen table. When McCartney discovered the painting, he knew it must have been Fraser who left it, and subsequently bought it. He liked the Magritte so much that it became the Beatles' famous Apple logo.

By mixing artists, musicians, and film stars at his parties, Fraser generated a real buzz. According to Shafrazi, Robert Fraser was a guru who set the trends. He had a tremendous flair, was superelegant, and dressed remarkably. He had the best gallery and the best openings. Tony Curtis was there, Marlon Brando, Keith Richards, Marianne Faithfull, and Dennis Hopper. Even Playboy bunnies were running around. In Fraser's world, gallery

openings were not genteel affairs. He created a model that is still with us today; art collecting had become "social studies."

Shafrazi grew so close to Fraser that the dealer offered him a show while he was still a student. He had been working on a number of pieces of sculpture and was eager to launch his artistic career. About a year later, when Shafrazi was ready, he called the gallery only to find out that Fraser had disappeared. Apparently, the dealer had decided to take a lengthy vacation to parts unknown and neglected to tell anybody. Once Fraser vanished, so did Shafrazi's show.

In 1965 Shafrazi finished up at the Royal College of Art and took his first trip to New York. Through either divine intervention or just dumb luck, he wound up staying at the YMCA on East Forty-seventh Street, located opposite Andy Warhol's silver-foil-covered Factory. Shafrazi has often told the story about going over to Warhol's studio on the day he landed in Manhattan. He introduced himself and was immediately invited by Andy to stay for lunch—"Would you like a sandwich and a Coca-Cola?"

On that same magical day, Shafrazi used the Factory's pay phone to call Roy Lichtenstein, another one of his heroes, and managed to wrangle an invitation to visit *his* studio the following day. The twenty-two-year-old Shafrazi arrived and gave Roy a hand moving some of his work to Leo Castelli, where he met the master dealer. As Tony tells it, Lichtenstein introduced him: "This is Tony Shafrazi, he's a young artist from England visiting me." To which the always enthusiastic Castelli responded: "Any friend of Roy's is a friend of mine! Welcome!" The next thing you knew, Shafrazi looked at a few inexpensive Lichtenstein prints hanging on the wall, including a science fiction city and a close-up of a lady's foot, and remarked, "Wow! These are great!" That was all Castelli needed to hear. "It would give me great pleasure if you had them in your collection." Despite

being a student with virtually no money (and no collection), he bought them, ingratiating himself with the most powerful dealer in America. Castelli became his American father. It was a relationship that would have positive repercussions for both of them further down the line.

During subsequent trips to the States, Shafrazi continued to hang around the downtown art scene, meeting people and making connections. He developed a friendship with the conceptual artist Joseph Kosuth, the neon artist Keith Sonnier, and the Earthwork artist Robert Smithson. When Smithson was killed in a plane crash while surveying the site for what was to become his last sculpture, *Amarillo Ramp*, it was Shafrazi who helped his widow Nancy Holt complete the piece. As Shafrazi recalled, "Robert was my best friend—when he died it was like the world stopped. On the night of his funeral, Virginia Dwan organized a dinner at her place. Carl Andre was there . . . Sol LeWitt, Richard Serra. Nancy Holt asked me where I was going from here. And I quickly told her, 'Back to Amarillo—I have to finish the piece.'"

Not long after, in 1974, Shafrazi made his infamous artistic gesture, spray-painting *Guernica*, while polarizing the New York art community. But typical of the art market, a number of dealers who swore they'd never have anything to do with him quickly changed their tune when the opportunity to do business arose. Perhaps the most forgiving were the artists. Since the art of the streets was about breaking the rules, Shafrazi was seen by some painters as an inspiration, though they probably wouldn't admit it.

As the seventies wore on, Shafrazi began to parlay his Iranian background to good effect, having grown up in a successful Persian family. He caught wind of a story that the shah was planning to build a museum of modern art as part of a push to update and Westernize the country. Given Shafrazi's art-world relationships in New York and his access to Farah Diba, the

shah's wife, he saw himself as the logical conduit to fill the museum with art. The only problem was he was an unknown entity to the museum committee, unproven to them as someone who could deliver world-class pictures. Having stayed in touch with Castelli since the days of purchasing the Lichtenstein prints, Shafrazi went to him and procured a letter of recommendation encouraging the museum to work with him. Castelli knew what he was doing. Shafrazi returned to Iran with both a letter of support and a suitcase full of transparencies of some choice paintings from Castelli's inventory.

Shafrazi's plan worked. The Teheran Museum of Contemporary Art acquired a significant Warhol *Disaster* painting, as well as major canvases by de Kooning, Johns, and Lichtenstein. His timing, at first, was opportune. Not only was Castelli grateful, the art world took note of the deal. Almost overnight, Shafrazi was seen as someone who could make things happen. Buoyed by this success, he decided to make a move. In 1979 he opened a gallery in Teheran—though unbeknownst to him, the Ayatollah Khomeini was only days away from coming to power and prematurely ending Shafrazi's art ambitions there.

Just as his grand opening was getting under way, featuring Zadik Zadikian's gold brick sculpture, Shafrazi smiled as he looked around a room filled with reveling guests. Had he looked out the window, he would have seen a street filled with approaching tanks. Martial law was declared and the shah was quickly swept from power. His gallery venture closed after only one show. A shell-shocked Shafrazi made a quick decision to move to New York and open his gallery in the heart of the art world.

As anyone who rode the New York subways during the early 1980s remembers, your underground experience was often unpleasant, thanks to a toxic combination of dirty stations, cars

covered with graffiti, and tracks swarming with rats. But public transportation also had its small pleasures. In 1984, if you took the train downtown to SoHo, you might have spotted something unusual among the poster advertisements that lined the Grueby-tiled walls. Next to the Manischewitz ads for Passover matzos—occasionally scribbled over with the expression "Jesus saves, Moses invests"—were crisp white chalk line drawings on black sheets of paper, depicting barking dogs or crawling babies.

A number of subway riders felt these drawings livened up their daily commute. Others dismissed them as yet another assault on the senses. Regardless, many people, including the authorities, wanted to know who was making them. It didn't take long to find out. A tall, wiry, bespectacled young man who wore casual clothes and high-top sneakers was exposed as the artist—or vandal, depending on which side of the argument you were on. Through word of mouth, admirers learned his name was Keith Haring, from Kutztown, Pennsylvania.

To understand the radical nature of Haring's art, you have to see it against the zeitgeist of New York during the eighties, when graffiti and "squeegee men" were an urban scourge. Graffiti artists, known as taggers, had been making their presence felt on subway cars, brick walls, and truck panels for years. During election season, politicians made bold campaign promises to get tough with graffiti. There was talk of banning the sale of spray paint cans to minors and making the parents of kids who got caught tagging pay stiff fines. Maintenance departments were given orders to paint over graffiti within twenty-four hours, hoping to send a message that law-abiding citizens were taking back the streets. But none of these measures worked. The human desire to leave your mark, whatever the risk, was simply too strong.

Keith Haring was also interested in making his presence felt. Haring sought recognition for himself *and* wanted his work to be

seen by a wide audience—which it was, possibly by millions. He distinguished himself from the myriad of tags by inventing his own language. He filled blank spaces on walls with eye-catching drawings of people and animals, surrounded by radiating lines, which gave off positive energy. Unlike most graffiti writers, who flaunted their alienation from society, Haring strove to connect with his fellow New Yorkers in a very human way. It was as if he was saying, "Urban life may be gritty, but it can also be fun."

Haring was a twenty-one-year-old East Village resident when he met Tony Shafrazi in 1980 while looking for work to support his art. At the time, Shafrazi's gallery had been open less than a year, and he hired Haring as a gallery assistant. Even as an employee, Shafrazi could see right away that he had tremendous abilities. While Shafrazi knew of Haring's underground reputation, he was unfamiliar with his work. That was until the day Haring handed him a show announcement for something called the *Club 57 Invitational*. Shafrazi skipped the show, but did take Haring up on a later offer to view an exhibition of his work at P.S. 1, out in Long Island City, which specialized in cutting-edge work by new talent.

Shafrazi arrived and had one of those revelatory moments. He was fully smitten by Haring's work. As he described it: "There were drawings from floor to ceiling and right away, I thought the work looked rather jarring. The originality was obvious and the vocabulary was almost like a dictionary of images. It was absolutely original. I couldn't place it in a gallery context. It was too alive for that!"

After a five-month stint working at the Tony Shafrazi Gallery, Haring decided to move on. He began to field offers for gallery representation, but remained noncommittal, preferring to represent himself. Haring was aware of Shafrazi's interest, but wasn't a fan of his uptown Lexington Avenue location. Finally, in 1982,

Shafrazi took a lease on a substantial space in SoHo, and began to woo Haring in earnest. Though Haring had firsthand knowledge of Shafrazi from being his assistant, and respected his seriousness, he had a problem with what had happened to *Guernica*.

Haring vacillated on whether to commit to Shafrazi. In his authorized biography, *Keith Haring*, he stated: "Being an artist, and loving Picasso, I couldn't justify his spray-painting the work. Of course, I read many articles and interviews as to why he did it. It was a very conscious act, and, in a way, I respect his basic motivation, which was to bring *Guernica* back to its original function as a symbol for the horrors of war. Tony felt the power of the painting wasn't functioning anymore." Haring was caught up in a conflict between Shafrazi's sordid past and his current popularity as a dealer. But the question at the heart of his debate was whether street art should literally remain street art, versus being displayed in a nice, clean, well-lit gallery isolated from the public, and patronized by the very people who probably fought against graffiti for fear it might harm their property values. Was the environment a necessary context for street art? Wasn't art supposed to be about authenticity?

In the end, Haring agreed to representation by the Tony Shafrazi Gallery. It turned out to be the decision that launched him into mainstream success, tapping into an audience that stretched beyond the New York City limits. In fact, I knew something was up when Haring visited my hometown of San Francisco in the early eighties, and I observed him do his thing on an outdoor black-skinned billboard in the city's edgy South of Market district, as a throng of young people reveled in watching him draw. His work eventually transcended the art world and spilled over into street fashion. In 1986 he opened the Pop Shop in SoHo, catering to young buyers of Swatches and other accessories, all emblazoned with Haring iconography.

Meanwhile, Shafrazi began to fill out his gallery stable. There were some regrettable picks like Ronnie Cutrone, a former Warhol studio assistant who liked to paint images of Donald Duck on American flags. Then there was Kenny Scharf, who gained some renown during the 1980s for his futuristic Jetsons cartoon-inspired imagery. Fortunately, Shafrazi also showed James Brown, an extremely talented painter who derived inspiration from primitive cultures—especially African art. Donald Baechler was another Shafrazi Gallery alumnus who covered his canvases with crude images—like a generic *Yellow Pages* advertisement, where the compositions and paint handling were disarmingly sophisticated.

Despite Shafrazi's success in showing and selling Haring and others, his art dealing legacy will always be linked to Jean-Michel Basquiat. Early on, he said he passed on courting the young Basquiat for his gallery lineup because he didn't want to interfere with the friendship between the two young artists. In fact, Shafrazi only mounted a single one-person Basquiat show during the artist's lifetime, and even that was an exhibition of drawings, not paintings. So why is Shafrazi so closely associated with Basquiat?

It was because of a signal event that took place at his gallery in 1985. Shafrazi, along with the Swiss dealer Bruno Bischofberger, mounted a double show of his work and Andy Warhol's. Not individual works, but the famous collaborative pictures, where each artist took turns painting on the same canvas. As Shafrazi put it, "Given my friendship with both artists, I decided I had to be the one to do the show." By most aesthetic standards the quality of the paintings was questionable. But in terms of the publicity they generated for Shafrazi, Warhol, and Basquiat, the dual effort was the "bomb."

It was here that Shafrazi became a dealer of consequence. Thinking like an artist, while also taking a page from Robert Fraser's promotional playbook, Shafrazi designed a traditional boxing poster to advertise the show, featuring a meek-looking Andy Warhol wearing boxing gloves and a dreadlocked, shirtless Jean-Michel Basquiat with his dukes up, looking very stylish in his Everlast boxing trunks. The two combatants appeared on a red-and-yellow sheet of cardboard, which spelled out the marquee matchup: WARHOL VS. BASQUIAT. The poster may have been tongue in cheek, but the art show was quite serious.

As usual, Shafrazi's timing was dead on. By 1985, Basquiat's career had peaked. Earlier that year, Mary Boone orchestrated an incredible publicity coup, which has become part of art-world folklore, landing him on the cover of the *New York Times Sunday Magazine*. There was Basquiat, who claimed to be a product of the streets, once homeless and living in a cardboard box, gracing America's "newspaper of record," barefoot in a paint-splattered Armani suit!

In a way the *Times* piece should have come as no surprise. From day one, Basquiat attracted an inordinate amount of attention. The media deluge had begun in 1981 with René Ricard's *Artforum* essay "The Radiant Child." Ricard referred to Basquiat as a "black prince," correctly identifying him as a future force to be reckoned with. And it continued from there with features in a grand slam of other important art-world publications—critics for ARTnews, *Art in America*, and *Flash Art* all weighed in.

As the Brooklyn-born artist's work began to attract attention, Tony Shafrazi took notice. Though Shafrazi insisted he never pursued Basquiat, various art-world accounts claim otherwise. The word was Basquiat resisted his overtures, as once again Shafrazi's encounter with *Guernica* came back to haunt

him. When he was a youngster, Basquiat's mother took him to MoMA, where the epic Picasso made an impression on him. Apparently, it also made Basquiat suspicious of getting involved with Shafrazi after his defacement of the painting. Instead, he went with Annina Nosei.

Nosei installed Basquiat in her gallery's basement, allowing him to use it as his studio. In fairness to Nosei, the room was spacious with generous skylights. Unfortunately, it produced the side effect of putting Basquiat on display, as if he were an exotic animal in a petting zoo. Nosei would bring her clients downstairs as an increasingly annoyed Basquiat looked over his shoulder while trying to paint.

With tones of perceived racism, the art world had a field day talking about the curious arrangement. But it wasn't that simple. Basquiat's complex relationship with Nosei was best summed up by Jeffrey Deitch: "Basquiat is likened to the wild boy raised by wolves, corralled into Annina's basement and given nice clean canvases to work on instead of anonymous walls. A child of the streets gawked at by the intelligentsia. But Basquiat is hardly a primitive. He's more like a rock star . . . [He] reminds me of Lou Reed singing brilliantly about heroin to nice college boys."

Perhaps fueled by all of the dissonant energy in his life, Basquiat embarked on a productive period in the early eighties, when his paintings showed signs of living up to their hype. Consulting art history books, he blended styles and periods, borrowing from such diverse sources as Cy Twombly's graffitilike marks and Leonardo da Vinci's notebooks, creating a synthesis that was all his own. What often emerged was more along the lines of comic book Pop imagery and associated words scattered all over the canvas. In one of Basquiat's best pictures, the *Undiscovered Genius of the Mississippi Delta*, which made references to the blues and the Southern roots of African-Americans,

he slathered a five-panel painting with the words "Mississippi," "Mark Twain," and "Negroes," while playing them off against images of a muskrat, a few black faces, and a cow's udders. Basquiat's drawing and paint handling were masterful, his imagery purposeful, and his message undeniable.

While the press continued to enable the Basquiat myth, even after he died of a heroin overdose in 1988 at the age of twenty-seven, Julian Schnabel's debut as a film director, *Basquiat*, brought him celebrity outside the art world. This posthumous biopic starred Dennis Hopper as the continental dealer Bruno Bischofberger, Parker Posey as the imperious Mary Boone, and David Bowie, who played a very credible Andy Warhol. From Basquiat's early days of couch surfing in the East Village to his salad days of being able to buy $2,000 worth of caviar at Dean & Deluca, the movie is an accurate portrayal of the New York art hustle of the 1980s.

There's a telling scene in the film where Basquiat shows up at Warhol's studio to work on their collaborative paintings. When Warhol observes Basquiat paint over his Pegasus flying horse logo adapted from Mobil gas stations, and whines, "Oh, you're painting out all of the good stuff," you feel a bit of their growing contempt for each other. And it was that tension, creative or otherwise, that Tony Shafrazi chose to exploit when he shrewdly came up with the idea of showing the Warhol/Basquiat collaborative paintings at his gallery.

By the time of Warhol vs. Basquiat, there was a continuous stream of art-world gossip about the symbiotic nature of their relationship. Cathleen McGuigan's *New York Times Sunday Magazine* article succinctly summed up the situation: "As an elder statesman of the avant-garde, Warhol stamps the newcomer Basquiat with approval and has probably been able to give him excellent business advice. In social circles and through

his magazine, *Interview*, he has given Basquiat a good deal of exposure. In return, Basquiat is Warhol's link to the current scene in contemporary art, and he finds Basquiat's youth invigorating."

While that may have been true when the artists first befriended each other, their deteriorating relationship divided the art world into two camps. The younger crowd claimed that Warhol was washed up and hanging out with Basquiat as a way of recapturing his relevance. More established art-world denizens felt it was just the opposite: Basquiat needed Warhol for his historical ballast. The collaborative paintings and the confrontational message of the Shafrazi Gallery poster only intensified the dialogue.

Shafrazi's intuition for putting Basquiat and Warhol together set an industry precedent. He established a new role for serious art dealers—the gallery owner as museum curator. When the Gagosian Gallery christened its new Madison Avenue space in 1989 with a show by Jasper Johns, called *The Maps*—which included a major painting loan from MoMA and the publication of a scholarly illustrated book—they ushered in a new era of galleries challenging museums for being the first to mount historic exhibitions.

In 1990 the art market suffered a nervous breakdown, and little was heard from Shafrazi. Like most dealers, he was now in survival mode. The artists he was closely aligned with, Basquiat and Haring, who died of AIDS that year, were gone, and without them the luster of the street art movement began to tarnish. But that didn't mean the art of the streets wasn't alive. It just meant some of the action had shifted to other cities, such as San Francisco, where Barry McGee took center stage. For years, the city's funky Mission District had cultivated a reputation for arresting murals, which graced the sides of the area's grimy buildings.

With the neighborhood anchoring the city's Latino community, much of its street art had Mexican overtones. Paintings of Aztec figures, Teotihuacán pyramids, and rainbow-colored Quetzalcoatls were common. While many of these urban murals were attractive, the iconography had become clichéd.

McGee changed that. As a local resident, he was familiar with the Mission and had absorbed its visual culture. He also received formal training at the San Francisco Art Institute, allowing him to take his strong drawing skills back to the "hood," where he developed a unique visual language. McGee's signature image was of a face, often moon-shaped, with cropped hair, expressive eyes, and big twisted lips. Many saw affinities between the ethnic faces he drew and his own likeness, since McGee is half Chinese.

Like most street artists, McGee chose to bear witness to what he observed. As anyone who ever walked around the Mission back then knows, it had its share of winos, as evidenced by countless scattered whiskey flasks. McGee seized upon these discarded bottles as both icons of street culture and surfaces to convey his message. Before long, McGee's faces began to adorn them. He'd even occasionally contextualize a flask by leaving it next to a snoring drunk, crashed out on the pavement.

McGee initially resisted showing in galleries, but eventually gave in, as his painted bottles developed a following among collectors. He often displayed them in clusters, creating a group portrait of the Mission's overlooked and downtrodden. Early on, his work was displayed at San Francisco's Yerba Buena Center for the Arts, where it was an immediate hit. Looking back on the many shows that McGee participated in, René de Guzman, the center's former director, said, "His work is great, and I'm surprised he's been able to keep it vital and unpredictable. It hasn't softened—in fact, it's getting more edgy."

By 2001 McGee had caught on, and in a scene reminiscent of Basquiat's early days of success, opportunists began prowling the streets of the Mission District, stealing boards covered in McGee's art, which soon found their way to market. McGee's street art, like that of Basquiat and Haring, became commodified. With a following for his work established at Sotheby's and Christie's, McGee accepted invitations to show at high-profile New York spaces, such as Jeffrey Deitch. There were also exhibitions at the San Francisco Museum of Modern Art and the Walker Art Center. Often, these shows were installations where McGee would combine dozens of small drawings and paintings, each of them displayed in skinny black frames gathered from thrift stores. While McGee's events were always memorable, they served notice that yet again the art of the streets had become the art of the establishment.

Around the same time, the art world's interest in street art migrated to London and to an enigmatic figure there who went by a lone name—Banksy. Using stencils, he spray-painted black-and-white images on urban walls, depicting rats, British bobbies, and the now famous man with his face partially covered and his baseball cap on backward, poised to throw a bouquet rather than a Molotov cocktail. Banksy seemed to be everywhere at once; his work soon became among the most recognizable street art in the international art world.

Banksy can be clever. Passersby can't help but smile when they look up and see John Travolta's character and Samuel Jackson's, from the movie *Pulp Fiction*, holding yellow bananas instead of guns. Banksy can be cute. Sometimes he pokes fun at the British royals, including Queen Victoria, Princess Diana, and the Queen Mother, once portrayed wearing a gas mask. But Banksy can also be serious. In 2005 he traveled to the Middle East and painted nine figures on the West Bank wall erected by

the Israelis. He included an image of a ladder going up and over the wall and a stencil of a child digging a hole through it.

Banksy's strategy was to reveal nothing about his personal identity, birthplace, or formal education. Despite the air of mystery that he's managed to cloak himself in, he's always been transparent about the energy he brings to the streets. Rather than seeing himself as an urban vandal, he shifted the blame to where he felt it belonged. "The people who truly deface our neighborhoods are the companies that scrawl giant slogans across buildings and buses trying to make us feel inadequate unless we buy their stuff. Well, they started the fight and the wall is the weapon of choice to hit them back."

While his art is especially popular with young people, it has also attracted a more mature following among collectors. Banksy has become a financial force and has grown accustomed to steadily rising prices at auction. As a street artist, he ended up rocking the art market. By 2007 his work had become so valuable that the owner of a brick home in Bristol, with a Banksy mural on the side, listed it with an art gallery rather than a realtor. It was then offered as a mural which came with a house attached.

Though Banksy creates paintings on canvas to supply his galleries, you somehow sense a certain cynicism behind that work as opposed to his street art. In fact, he likes nothing better than to mock the collectors who acquire it. During a week of auctions in London during the late 2000s, he posted an image on his Web site showing people bidding on a picture, with the caption, "I Can't Believe You Morons Actually Buy This Shit." Oddly enough, collectors just see his reactionary tactics as part of his art, and keep on buying.

With the coming of the 1990s, Shafrazi still had his gallery on SoHo's Mercer Street, and remained bullish on the art market

by opening a second space in the luxurious Bakery Building on Prince Street. But as the decade wore on, he experienced the same downturn in business that plagued his colleagues, and he closed his Mercer Street location. In 1993, with sales slowing to a trickle, he cut his overhead further by leaving the Bakery Building too and relocating to Wooster Street. Shafrazi's inaugural show paid homage to the SoHo scene of the eighties that he was so much a part of. Titled *Ten Years After*, his walls were covered in works from 1982 to 1992 by the era's young stars: Fischl, Salle, Basquiat, Haring, Koons, Bleckner, and others. Shafrazi stayed "true to his school" by continuing to support the work he always loved—and continued to do so through the nineties.

One of the major developments at the gallery during those years was Shafrazi's decision to make a strong commitment to the photography and paintings of Dennis Hopper. Since his early days hanging out at the Robert Fraser Gallery, Shafrazi cultivated a friendship with Hopper, leading to the honor of being best man at *two* of his weddings. The actor, who could trace his career back to working with James Dean in *Rebel Without a Cause* and *Giant*, was one of those people who always found himself in the right place at the right time. During Pop Art's formative years, he carried a camera everywhere and wound up taking intimate portraits of many seminal artists of the sixties, including Jasper Johns, Robert Rauschenberg, and Andy Warhol, before they became self-conscious about their fame.

While many art-world followers admired Hopper's photographs, most were unaware of his paintings, which were a direct response to street art. The work came about during the early 1990s, when Hopper was living in Venice, California. In those days Venice wasn't lined with trendy clothing and furniture shops; it resembled the East Village urban wasteland of the eighties.

Hopper's paintings were inspired by accidental imagery, derived from the city maintenance crew's running battle with the local taggers. The maintenance men would come across a graffiti-laden wall, but could never match its color when they tried to paint over the writing, because the Venice sun quickly faded the previous paint job. The twisting of horizontal and vertical paint roller swaths produced a veritable freeway of color. The fresh paint often contrasted beautifully with the weathered pigment. A few weeks later, the mischief makers would return, and the process would repeat itself. Before long, the wall resembled an Abstract Expressionist painting. Fascinated by this urban visual treat, Hopper transferred his observations to canvas. The paintings made their debut at the Shafrazi Gallery in 1992, with the glamorous opening reception echoing the glory days of the Robert Fraser Gallery.

As the art market began to rebound in the late 1990s, Shafrazi began to assert himself more in the secondary market. His big break came in 1997, when he was awarded half of the lucrative Francis Bacon estate, raising eyebrows and envy in the art dealer community. The other 50 percent went to the London dealer Faggionato Fine Art. Shafrazi received his share of the "franchise" through a friendship with John Edwards, Bacon's muse and young lover. The irony of the moment was not lost on Shafrazi; he told me his early figurative sculpture was heavily influenced by Francis Bacon. In 1998 the Shafrazi Gallery presented its first Bacon exhibition, which included one of the artist's rare and extremely expensive screaming pope paintings—a small series from early 1950s depicting a seated pontiff with his mouth wide open. With the cachet that went with handling the work of one of the greatest artists of the twentieth century, Shafrazi's rise to the top of art-world respectability was complete.

In recent years, Tony Shafrazi has become part of the art-world social elite, hanging out with megacollectors Peter Brant, Laurence Graff, and Alberto Mugrabi—all dedicated Basquiat and Warhol enthusiasts. In 2005 his current Chelsea gallery hosted a show of Andy Warhol society portraits that rivaled the original Whitney Museum show in 1979. To celebrate the occasion, Shafrazi authored a colorful book on the subject, *Andy Warhol Portraits*. A striking ruby-lipped Deborah Harry, the lead singer of Blondie, graced the lavender dust jacket, reminding readers of Harry's early days performing at the downtown club CBGB—where Basquiat's noise band Gray also played. Shafrazi's involvement in authoring books continued to develop. Right before Dennis Hopper passed away, in 2010, Shafrazi was approached by Benedikt Taschen to edit and contribute an essay to the deluxe 546-page monograph *Dennis Hopper: Photographs 1961–1967*.

In looking back on his career, Shafrazi shared with me how important his early days as a sculptor were in developing his artistic sensibility. "When I began making art in the 1960s, the spirit of my work was informed by a 'street' sensibility. In 1972, the year before I sprayed *Guernica*, I walked around Manhattan and saw the words 'Fight Back,' painted on the side of a building. And that's what I did."

Tony Shafrazi recognized that the art of the streets speaks loudly of the need to leave your mark, whether it's on a grungy brick facade or a newly stretched canvas. His demonstrated desire to preserve and display these creations speaks with equal force. From his questionable early days as a "graffiti artist" to his recent years as an art-world impresario, it has always been about the creative gesture. As Shafrazi explains, "I never stopped studying art, talking about it . . . thinking about it all day long. The point is I've never stopped being an artist."

## Epilogue
## Prophesying

I N THE FUTURE, there's no doubt that new art prophets will emerge. The only question is whether they will evolve from an artistic discipline that has yet to reveal itself. In the meantime, art-world seers are likely to come from areas of collecting that have been around for many years. After recently spending time in Santa Fe and Taos, I walked away convinced that the final frontier in collecting is the frontier itself—Western art. While this field has plenty of schlock, the genre's finest artists are incredible painters, who continue to update imagery that has existed for over a hundred years. Mention Western art and anyone even remotely knowledgeable can recite the classic names Charles Russell and Frederic Remington; bonus points for those who can differentiate Remington as the sculptor and Russell as the painter.

There were plenty of outstanding artists who followed these nineteenth-century pioneers. During the teens and twenties, the Taos Society of Artists sprung up, including the celebrated E. Irving Couse—eventually attracting Nicholai Fechin and Georgia O'Keeffe to the region. These painters derived their inspiration from the isolation of Taos and the rugged New Mexican landscape. The Taos painters were the aesthetic equal of Arthur Dove, Marsden Hartley, and John Marin, their more

established contemporary counterparts, who exhibited in New York. While the latter artists chose to abstract nature, the Taos painters were driven by realism, reveling in the natural world just "as is."

Farther south in New Mexico, there was the Santa Fe–based Gustave Baumann, whose best work dates from 1920–1930. Baumann was the master of the woodcut, whose subtle layering of printed inks has never been equaled. His landscapes, including those of the Grand Canyon, have an immediacy of experience that put them on par with great paintings. With each viewing, Baumann's prints transport you to New Mexico's land of enchantment.

In more recent years, literally hundreds of Western painters have surfaced, called to action by the myriad of Americans who purchased second homes in Sun Valley, Aspen, Jackson Hole, Bozeman, and, of course, Santa Fe. Whether the likes of Ted Turner, or former Sotheby's chairman John Marion, or moneyed folks of lesser notoriety, the need to fill their walls with regional art has created a boom market in Western painting. Most buy pictures that are mere decoration. The more sophisticated seek to connect with the undercurrent of mystery that runs through the West. It is that audience that the painter Bill Anton is concerned with.

Anton, born in Chicago in 1957, works out of his spacious studio in Prescott, Arizona. His imagery reflects days spent on horseback quietly tracking subtle shifts in cloud formations, light, and weather; observing those movements creates an ever-changing visual panorama. Be it a walking thunderstorm, a nuclear sunset, or the first reflection of morning light ricocheting off a red rock mesa, Anton interprets what working cowboys witness every day. His paintings are a distinct cut above other Western pictures. A fair comparison would be the

early-twentieth-century cowboy art deity Frank Tenney Johnson, whose work evoked the spirit of the vanishing frontier.

As for his colleagues, Anton is often compared to the current dean of the cowboy genre, Howard Terpning. It is an inaccurate comparison. Though Terpning is talented, his slightly acidic palette and overly nostalgic portrayals of nineteenth-century Native Americans have turned his imagery into what certain rich but unsophisticated collectors of Western pictures want—overly romantic art. Anton transcends the Western artist label, finding kinship with contemporary artists like Agnes Martin. Early in her career, she created six-foot-square canvases that were composed entirely of graphite lines with the occasional thin wash of color; often color that reflected the sweet blue of the New Mexican sky or the deep red of its earth. Her paintings possessed a calm, meditative surface that drew you in, becoming touchstones for your own spiritual reflections—a distillation of the rural Southwest. Though her style of painting was classified by critics as Minimalism, and her imagery couldn't be more dissimilar from Anton's, the spirit behind their work is identical. Both are about feeling. Whether you view an Anton or a Martin, you soon forget what you're looking at and lose yourself in the emotional content of the picture.

Anton is one of the rare living Western artists who has achieved a high level of recognition, including multiple awards and purchases at the 2011 *Masters of the American West* exhibition at the Autry National Center in Los Angeles. Anton has also developed a strong auction market, thanks in part to Peter Stremmel, who has succeeded in orchestrating demand for Anton's work on the secondary market. It might be too early to call Stremmel a visionary, but if Coeur d'Alene Auctions, in which he's a partner, continues to grow at its current rate, he may be looked back on as just that. Stremmel got his start in the

art business four decades ago. After ten years of kicking around trying to find his life's direction, he became an auctioneer. Around 1980 he experienced a moment of clarity while talking to the little-known Abstract Expressionist Paul Brach. The artist showed him a new painting, which Stremmel described as "stylized mustangs running through the desert." Whether luck or fate, Stremmel connected deeply with the work's Western roots and he discovered his passion for the auction world.

With a group of partners, he opened Coeur d'Alene, which has revolutionized the Western art market by working directly with a number of the artists featured in their sales. Typically, they will call Bill Anton, request a painting for the next auction, and offer him a 60/40 split in his favor (as opposed to a typical gallery split of 50/50). The brilliance of the ploy is that it allows the artist to share in the upside, while providing the auction house with a continuous stream of fresh material. Anton once had a painting appear on the auction block with a $30,000–$50,000 estimate, which ended up bringing $89,600, making the artist a very happy camper.

In 1990, Stremmel was approached by Sotheby's and New York's Acquavella Galleries. They had just jointly purchased the entire inventory of the Pierre Matisse Gallery for $143 million. At the time, it was far and away the largest art transaction ever to go down. Despite Pierre being the son of the great Henri Matisse, the stock contained no Matisses. But it did have some incredible Mirós, Dubuffets, and Giacomettis. Through a pre-existing friendship with Bill Acquavella, Stremmel was tapped because running the business through him in Reno—Nevada has no corporate taxes—would save a fortune.

Acquavella called Stremmel and said, "How would you like to be the most important dealer in the world?"

For a split second, Stremmel thought of saying, "But I already

am!"—then thought better of it. A deal was struck and he became a participant in the Matisse trove. The gradual sale of paintings and sculpture kept all three parties going during the art market recession of the early nineties. Eventually, Sotheby's and Acquavella more than doubled their money.

For Stremmel, his cut of the action allowed him to develop Coeur d'Alene into a force. In conversation with him, he was surprisingly candid about the Western art field. He emphasized that it is purely an American market. Despite the plethora of European tourists who visit our national parks, they have little interest in acquiring the art that captures the sublime beauty of the region they love. Given wealthy America's ongoing obsession with owning second residences, and the desire to be in touch with our country's Western heritage, it seems this market (though limited) will continue to flourish.

It's entirely possible that Bill Anton's work will someday move from the Western auctions of Reno to the contemporary art galleries of New York. Until that moment arrives, Anton's list of dedicated collectors continues to expand, building momentum, which could eventually turn him into the first Western artist to show in Chelsea. If that happens, look for Peter Stremmel to cross over as well, into a new role as an art-world visionary.

Art prophets often attract disciples from every stretch of the industry, from collectors to emerging artists. Those who have come under the spell of the individuals in this book have been exposed to some of the best contemporary artists, developed their personal collections, and honed their eye for the great works that hang in the finest art institutions. The avatars in these pages, from Ivan Karp to Tony Shafrazi, were successful in sharing their passion for the innovative and challenging, while broadening the horizons of the art world.

Aficionados who love art, in whatever form, are the ones who reap the pleasures visionary dealers have to offer. There's nothing more satisfying than sharing a space with an object of beauty, especially when you have absorbed the story behind it and can place it in historical context. There is a certain intimacy that develops between the viewer and the work of art. The key, as always, is finding art that means something to you. When you select a painting where you feel the presence of the artist in the room, you've discovered a work with a soul, and the circuit between creator and appreciator is completed.

You've become your own art prophet.

## Acknowledgments

With thanks to Bonnie Nadell of the Hill Nadell Literary Agency in Los Angeles for continuing to do such a great job representing me; Corinna Barsan, senior editor at Other Press, for being a true collaborator, along with Judith Gurewich, publisher; Paul Kozlowski, associate publisher; Yvonne E. Cárdenas, production editor; and Terrie Akers, manager of online publicity and social media.

And, in alphabetical order:

Joshua Baer, Martha and Barnaby Conrad III, Paula Cooper, Daniel Douke, Virginia Dwan, Shepard Fairey, Tony Fitzpatrick, Deborah and David Flaschen, Jeffrey Fraenkel, Lisa Friedman and Jim Harris, Pheme and Matt Geyer, Lorrie Goldin and Jonathan Marshall, Foster Goldstrom, Andy Goldsworthy, Helen and Milton Herder, Pieter Hugo, Robert Flynn Johnson, Denise and Bill Kane, Whitney and Lee Kaplan, Ivan Karp, Anne Kovach, Peter Max, Jane McDonald, Louis Meisel, Thomas Meyer, Richard Misrach, Stanley Mouse, Martin Muller, John Ollman, Cindi, Todd, and Luke Osborn, Marlit Polsky, Diego Romero, Alissa Schoenfeld, Tony Shafrazi, Sandra Shannonhouse, Marcia and Gunter Stern, Jay Strell, Peter Stremmel, Tod Volpe, and Joe Wachs.

# Notes and Sources

## Introduction
### What Is an Art Prophet?
1 *America had plenty of money.* S.N. Behrman, *Duveen* (Boston: Little, Brown, 1972), p. 9.

## Chapter One
### Ivan Karp and Pop Art
10 *"I have a flirtatious eye for objects."* John Loring, "Cornucopia in SoHo: The New York Apartment of Ivan and Marilyn Karp," *Architectural Digest*, January 1979.

12 *"Art dealers are like surfboard riders."* Laura De Coppet and Alan Jones, "André Emmerich," in *The Art Dealers* (New York: Cooper Square Press, 2002), p. 57.

12 *"not a scholarly process."* Author's interview with Ivan Karp, April 8, 2010.

13 *"There was magic in Leo."* Annie Cohen-Solal, *Leo & His Circle: The Life of Leo Castelli* (New York: Alfred A. Knopf, 2010), p. 362.

25 *Benday-dot blond beauty.* Author's interview with Ivan Karp, September 16, 2009.

26 *"Warhol certainly enjoyed being prosperous."* Author's interview with Ivan Karp, September 17, 2010.

ADDITIONAL SOURCES

De Coppet, Laura, and Alan Jones. "Ivan Karp." In *The Art Dealers*. New York: Cooper Square Press, 2002.

Diamonstein, Barbaralee. "Ivan Karp." In *Inside New York's Art World*. New York: Rizzoli, 1979.

Scherman, Tony, and David Dalton. *Pop: The Genius of Andy Warhol*. New York: Harper Collins, 2009.

Warhol, Andy, and Pat Hackett. *Popism*. New York: Harcourt, 1980.

Chapter Two
## Stan Lee and Comic Book Art

36 *as faithfully to the script as possible.* Jordan Raphael and Tom Spurgeon, *Stan Lee and the Rise and Fall of the American Comic Book* (Chicago: Chicago Review Press, 2003), p. 91.

37 *"Ditko was drawing his own plots."* Ronin Ro, *Tales to Astonish* (New York: Bloomsbury, 2004), p. 106.

40 *"He took vaudeville."* Neil Gaiman, "Introduction," Mark Evanier, in *Kirby: King of Comics* (New York: Abrams, 2008).

45 Price quotes from *Overstreet Comic Book Price Guide*, 40th edition (New York: Gemstone Publishing, 2010/2011), pp. 393, 409, 549, 580.

46 *"It was like an old script."* Quote from Flo Steinberg in Ro, *Tales to Astonish*, p. 225.

46 *"less than what he'd drawn."* Ro, *Tales to Astonish*, p. 241.

50 *Besides giving a thumb's-up.* Author's interview with Martin Muller, March 4, 2010.

ADDITIONAL SOURCES

Bell, Blake. *The World of Steve Ditko*. Seattle: Fantagraphic Books, 2008.

*Crumb*. Film directed by Terry Zwigoff, 1999.

Lee, Stan, and George Mair. *Excelsior!* New York: Simon & Schuster, 2002.

Miller, Frank. *Batman: The Dark Knight Returns.* New York: DC Comics, 1986.

Moore, Alan, and Dave Gibbons. *Watchmen.* New York: DC Comics, 1986, 1987.

Spiegelman, Art. *Maus: A Survivor's Tale,* Part I. New York: Pantheon, 1986.

———. *Maus: A Survivor's Tale,* Part II. New York: Pantheon, 1991.

Chapter Three
## Chet Helms, Bill Graham, and the Art of the Poster
56 *an impressive $375,000.* Shepard Fairey, *Obey: Supply and Demand, The Art of Shepard Fairey* (Berkeley: Gingko Press, 2009), p. 271.

57 *3,000 offset prints sold out.* Fairey, *Obey: Supply and Demand,* p. 272.

57 *"Your images have."* Quote from Obama letter in Fairey, *Obey: Supply and Demand,* p. 273.

59 *in for free.* Robert Greenfield and Bill Graham, *Bill Graham Presents* (New York: Doubleday, 1992), p. 239.

59 *"He was one of us."* Quote from Grace Slick from inside of dust jacket in Greenfield and Graham, *Bill Graham Presents.*

61 *"get up early!"* Greenfield and Graham, *Bill Graham Presents,* p. 147.

64 *"a hundred dollars a poster."* Author's interview with Stanley Mouse, October 12, 2010.

66 *a roll of adhesive tape.* Greenfield and Graham, *Bill Graham Presents,* p. 162.

66 *"The first poster was free."* Author's interview with Harry Tsvi Stauch, October 21, 2010.

68 *"Comic books taught me how to draw."* Charles Riley, *The Art of Peter Max* (New York: Abrams, 2002), p. 18.

70 *Peter Max and Pop Art.* Author's interview with Peter Max, April 5, 2009.

76 *"I found the Obey Giant campaign."* Quote from Banksy in Fairey, *Obey: Supply and Demand*, p. 44.

77 *called the Western Front.* Author's interview with Stanley Mouse, October 12, 2010.

ADDITIONAL SOURCES

Fairey, Shepard. *Mayday*. Berkeley: Gingko Press, 2011.

Grushkin, Paul D. *The Art of Rock*. New York: Abbeville Press, 1987.

"Peter Max: Portrait of the Artist as a Very Rich Man" (no author indicated). *Life*, September 5, 1969.

Chapter Four
## John Ollman and Outsider Art

86 *"It is about coming down."* Author's interview with John Ollman, July 7, 2010.

87 *One day, in 1981.* Author's interview with John Ollman, July 8, 2010.

89 *"A drawing brought $179,500!"* Author's interview with John Ollman, July 12, 2010.

91 *"the real Wireman."* Author's interview with John Ollman, September 14, 2010.

98 *he emerged as an artist.* Author's interview with Tony Fitzpatrick, October 16, 2010.

ADDITIONAL SOURCES

Fitzpatrick, Tony. *The Wonder: Portraits of a Remembered City*, Volumes 1–3. San Francisco, Los Angeles: Last Gasp/ La Luz de Jesus, 2005, 2006, 2008.

Helfenstein, Josef, and Roman Kurzmeyer. *Bill Traylor, Deep Blues*. New Haven: Yale University Press, 1999.

Jarmusch, Ann. "Mysterious Stranger." *ARTnews*, circa mid-1980s.

Livingston, Jane, John Beardsley, and Regenia Perry. *Black Folk Art in America*. Washington, DC: Corcoran Gallery of Art, 1989.

Montoya, Maria. "The 60-Second Interview: Tony Fitzpatrick." Archived column from Chris Rose, October 31, 2008.

Sotheby's. *Bill Traylor Drawings from the Collection of Joe and Pat Wilkinson.* New York: December 3, 1997.

## Chapter Five
### Joshua Baer and Native American Art

107 *if they painted Indian subject matter.* Charles Giuliano, review of the exhibition *Fritz Scholder: Indian/Not Indian,* posted on Web site of Berkshire Fine Art.

109 *"framed his life and enriched us."* Paul Chaat Smith, essay for exhibition catalog, *Fritz Scholder: Indian/Not Indian* (New York: Prestel, 2008), p. 35.

111 *"I would visit these shows."* Author's interview with Joshua Baer, July 10, 2010.

114 *"Rather than treat this material."* Author's interview with Joshua Baer, November 1, 2010.

115 *"enhance the material value."* Joshua Baer, catalog essay for *The Last Blankets* (1998), p. 3.

116 *Thus, the Navajo rug.* Joshua Baer, catalog essay for *The Last Blankets,* p. 4.

117 *"I will bet you two huge."* Nancy Blomberg, *Navajo Textiles: The William Randolph Hearst Collection* (Tucson: University of Arizona Press, 1988), p. 12.

121 *It's used by a medicine man.* Jori Finkel, "Is Everything Sacred?" *Legal Affairs,* July/August 2003.

122 *it wasn't art.* Author's interview with Diego Romero, August 15, 2010.

124 *"Indians playing golf."* Author's interview with Diego Romero, August 15, 2010.

ADDITIONAL SOURCES

Berlant, Anthony. *Mimbres Painted Pottery.* New York: Bykert Gallery, and Los Angeles: James Corcoran Gallery, circa 1970s.

Brody, J. J., Steven LeBlanc, and Catherine Scot. *Mimbres Pottery: Ancient Art of the American Southwest.* New York: Hudson Hills Press, 1983.

Fried, Stephen. *Appetite for America*. New York: Bantam, 2010.

*Intuitive Line*. Exhibition brochure. New York: Hirschl & Adler Modern, 1986.

James, H. L. *Rugs & Posts: The Story of Navajo Weaving and Indian Trading*. Atglen, PA: Schiffer Publishing, 2005.

Kahlenberg, Mary Hunt, and Anthony Berlant. *The Navajo Blanket*. Los Angeles: Los Angeles County Museum, 1972.

———. *Walk in Beauty*. Layton, Utah: Gibbs Smith, 1977.

Kaufman, Alice, and Christopher Selser. *The Navajo Weaving Tradition*. Tulsa, Okla.: Council Oak Books, 1985.

Monthan, Guy, and Doris Monthan. *Art and Indian Individualists*. Flagstaff, N.Mex.: Northland Press, 1975.

Smith, Paul Chaat. *Everything You Know About Indians Is Wrong*. Minneapolis: University of Minnesota Press, 2009.

Stavitsky, Gail, and Twig Johnson. *Roy Lichtenstein: American Indian Encounters*. Montclair, N.J.: Montclair Art Museum, 2005.

Wittman, Robert K. "Befriend and Betray." In *Priceless*. New York: Crown, 2010.

Chapter Six
## Virginia Dwan and Earthworks

129  *"to trust their seeing, too."* Charles Stuckey, interview with Virginia Dwan, Smithsonian Archives of American Art, March 21, 1984, p. 32.

130  *"It was not a consequential development."* Author's interview with Ivan Karp, November 1, 2010.

131  *"concentrate on the work."* Author's interview with Paula Cooper, February 18, 2011.

132  *"the business as a hobby."* Michael Kimmelman, "The Forgotten Godmother of Dia's Artists," *New York Times*, May 11, 2003.

133  *"a good* woman *artist."* From the film *Pollock*, directed by Ed Harris, 2001.

134  *"That was part of my faith."* Stuckey, interview with Virginia Dwan, p. 38.

135 *"so we can go home."* Lynne Cooke, and Karen Kelly, *Robert Smithson Spiral Jetty* (Berkeley: University of California Press, 2005), p. 191.

137 *"because he had to."* Stuckey, interview with Virginia Dwan, p. 42.

138 *"I didn't know how."* Stuckey, interview with Virginia Dwan, p. 18.

139 *decided to hold onto it longer.* Stuckey, interview with Virginia Dwan, p. 8.

140 *as an aesthetic yardstick.* Lynne Cooke, "Preface," in Kenneth Baker, *The Lightning Field* (New Haven: Yale University Press, 2005).

146 *"and her flank steak."* Adam Sternbergh, "The Passion of the Christos," *New York Magazine*, May 21, 2005.

148 *"vehicle that worked for him."* Author's interview with Virginia Dwan, April 21, 2010.

150 *"that's a very beautiful balance."* From the film *Rivers and Tides*, directed by Thomas Riedelsheimer, 2001.

151 *"I take art very seriously."* Author's interview with Virginia Dwan, April 21, 2010.

## ADDITIONAL SOURCES

Boettger, Suzaan. *Earthworks, Art and the Landscape of the Sixties.* Berkeley: University of California Press, 2002.

De Maria, Walter. "Some Facts, Notes, Data, Information, Statistics and Statements." *Artforum*, April 1980.

Fineberg, Jonathan. *On the Way to The Gates.* New Haven: Yale University Press, 2004.

Friedman, Terry, and Andy Goldsworthy. *Hand to Earth: Andy Goldsworthy Sculpture 1976–1990.* New York: Abrams, 1990.

Hogan, Erin. *Spiral Jetta.* Chicago: University of Chicago Press, 2008.

Kimmelman, Michael. "The Way We Live Now." *New York Times*, October 13, 2002.

La Prade, Erik. *Breaking Through: Richard Bellamy and the Green Gallery.* New York: Midmarch Arts Press, 2010.

McGill, Douglas. *Michael Heizer Effigy Tumuli*. New York: Abrams, 1990.

## Chapter Seven
### Tod Volpe and Contemporary Ceramic Sculpture

158 *"high art, almost priceless."* Garth Clark, Robert Ellison Jr., and Eugene Hecht, *The Mad Potter of Biloxi: The Art of Gorge Ohr* (New York: Abbeville Press), p. 34.

160 *"which were merely good."* Author's interview with Tod Volpe, May 3, 2010.

165 *"You gonna invite us in?"* Tod Volpe, *Framed* (Toronto: ECW Press, 2003), p. 81.

166 *"You're gonna live like a king!"* Volpe, *Framed*, p. 168.

167 *"people would know I had class."* Volpe, *Framed*, p. 171.

168 *the painting wasn't a genuine Pollock.* From the film *Who the #$&% Is Jackson Pollock?*, directed by Harry Moses, 2006.

169 *"I was astounded, knowing Volpe."* Interview with Thomas Hoving, "The Fate of the $5 Pollock," *Artnet.com Magazine*, November 6, 2008.

171 *cross over into sculpture.* Author's interview with Jane McDonald, June 1, 2010.

ADDITIONAL SOURCES

Benezra, Neal. *Robert Arneson: A Retrospective*. Des Moines, Iowa: Des Moines Art Center, 1985.

Bering, Henrik. "The Most Elegant Thieves of All." *Policy Review*, Hoover Institute, Stanford University, April & May 2003.

Celmins, Vija, and Matthew Higgs. *Ken Price*. New York: Matthew Marks Gallery, 2006.

Hanks, Robert. "Tod Volpe: A Rogue's Gallery." *The Independent*, November 27, 2002.

Kennedy, Randy. "Could Be a Pollock; Must Be a Yarn." *New York Times*, November 9, 2006.

Stillman, Nick. "The Blobs Aren't Talking." *New York Times*, March 3, 2010.

## Chapter Eight
### Jeffrey Fraenkel and Photography

180 *"He knew how to bring the work to life."* Author's interview with Thomas Meyer, August 2, 2010.

181 *"People would look at the Adams prints."* Author's interview with Thomas Meyer, August 7, 2010.

185 *"a more complicated story."* Author's interview with Jeffrey Fraenkel, September 1, 2010.

186 *the long-gone Hubert's.* Gregory Gibson, *Hubert's Freaks* (New York: Harcourt), 2008.

192 *"She became a huge part."* Author's interview with Jeffrey Fraenkel, September 1, 2010.

193 *"I had gotten there early."* Author's interview with Richard Misrach, September 20, 2010.

194 *"Gursky's huge, panoramic color prints."* Calvin Tomkins, "The Big Picture," *The New Yorker*, January 22, 2001, p. 62.

196 *"we know it is not real."* Press release from Museum of Modern Art, "Cindy Sherman: The Complete Untitled Film Stills," curated by Peter Galassi.

198 *"connection to the real world."* Author's interview with Jeffrey Fraenkel, September 1, 2010.

ADDITIONAL SOURCES

Arbus, Doon, and Richard Avedon. *The Sixties*. New York: Random House, 1999.

Arbus, Doon, and Marvin Israel. *Diane Arbus*. New York: Aperture, 1972.

Bosworth, Patricia. *Diane Arbus*. New York: Norton, 1984.

Hentschel, Martin. *Andreas Gursky: Works 80-08*. Ostfildern, Germany: Hatje Cantz, 2009.

Misrach, Richard. *Richard Misrach: Chronologies*. New York: D.A.P., and San Francisco: Fraenkel Gallery, 2005.
Schjeldahl, Peter. *Cindy Sherman*. New York: Pantheon, 1984.
Sussman, Elizabeth. *Diane Arbus Revelations*. New York: Random House, 2003.
Szarkowski, John. *William Eggleston's Guide*. New York: Museum of Modern Art, 1976.
Taylor, Paul. *After Andy: SoHo in the Eighties*. Melbourne, Australia: Schwartz City, 1995.
Wilson, Laura, and John Rohrbach. *In the American West*. New York: Abrams, 1985.

## Chapter Nine
### Louis Meisel and Photorealism
**204** *"I owned a Rothko!"* Author's interview with Louis Meisel, September 4, 2010.
**206** *"think of Photorealists?"* Author's interview with Louis Meisel, September 4, 2010.
**213** *"more disturbing than any fiction."* John Yau, *Daniel Douke* (Los Angeles: Peter Mendenhall Gallery, 2008), p. 13.
**213** *"about to lift off!"* Author's interview with Daniel Douke, September 30, 2010.
**214** *"We are taught that we don't have to study."* David Lubin, "They Were Really Nice Guys: Louis K. Meisel talks to David Lubin about Photorealism's Beginning," *Deutsche Bank Art Works* (2010), p. 2.
**218** *"It's that simple."* Author's interview with Louis Meisel, September 6, 2010.

#### ADDITIONAL SOURCES
Arthur, John, and John Canaday. *Richard Estes: The Urban Landscape*. New York: New York Graphic Society, 1979.
Battcock, Gregory. *Super Realism*. New York: Dutton, 1975.
Chase, Linda. *Ralph Goings*. New York: Abrams, 1988.

Finch, Christopher. *Chuck Close/Life.* New York: Prestel, 2010.

Geldzahler, Henry. *Charles Bell: The Complete Works,* 1970–1990. New York: Abrams, 1991.

Joyce, Julie. *Daniel Douke: Endless Instant.* Los Angeles: California State University Press, 2006.

## Chapter Ten
### Tony Shafrazi and Street Art

221 *"a dazzling act of chutzpah."* Robert Hughes, "Jean-Michel Basquiat: Requiem for a Featherweight," in *Nothing if Not Critical.* (New York: Knopf, 1987), p. 310.

224 *a composite of three distinct cultures of artists.* From black-and-white photo spread in Phoebe Hoban, *Basquiat: A Quick Killing in Art* (New York: Viking, 1998).

226 *"It would give me great pleasure."* Annie Cohan-Solal, *Leo & His Circle: The Life of Leo Castelli* (New York: Knopf, 2010), p. 342.

227 *"I have to finish the piece."* Author's interview with Tony Shafrazi, November 15, 2010.

230 *"too alive for that!"* John Gruen, *Keith Haring* (New York: Prentice Hall, 1991), p. 60.

231 *"Being an artist, and loving Picasso."* Gruen, *Keith Haring* (New York: Prentice Hall, 1991), p. 84.

234 *"heroin to nice college boys."* Quote from Jeffrey Deitch in Hoban, *Basquiat: A Quick Killing in Art,* p. 110.

235 *"painting out all of the good stuff."* From the film *Basquiat,* directed by Julian Schnabel, 1996.

235 *"As an elder statesman."* Cathleen McGuigan, "New Art, New Money," *New York Times Sunday Magazine,* February 10, 1985.

239 *"The people who truly deface."* Banksy, *Banksy Wall and Piece* (London: Century, 2006), p. 8.

242 *"I've never stopped studying art."* Author's interview with Tony Shafrazi, November 15, 2010.

**ADDITIONAL SOURCES**

Colacello, Bob. *Holy Terror: Andy Warhol Close Up*. New York: Harper Collins, 1990.

De Coppet, Laura, and Alan Jones. "Tony Shafrazi." In *The Art Dealers*. New York: Cooper Square Press, 1984.

*Jean-Michel Basquiat: The Radiant Child*. Film directed by Tamra Davis, 2010.

Shafrazi, Tony. "Dennis Hopper." *Index Magazine*, 1999.

Taylor, Paul. *After Andy: SoHo in the Eighties*. Melbourne, Australia: Schwartz City, 1995.

Vyner, Harriet. *Groovy Bob: The Life and Times of Robert Fraser*. London: Faber and Faber, 1999.

Zeitz, Lisa. "The Tony Shafrazi Story." *Artnet.com Magazine*, September 10, 2009.

Epilogue
**Prophesying**
**246** *"But I already am!"* Author's interview with Peter Stremmel, November 20, 2010.

## About the Author

RICHARD POLSKY is the author of *I Sold Andy Warhol (Too Soon)*, *I Bought Andy Warhol*, *The Art Market Guide (1995–1998)*, and *Boneheads: My Search for T. Rex*. He began his professional career in the art world thirty-three years ago. In 1984 he cofounded Acme Art, where he showed the work of such artists as Joseph Cornell, Ed Ruscha, Andy Warhol, and Bill Traylor. Since 1989 he has been a private dealer specializing in works by postwar artists, with an emphasis on Pop Art. He lives in Sausalito, California. His Web site is www.richardpolsky.com